THE NEW NYLON BOOK OF GLOBAL STYLE

STREE
NYLON

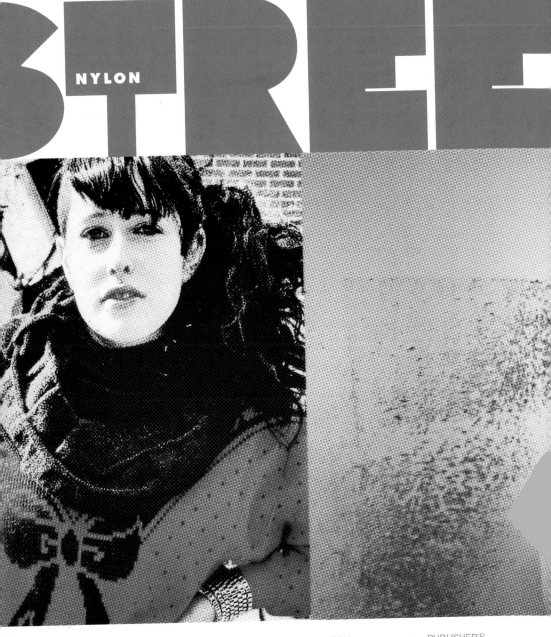

Design by
Rob Vargas

2010 2011
2012 2013

10 9 8 7 6 5 4 3 2 1

First Edition

Printed in China

ISBN:
978-0-7893-2088-9
Library of
Congress Control
Number:
2010921399

PUBLISHER'S
NOTE

Neither Universe
Publishing nor
NYLON has any
interest, financial
or personal, in
the businesses listed
in this book. No
fees were paid or
services rendered in
exchange for inclusion
in these pages.

This edition first
published in 2010
by UNIVERSE
PUBLISHING
A division of
Rizzoli International
Publications, Inc.
300 Park Ave. South
New York
NY 10010
www.rizzoliusa.com

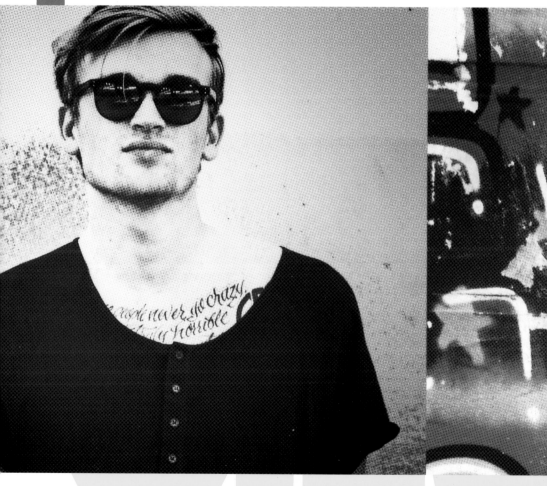

contents

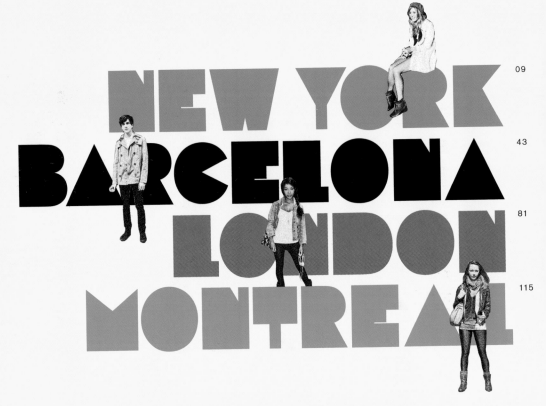

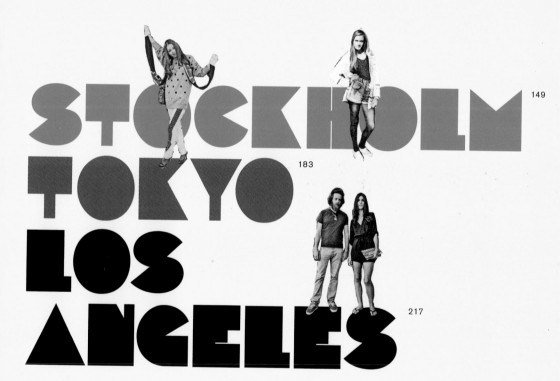

STOCKHOLM

TOKYO

LOS ANGELES

foreword

As *NYLON*'s editor-in-chief, I'm
lucky enough to travel around
the world nearly nonstop,
meeting and collaborating with
the people we love to cover in
the magazine—and being
incidentally inspired by the street
fashion of each city I visit all
along the way. Four years have
passed since the first edition
of this book was released,
and some things have changed
over that time—we'll see different
hybrids, evolving takes on what
we saw the first time around.
Others haven't, like our belief
that street fashion is the equal
of any runway show you'll
see, and a better gauge of
what a place is really like. We're
convinced that Barcelona,
Montreal, London, Stockholm,
Los Angeles, Tokyo—and,
of course, our hometown city,
New York—are the absolute
best places to see street fashion
in action today.
 Fashion is a business, but
street fashion can be an art.
It's one we're proud to showcase
in this book.

Marvin Scott Jarrett
Editor-in-Chief, *NYLON*

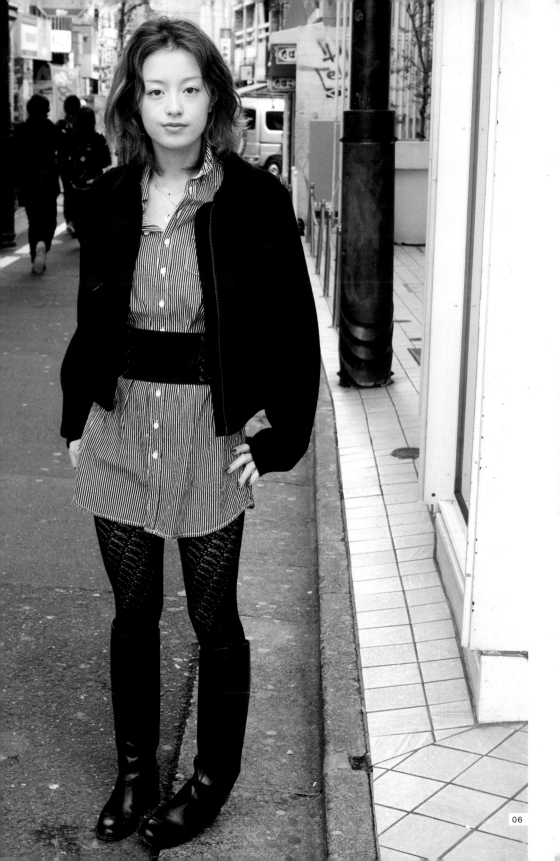

introduction

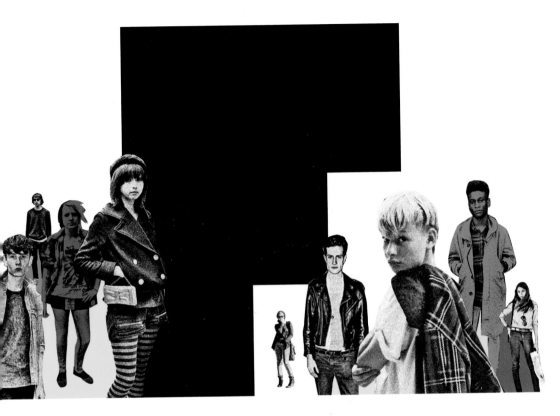

Fashion is over. Blame Etsy. Blame the Internet, blame the Sartorialist and those who came before (and after) him. Fashion as we knew it—as a codified set of instructions, a paint-by-numbers shopping guide for those who would buy what they could neither create nor imagine—is over. It is no longer enough to have a trust fund and live at the correct address.

This is no recent phenomenon: Remember Karl Lagerfeld for H&M, a million years ago in 2004? These days, every big-box store in America (and half of those in Europe) claim a high-fashion partner in producing mass-market pieces at affordable prices. Stella McCartney, Loeffler Randall, Viktor & Rolf, Giles Deacon, Jimmy Choo, and dozens more designers have recognized the obvious truth: There's little fun to be had in making clothes for a few dozen rich, bored housewives and their petulant offspring.

The cheap-chic style revolution reinforces what we have always known and always celebrated at *NYLON*: Fashion—true style, if you will—has always been more about creativity than it has been about privilege. This blurring-to-nothing of the line between designer boutique and mass-market emporium is one example. The democratization of the fashion authority is another. While a handful of people once decreed each

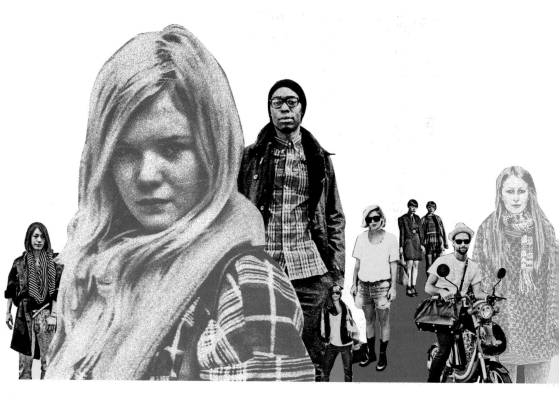

season's rigorous (and ridiculous) dos and don'ts, these days, we're all as likely to check our favorite niche Web sites—or Etsy, or our Flickr photostream—for ideas as we are anything else. The bloggers, one might say, have stormed the runways. What this means is that we have all been empowered like never before. There are no excuses: no complaints about not having the money or the ideas to create something amazing with what we wear, how we look, and what we carry.

We're convinced you'll see this on every page of this book, which presents the most amazing street fashion in the world. As we did in 2006 for *STREET*, we traveled to seven cities, scouring the sidewalks for the best and the brightest. London, Tokyo, and —of course—our hometown, New York, are in here, as they were in the first book. We've made space for exciting new additions as well: Stockholm, Barcelona, Montreal, and Los Angeles.

Consider this our valentine to your creativity—and consider it as much a manifesto as a celebration. Fashion belongs to us: to the amazingly creative people featured in this book, and to the amazingly creative people reading it. We're inspired by all of you.

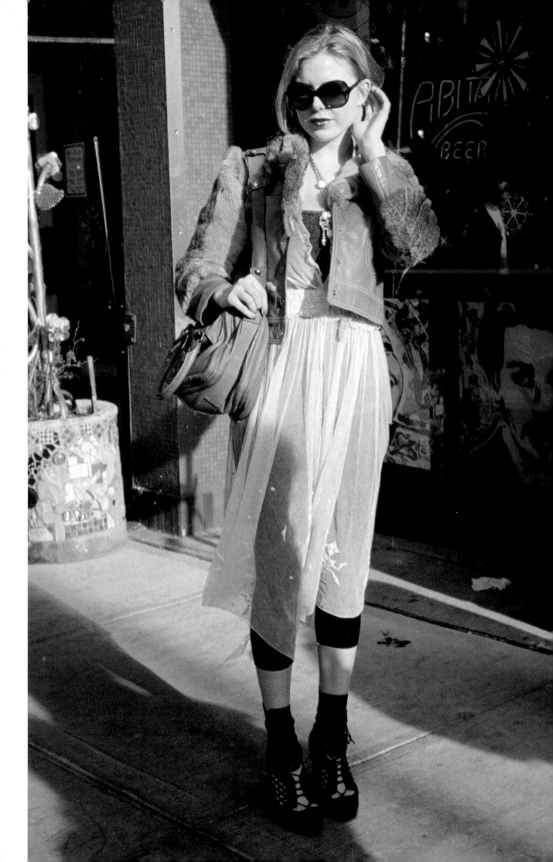

NEW YORK

ALYSSA, 25

OCCUPATION Owner
of vintage shop
The Sweet Ones
I'M WEARING an
embroidered '20s
dress, Topshop
boots, a Chloe
bag, and Prada
sunglasses.
**WHAT DO YOU LOVE
ABOUT NEW YORK?**
You can always
find a 24-hour diner
or bodega.

New York is the melting pot made literal, especially on a hot summer's afternoon when everyone—young and old, rich and poor, punk and skater and art student and banker and rapper and the mayor himself—sweats out an uptown ride on the 6 train. Take that same trip on any other city's metro and chances are you won't see quite so many variations on the human experience. A uniform will likely emerge—a *soignée* uniform perhaps, but a uniform all the same—a scarf arranged just so, a jacket cut just right. That's not New York. For decades the city has been a magnet to kids who can't bear the uniform, who dream of a place where no one minds if they can't manage to conform, if they're too tall, too smart, too weird, too much for their homeroom classmates. New York is made of too much.

For centuries, New York's—and by extension, America's—fashion center was the Garment District, a ten-block stretch of warehouses, showrooms, and studios between Midtown and Chelsea where, 150 years ago, manufacturers produced clothing for slaves and soldiers fighting the Civil War. Its boundaries shrank in the ensuing decades, as manufacturing moved overseas and designers sought out lower rents. In recent years, neighborhood stalwarts like Anna Sui and Nanette Lepore have led campaigns to

save the Garment District, but this tiny area is by no means an irrelevant piece of nostalgia—it's still home to major American designers like Calvin Klein and Nicole Miller and Oscar de la Renta.

Unlike other cities, New York operates under the fiercest sort of democracy: "a dollar and a dream" is as much the municipal motto as it is our lottery slogan. Don't want to spring for a Bryant Park show? Stage one on the streets outside. Can't afford a SoHo studio? Who can? Follow Vena Cava's Sophie Buhai and Lisa Mayock—or *NYLON*'s very own Eviana Hartman, who now designs the organic line Bodkin—to Brooklyn. In other cities, an economic recession might signal the deferral of the dream, but in New York, we just get more creative. Designers colonize neighborhoods at the outer reaches—in the post-art-school dorms of East Williamsburg, or the brownstones inBed-Stuy, or the (pre-renovation) lofts of Red Hook. And they dress their friends, the passersby on the street, the bands they play in at Pete's Candy Store or Galapagos. New York is not so much about the label as it is about the reference: the Lyell blouse, the hand-knit cape, the Dee and Ricky pin (all designed in New York, of course). Each piece signals a membership in the myriad tribes that make up New York, where the same pair of jeans can be worn a thousand different ways and say a million different things, where khakis and a button-down shirt are as likely to be worn as a conceptual art project as they are to be an office-goer's acquiescence to the work of getting dressed.

There's a reason we at *NYLON* make our home in New York, alongside so many of our favorite designers, artists, eccentrics, and entertainers. Anything can happen here, and everyone's invited. That's the thing about New York: Step across the boundary, and you're a New Yorker. What comes next is up to you.

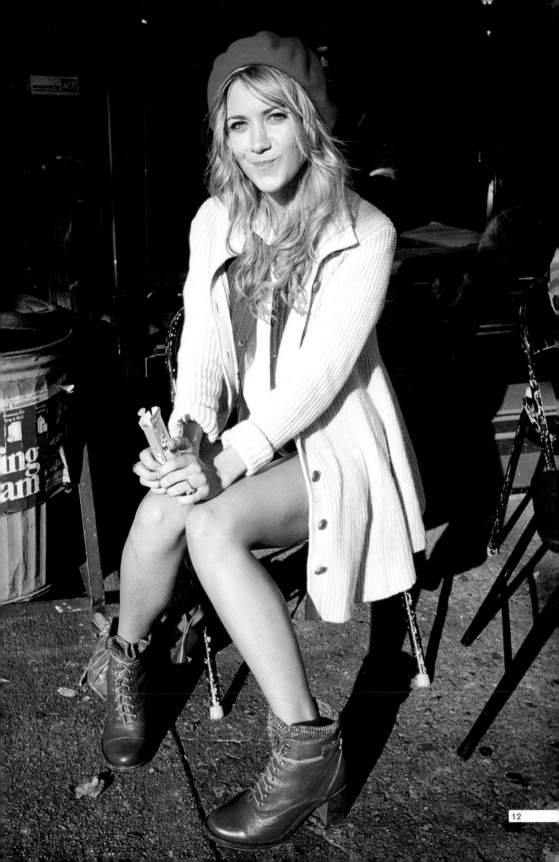

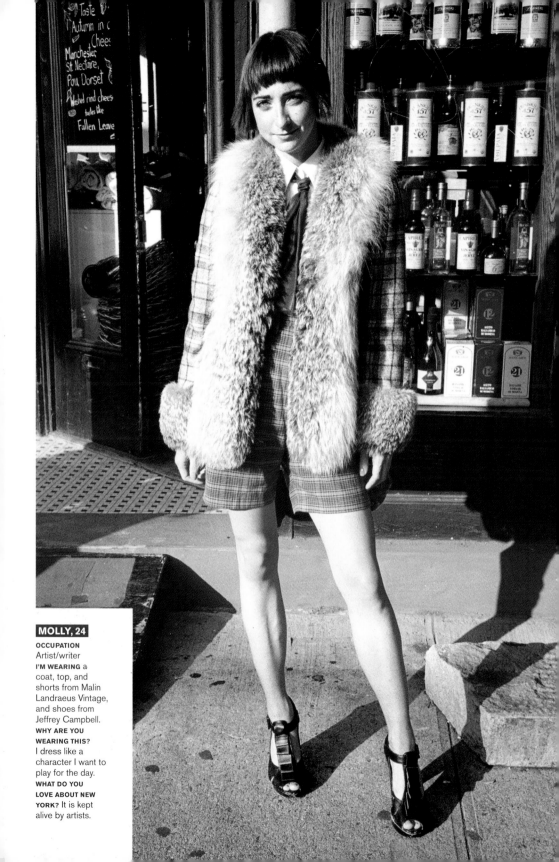

MOLLY, 24

OCCUPATION
Artist/writer
I'M WEARING a
coat, top, and
shorts from Malin
Landraeus Vintage,
and shoes from
Jeffrey Campbell.
**WHY ARE YOU
WEARING THIS?**
I dress like a
character I want to
play for the day.
**WHAT DO YOU
LOVE ABOUT NEW
YORK?** It is kept
alive by artists.

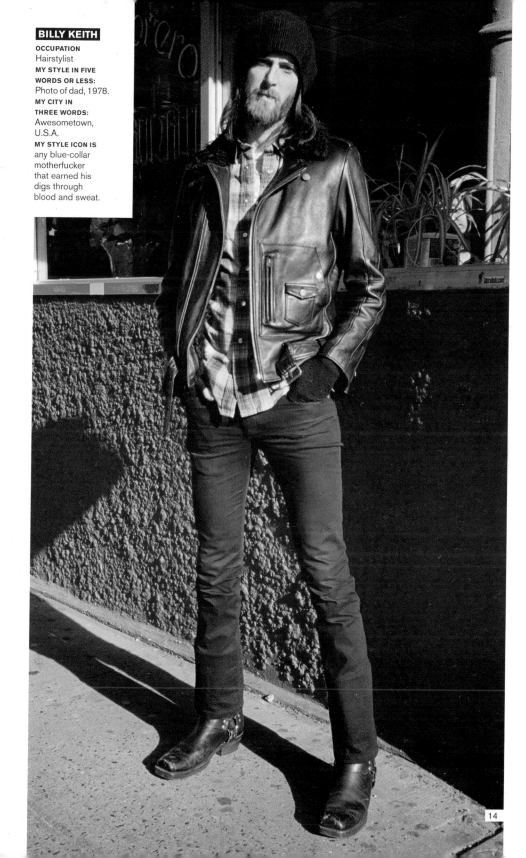

BILLY KEITH

OCCUPATION
Hairstylist
**MY STYLE IN FIVE
WORDS OR LESS:**
Photo of dad, 1978.
**MY CITY IN
THREE WORDS:**
Awesometown,
U.S.A.
MY STYLE ICON IS
any blue-collar
motherfucker
that earned his
digs through
blood and sweat.

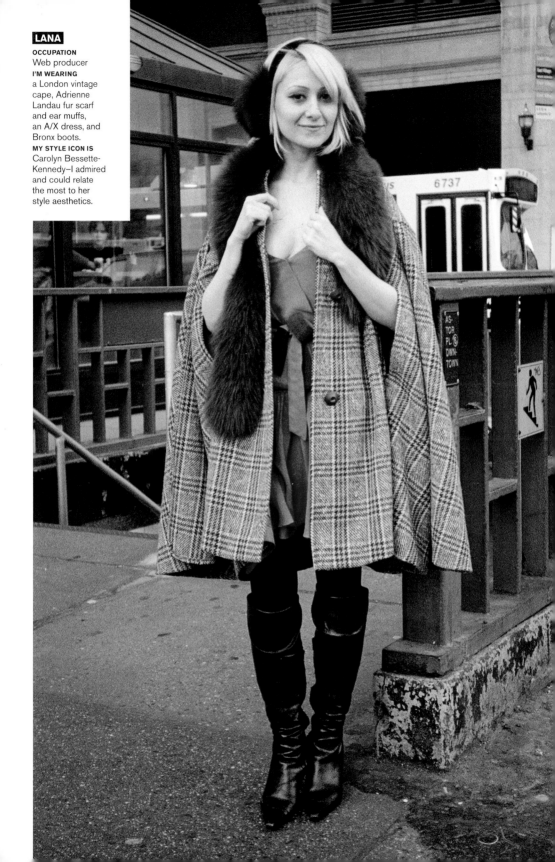

LANA

OCCUPATION
Web producer
I'M WEARING
a London vintage
cape, Adrienne
Landau fur scarf
and ear muffs,
an A/X dress, and
Bronx boots.
MY STYLE ICON IS
Carolyn Bessette-
Kennedy–I admired
and could relate
the most to her
style aesthetics.

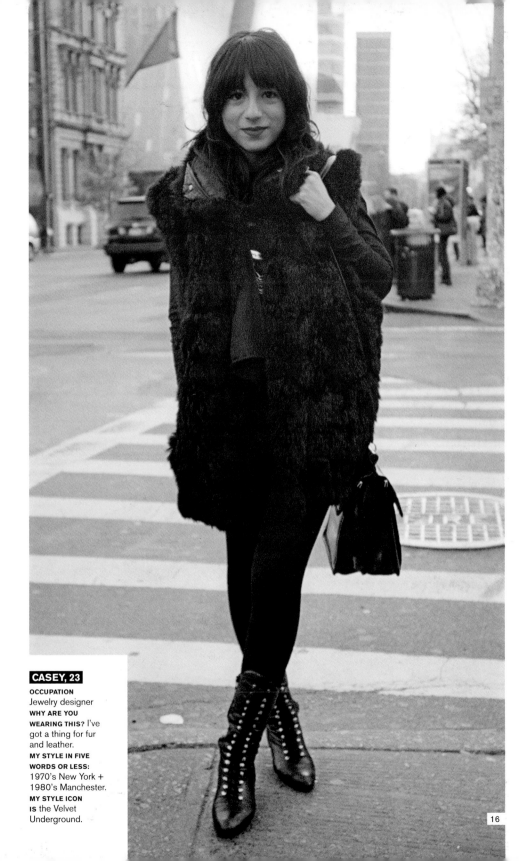

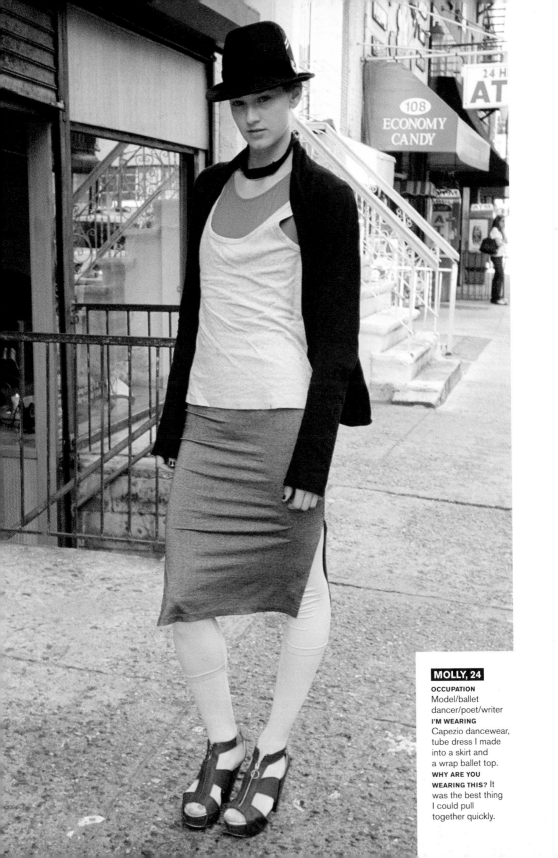

MOLLY, 24

OCCUPATION
Model/ballet
dancer/poet/writer
I'M WEARING
Capezio dancewear,
tube dress I made
into a skirt and
a wrap ballet top.
**WHY ARE YOU
WEARING THIS?** It
was the best thing
I could pull
together quickly.

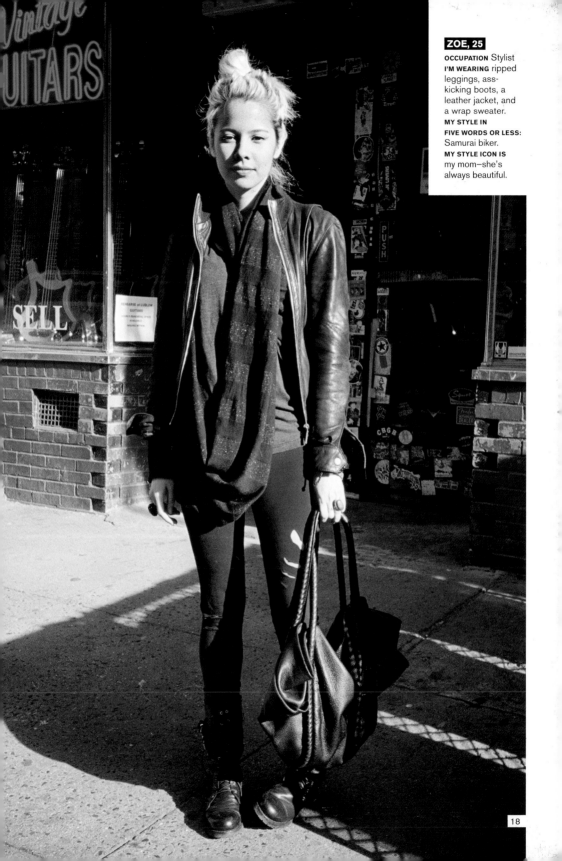

MY STYLE ICON IS

Theda Bara. She is elegant and enigmatic.

LARA, 25

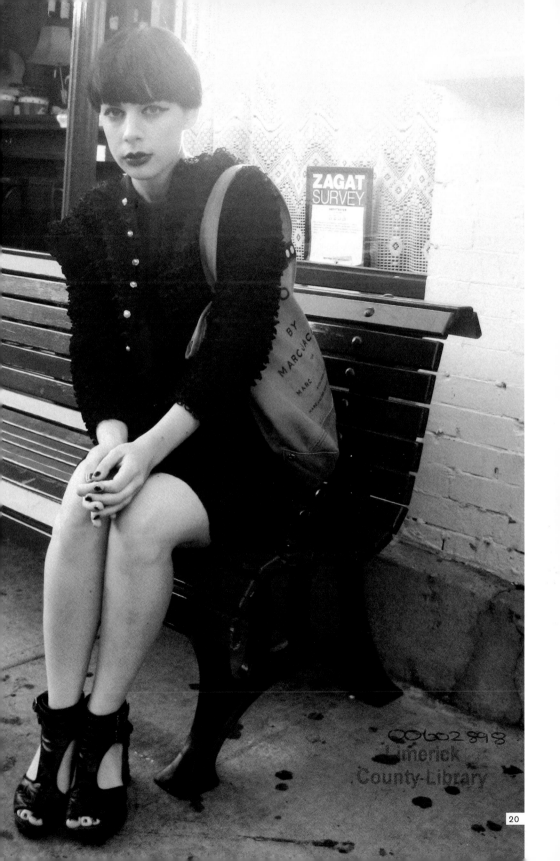

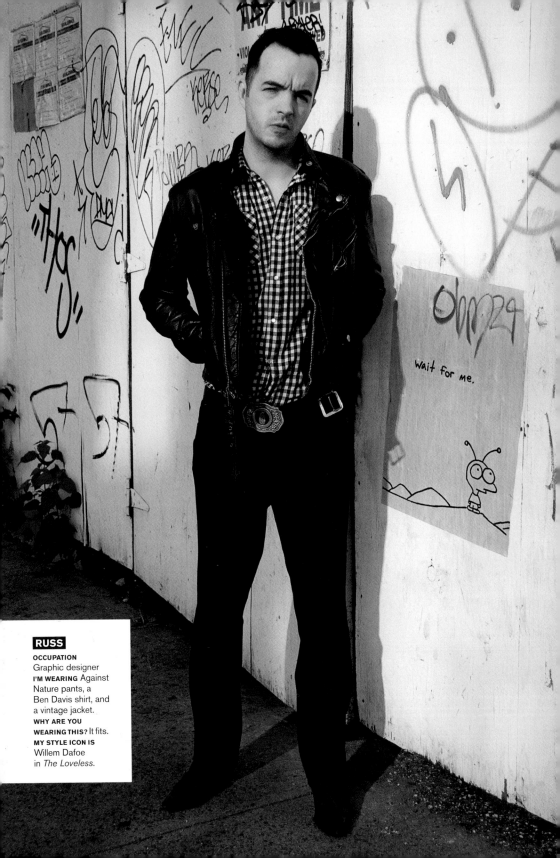

RUSS

OCCUPATION
Graphic designer
I'M WEARING Against
Nature pants, a
Ben Davis shirt, and
a vintage jacket.
**WHY ARE YOU
WEARING THIS?** It fits.
MY STYLE ICON IS
Willem Dafoe
in *The Loveless*.

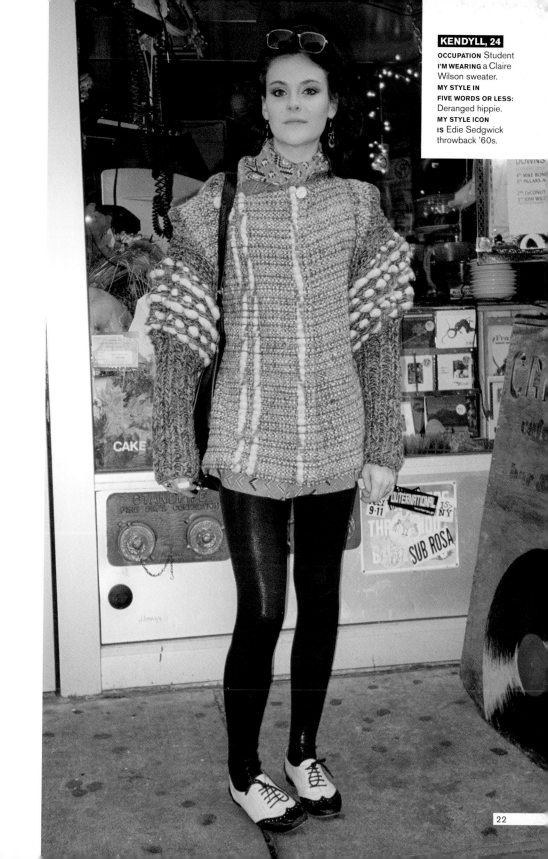

KENDYLL, 24

OCCUPATION Student
I'M WEARING a Claire
Wilson sweater.
MY STYLE IN
FIVE WORDS OR LESS:
Deranged hippie.
MY STYLE ICON
IS Edie Sedgwick
throwback '60s.

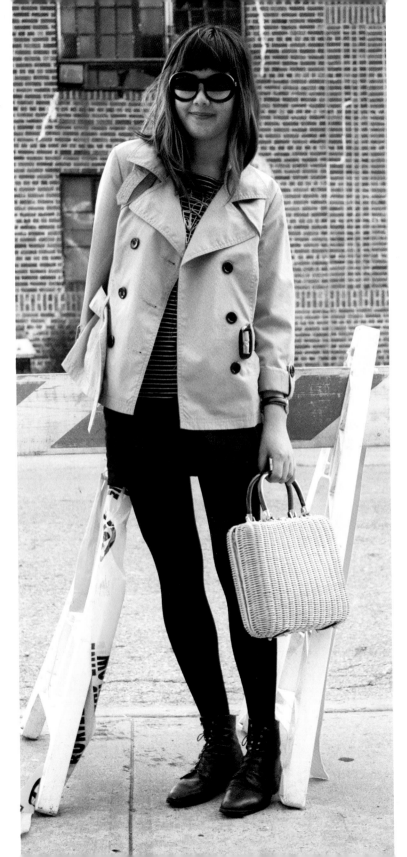

BRITTANY, 24

OCCUPATION
Graphic design
student at Parsons

I'M WEARING
Chanel sunglasses,
an H&M jacket,
vintage boots, a
Lands End shirt, and
a black American
Apparel skirt.

MY STYLE ICON IS
Diane Keaton as
Annie Hall because
she looked sick
as hell in her
seersucker suits.

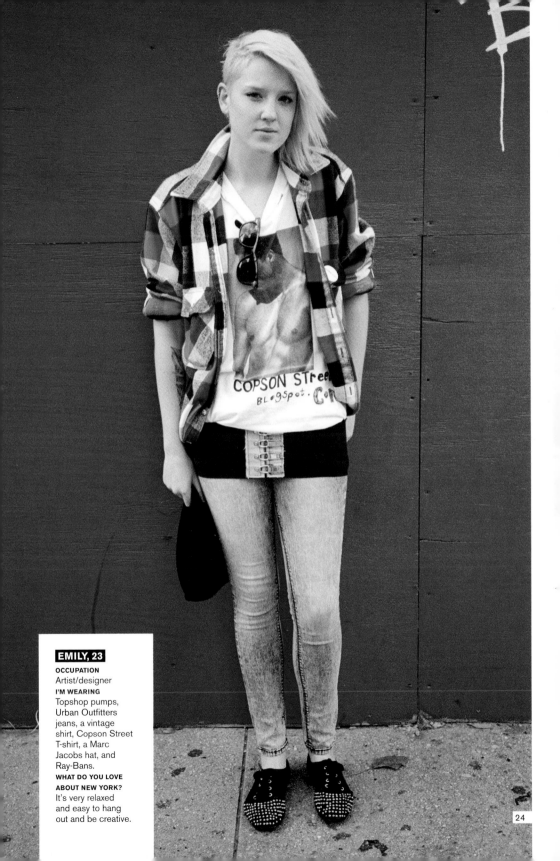

EMILY, 23

OCCUPATION
Artist/designer
I'M WEARING
Topshop pumps,
Urban Outfitters
jeans, a vintage
shirt, Copson Street
T-shirt, a Marc
Jacobs hat, and
Ray-Bans.
**WHAT DO YOU LOVE
ABOUT NEW YORK?**
It's very relaxed
and easy to hang
out and be creative.

24

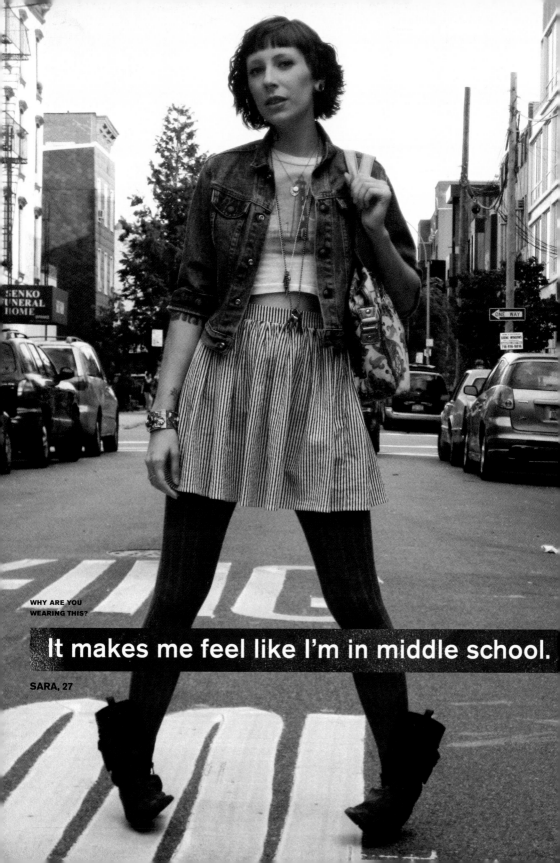

WHY ARE YOU
WEARING THIS?

It makes me feel like I'm in middle school.

SARA, 27

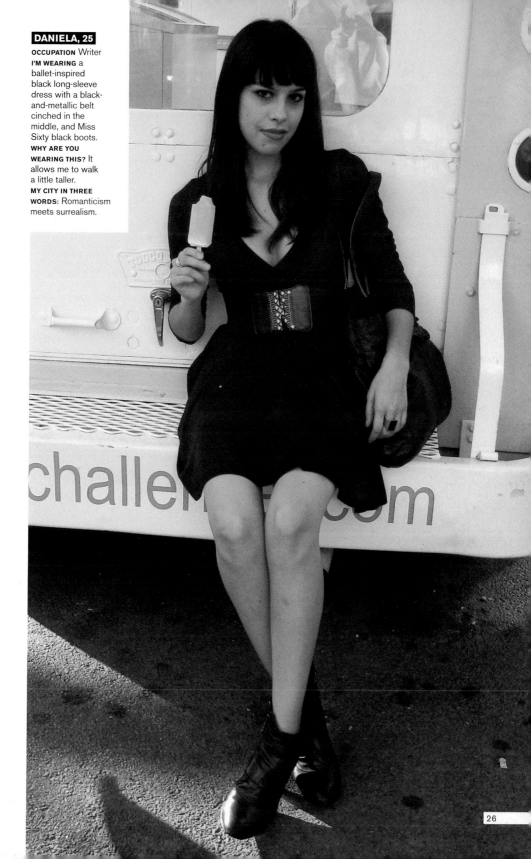

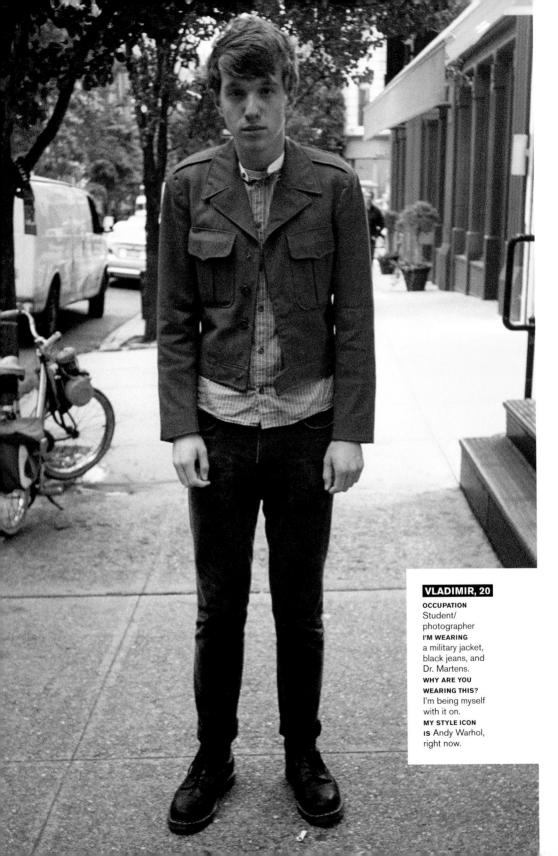

VLADIMIR, 20

OCCUPATION
Student/
photographer
I'M WEARING
a military jacket,
black jeans, and
Dr. Martens.
**WHY ARE YOU
WEARING THIS?**
I'm being myself
with it on.
**MY STYLE ICON
IS** Andy Warhol,
right now.

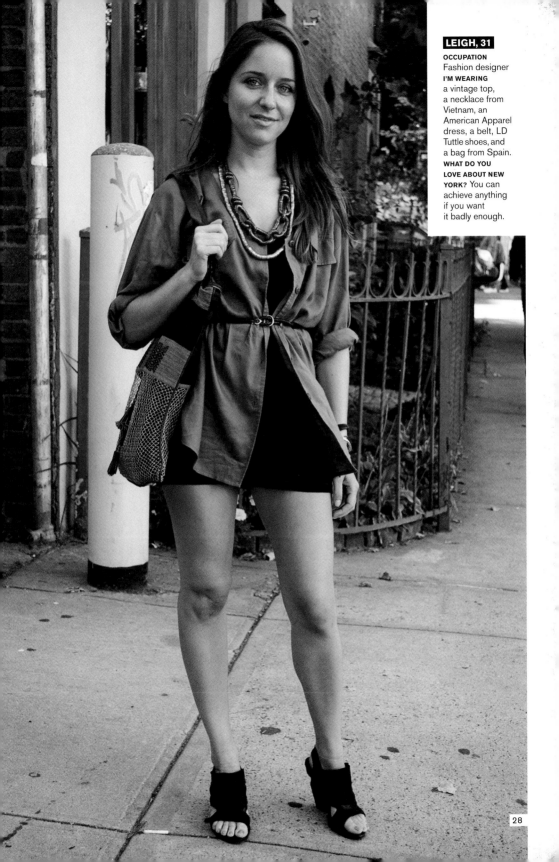

LEIGH, 31

OCCUPATION
Fashion designer
I'M WEARING
a vintage top,
a necklace from
Vietnam, an
American Apparel
dress, a belt, LD
Tuttle shoes, and
a bag from Spain.
**WHAT DO YOU
LOVE ABOUT NEW
YORK?** You can
achieve anything
if you want
it badly enough.

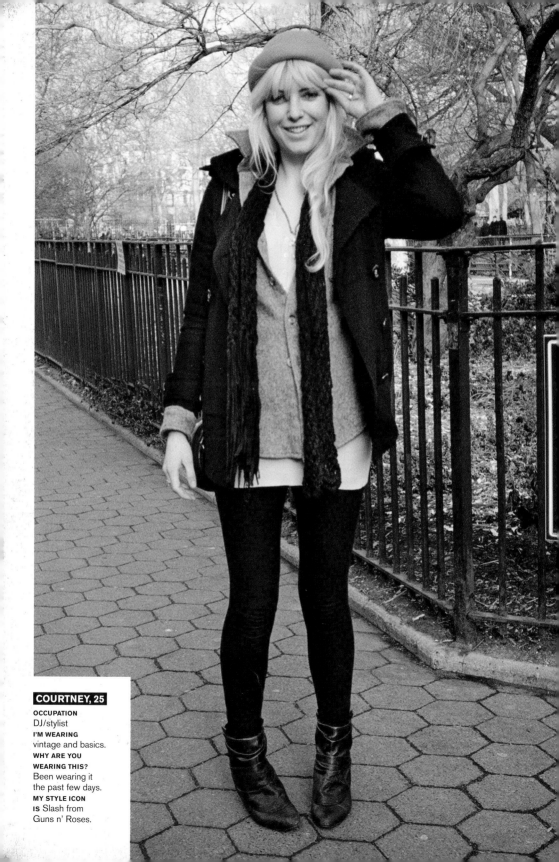

COURTNEY, 25

OCCUPATION
DJ/stylist
I'M WEARING
vintage and basics.
WHY ARE YOU
WEARING THIS?
Been wearing it
the past few days.
MY STYLE ICON
IS Slash from
Guns n' Roses.

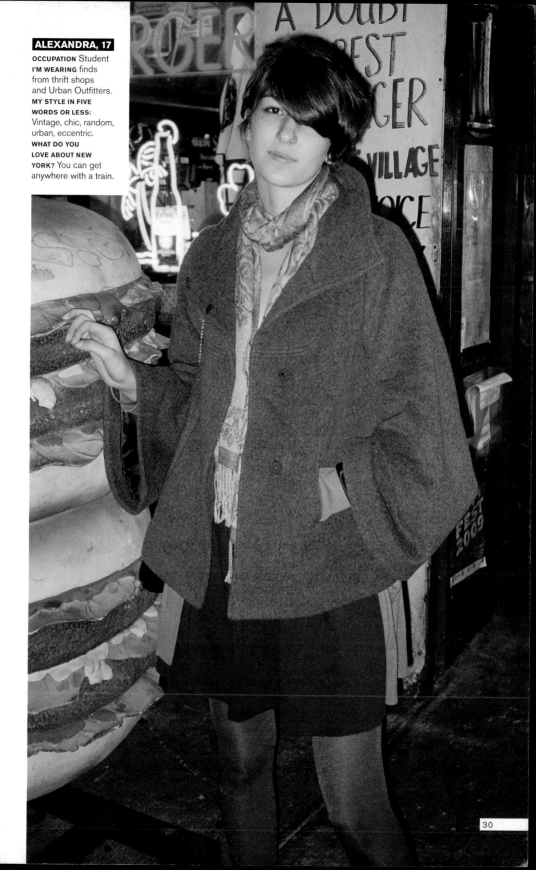

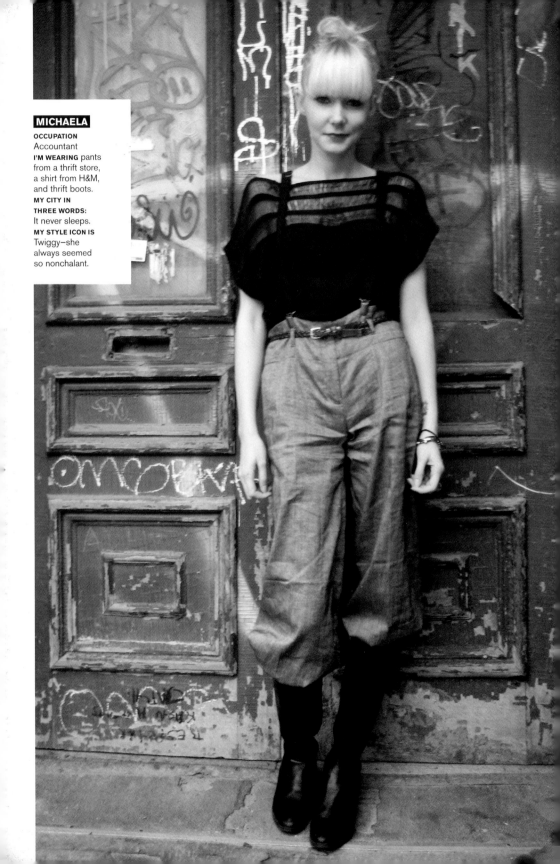

MICHAELA

OCCUPATION
Accountant
I'M WEARING pants
from a thrift store,
a shirt from H&M,
and thrift boots.
**MY CITY IN
THREE WORDS:**
It never sleeps.
MY STYLE ICON IS
Twiggy—she
always seemed
so nonchalant.

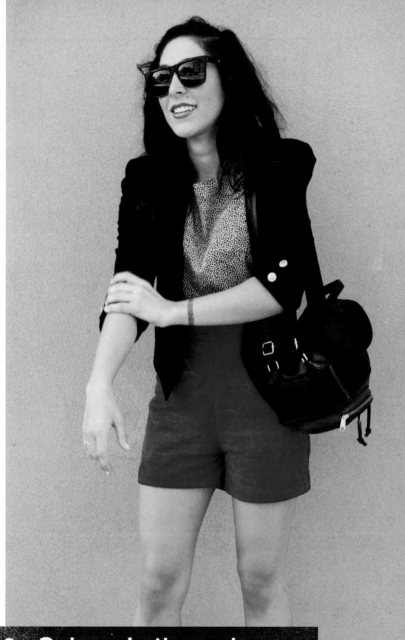

Early '90s Selena Latina princess.

HAYDEN, 25

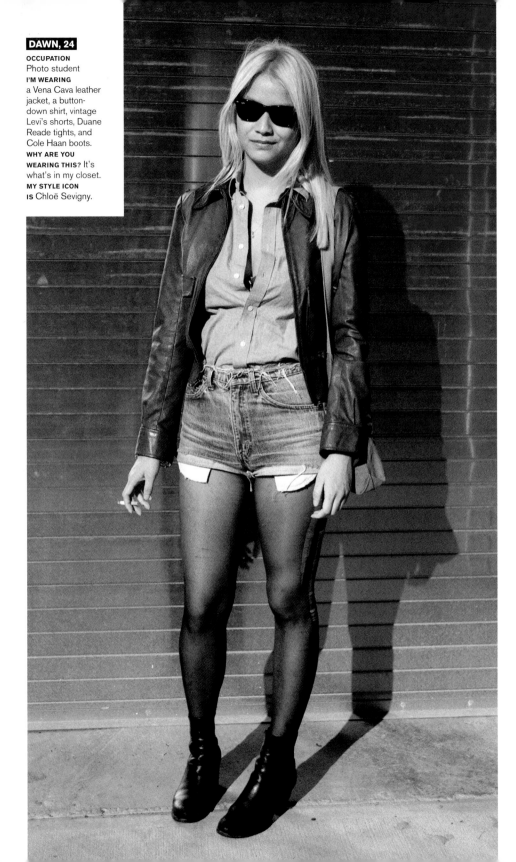

DAWN, 24

OCCUPATION
Photo student
I'M WEARING
a Vena Cava leather
jacket, a button-
down shirt, vintage
Levi's shorts, Duane
Reade tights, and
Cole Haan boots.
**WHY ARE YOU
WEARING THIS?** It's
what's in my closet.
**MY STYLE ICON
IS** Chloë Sevigny.

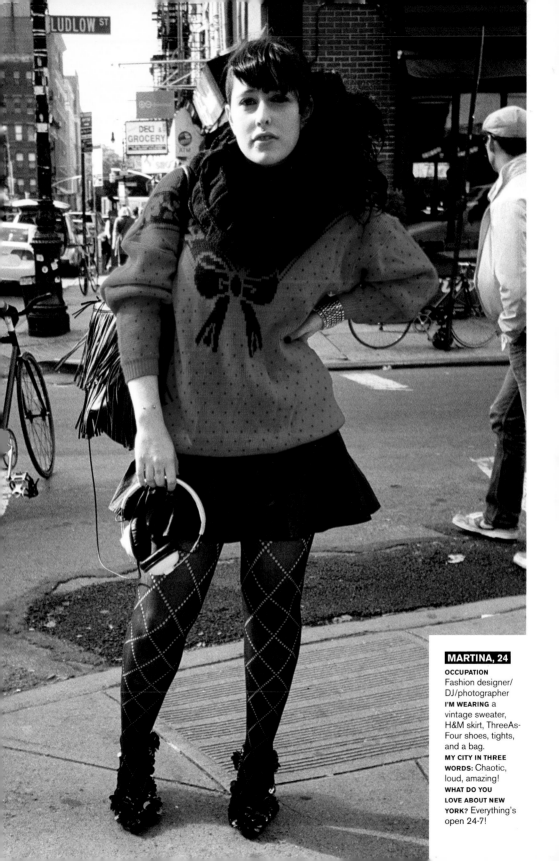

MARTINA, 24

OCCUPATION
Fashion designer/
DJ/photographer
I'M WEARING a
vintage sweater,
H&M skirt, ThreeAs-
Four shoes, tights,
and a bag.
MY CITY IN THREE
WORDS: Chaotic,
loud, amazing!
WHAT DO YOU
LOVE ABOUT NEW
YORK? Everything's
open 24-7!

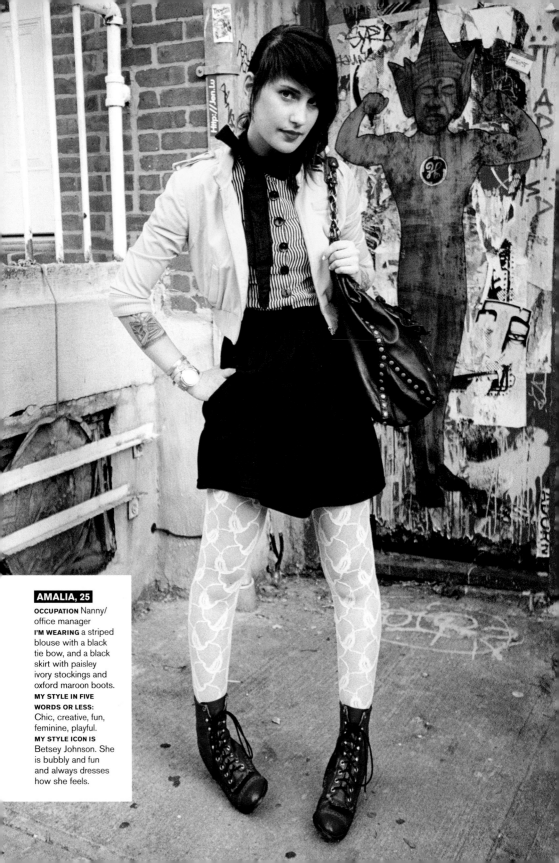

AMALIA, 25

OCCUPATION Nanny/
office manager
I'M WEARING a striped
blouse with a black
tie bow, and a black
skirt with paisley
ivory stockings and
oxford maroon boots.
**MY STYLE IN FIVE
WORDS OR LESS:**
Chic, creative, fun,
feminine, playful.
MY STYLE ICON IS
Betsey Johnson. She
is bubbly and fun
and always dresses
how she feels.

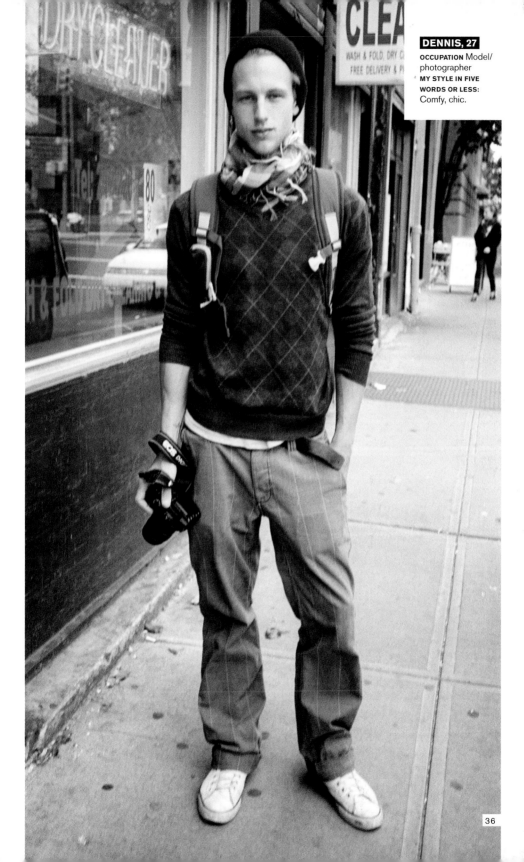

DENNIS, 27

OCCUPATION Model/
photographer
MY STYLE IN FIVE
WORDS OR LESS:
Comfy, chic.

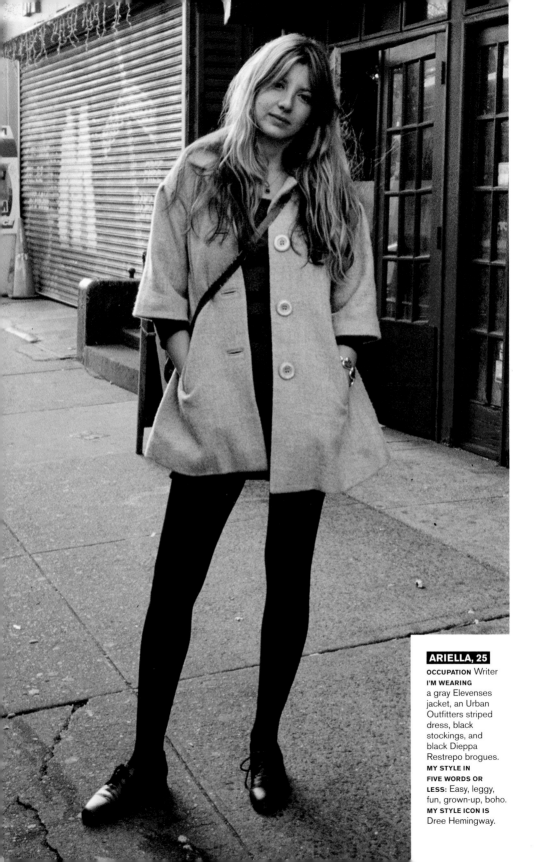

ARIELLA, 25

OCCUPATION Writer
I'M WEARING
a gray Elevenses
jacket, an Urban
Outfitters striped
dress, black
stockings, and
black Dieppa
Restrepo brogues.
**MY STYLE IN
FIVE WORDS OR
LESS:** Easy, leggy,
fun, grown-up, boho.
MY STYLE ICON IS
Dree Hemingway.

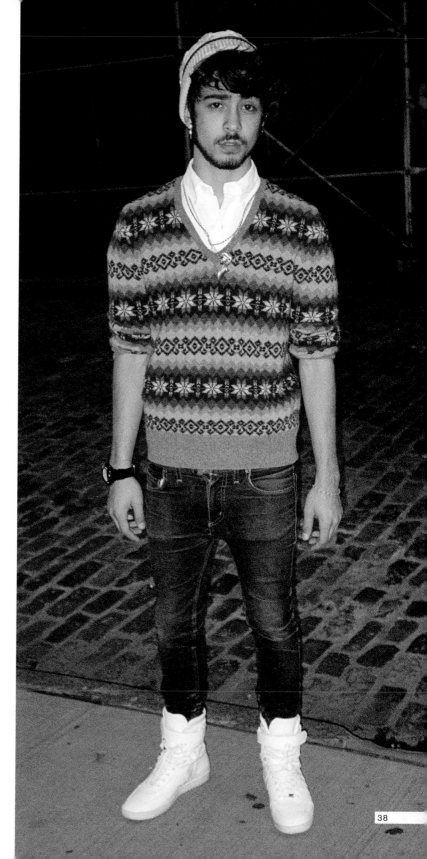

REMBRANDT, 19

OCCUPATION
Student

I'M WEARING a
Ralph Lauren button-
up, rugby sweater,
Cheap Monday
jeans, Christian
Dior sneakers, and
a Gucci beanie.

**WHY ARE YOU
WEARING THIS?**
Because I love
dressing preppy
and urban.

**MY CITY IN THREE
WORDS:** The
greatest ever.

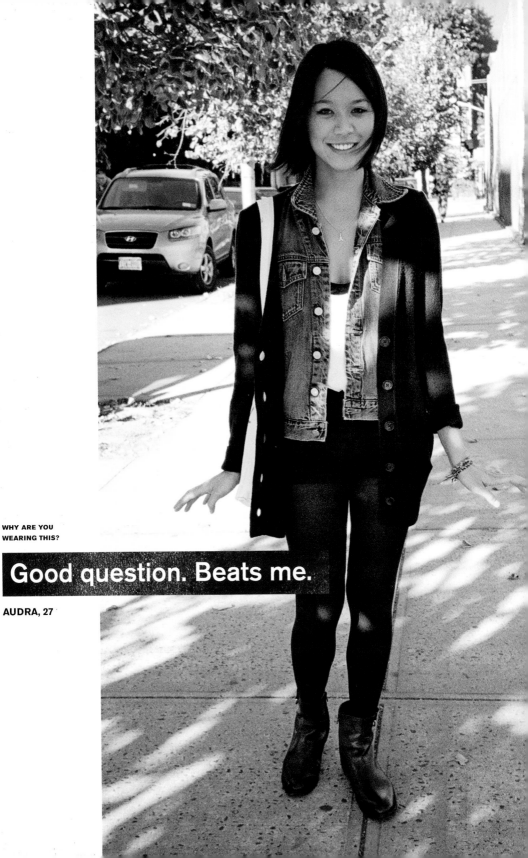

WHY ARE YOU
WEARING THIS?

Good question. Beats me.

AUDRA, 27

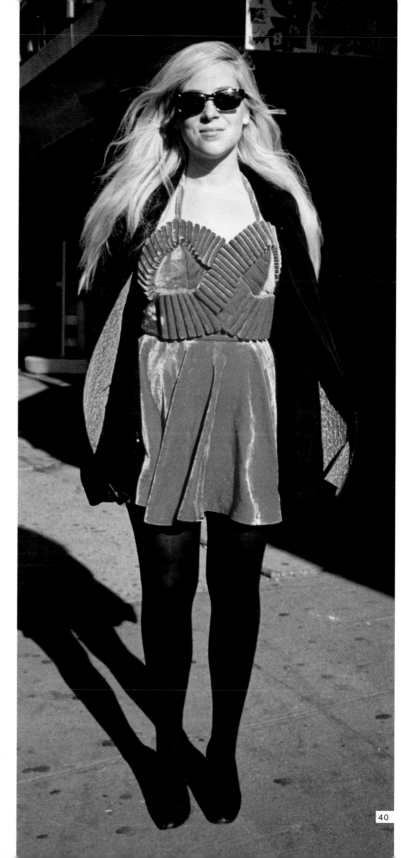

KELLEY, 26

OCCUPATION Writer and fashion editor

I'M WEARING Christian Louboutin heels, Kara Walker sunglasses, a pink Christopher Kane velvet dress, and a black slouchy blazer from Malin Landeaus.

MY STYLE IN FIVE WORDS OR LESS: Swedish child prostitute.

MY STYLE ICON IS Kim Basinger in *9 1/2 Weeks*.

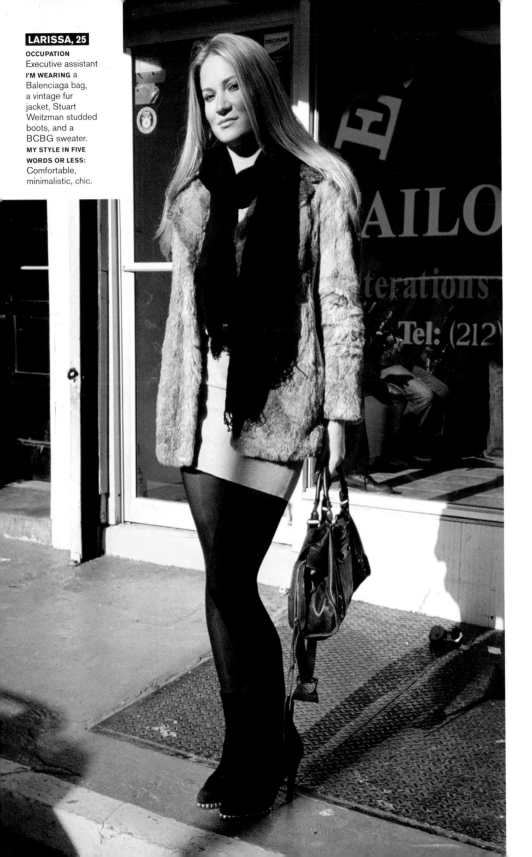

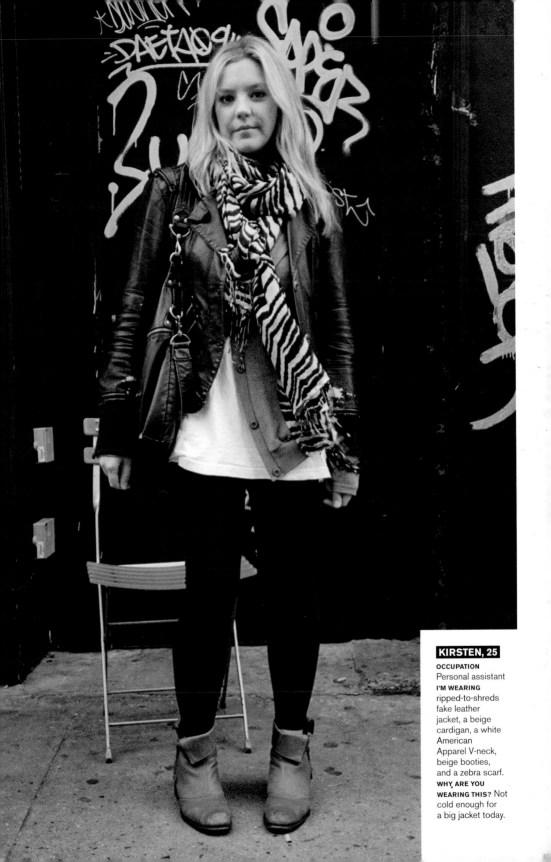

KIRSTEN, 25

OCCUPATION
Personal assistant
I'M WEARING
ripped-to-shreds
fake leather
jacket, a beige
cardigan, a white
American
Apparel V-neck,
beige booties,
and a zebra scarf.
WHY ARE YOU
WEARING THIS? Not
cold enough for
a big jacket today.

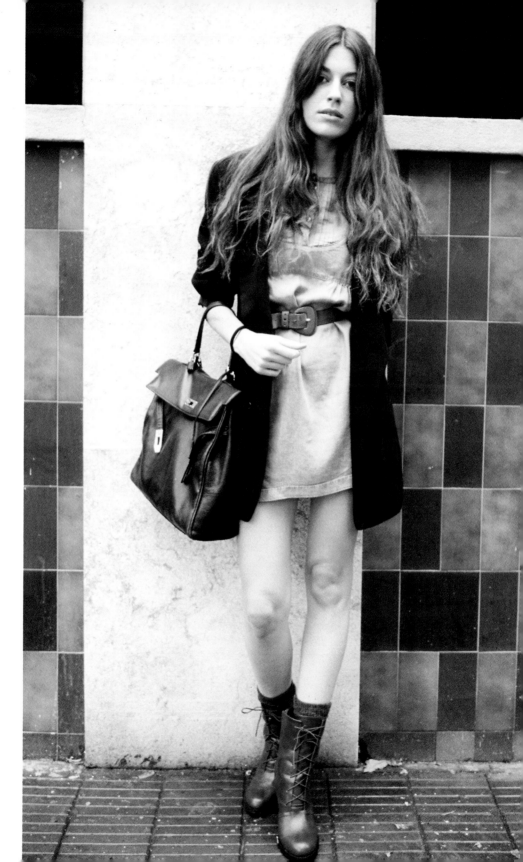

Perhaps no other city in the world is defined by a single artist as Barcelona is by architect Antoni Gaudí. He is—quite happily and quite literally—everywhere you look, from the unfinished spires of his fantastical cathedral masterwork, the Sagrada Família, to the willfully loopy Park Güell, which looks like nothing so much as the architectural equivalent of a mescaline hallucination. Gaudí's mark is found even on the city's paving stones, each intricately adorned with nautical elements: the swirl of a conch shell and the waves of the sea. Within an artistic practice not typically dedicated to the expression of delight, Gaudí is a notable exception.

Architecture is inherent to the experience of Barcelona, and the city offers a sturdy sort of structural whimsy that traces fanciful forms on cement and stone—a mirror, in many ways, of the city itself, which is both the political capital of Catalonian Spain and, perhaps, the European city most dedicated to the pursuit of fun, with its beach and a particularly Spanish appreciation for the worth of the promenade—whether a Sunday afternoon stroll or the walk leading from the car to the city's infamous nightclubs. This is an aesthetic equally at play—and play is the only

suitable word—in the city's street fashion. No other city does grown-up cute like Barcelona, but neither does any other city do rigorous quite so confidently, either.

Barcelona is not Berlin, Europe's reigning capital of underfed young creatives who patiently assemble conceptual art pieces in the basements of unheated warehouses for small audiences and little money. The artists, designers, and musicians who've come from across Europe to call Barcelona home would likely argue that life simply does not need to be so difficult, and the process of making new things under sunny skies is roughly equivalent to that performed under slate-gray clouds. This is Spain, after all, home to a culture that rightly worships food and fiestas. And it is not without its own intellectual heft. Pablo Picasso came of age in Barcelona, and even though his most important works have been spirited away to Madrid or farther afield, the city's best museum is its Museu Picasso, home to many of his sketches and studies.

The foundations are here, in other words, and the love of shape and architecture is evident in the regard for Gaudí's gifts to the city. On his sidewalks there is, conversely, evident talent for deconstruction, the signaling of larger ideas with the smallest of gestures: the oversized cuff, the unsuitable hat, too-short skirt over too-bright tights—though, in context, this all, like Gaudí's loops and whirls, makes a perfect sort of sense. The underpinnings are European, the tailoring is impeccable, the proportions are precise—but it is somehow enlivened by being slightly off, slightly wrong, completely unexpected, in the most minute but insistent ways. Make no mistake: The city's street fashion betrays an affection for designer offerings and for the luxury they provide—but that imprimatur is not nearly sufficient on its own, without the mediating quality of the individual touch. Barcelona proves that the finest details demand attention, that a half-inch at the hem and a quarter-inch at the waist could add up to something like transcendence when right, or disaster when wrong—but that either way, there will be drinks before dancing, and perhaps after as well.

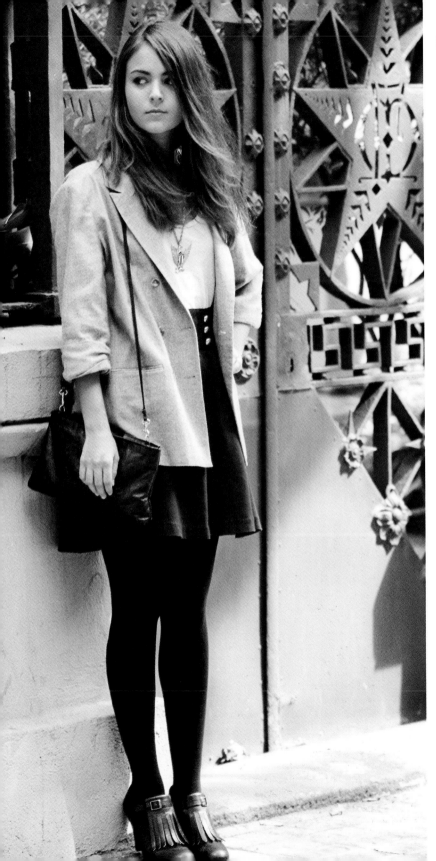

I'M WEARING an H&M T-shirt, a vintage skirt, vintage necklace, Urban Outfitters heels, and a vintage jacket. **MY CITY IN THREE WORDS:** Sunny, Mediterranean food, and sea. **WHAT DO YOU LOVE ABOUT BARCELONA?** Coke the photographer, my family, and the Eixample.

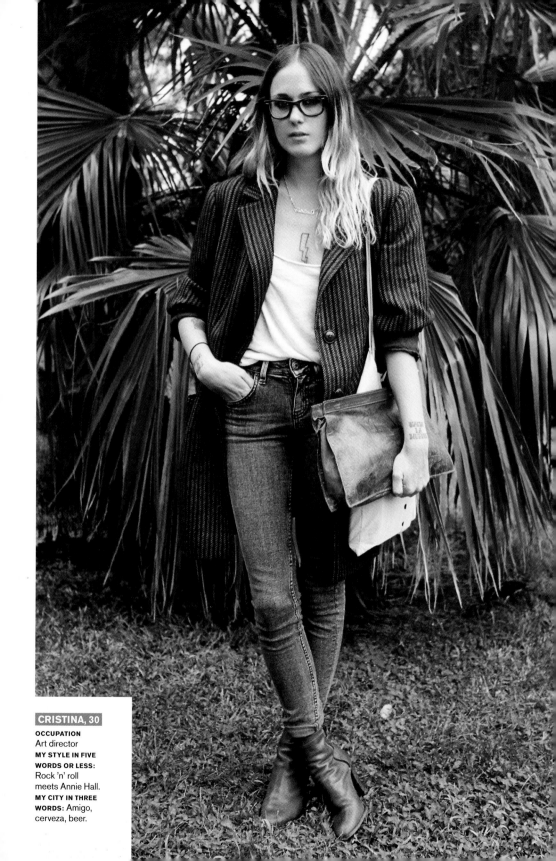

CRISTINA, 30
OCCUPATION
Art director
MY STYLE IN FIVE
WORDS OR LESS:
Rock 'n' roll
meets Annie Hall.
MY CITY IN THREE
WORDS: Amigo,
cerveza, beer.

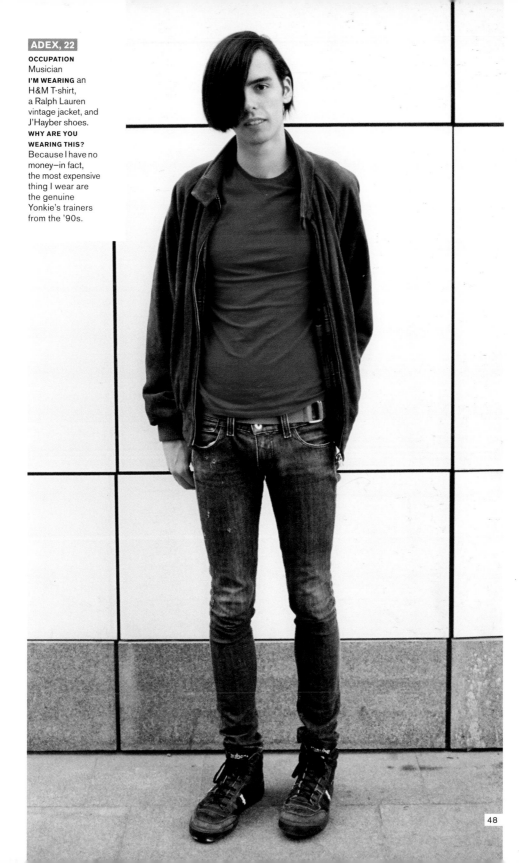

OCCUPATION
Musician
I'M WEARING an
H&M T-shirt,
a Ralph Lauren
vintage jacket, and
J'Hayber shoes.
**WHY ARE YOU
WEARING THIS?**
Because I have no
money—in fact,
the most expensive
thing I wear are
the genuine
Yonkie's trainers
from the '90s.

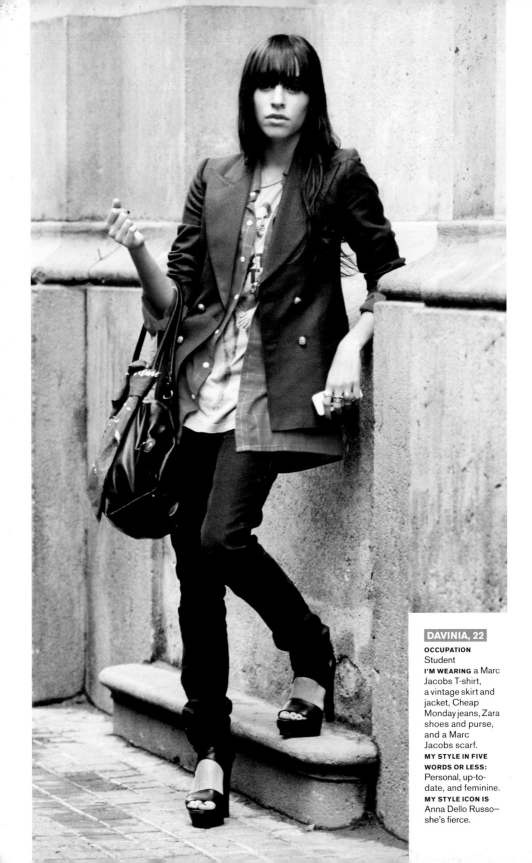

DAVINIA, 22

OCCUPATION
Student
I'M WEARING a Marc
Jacobs T-shirt,
a vintage skirt and
jacket, Cheap
Monday jeans, Zara
shoes and purse,
and a Marc
Jacobs scarf.
**MY STYLE IN FIVE
WORDS OR LESS:**
Personal, up-to-
date, and feminine.
MY STYLE ICON IS
Anna Dello Russo—
she's fierce.

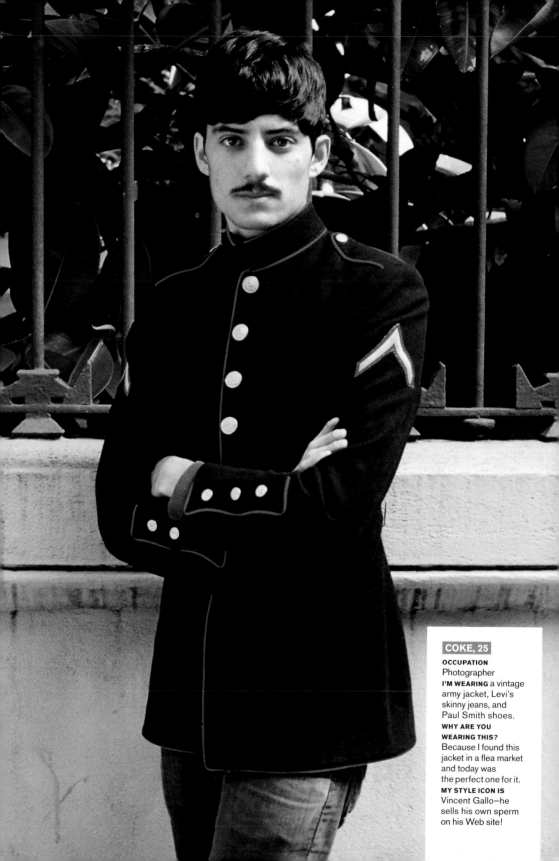

COKE, 25

OCCUPATION
Photographer
I'M WEARING a vintage
army jacket, Levi's
skinny jeans, and
Paul Smith shoes.
**WHY ARE YOU
WEARING THIS?**
Because I found this
jacket in a flea market
and today was
the perfect one for it.
MY STYLE ICON IS
Vincent Gallo—he
sells his own sperm
on his Web site!

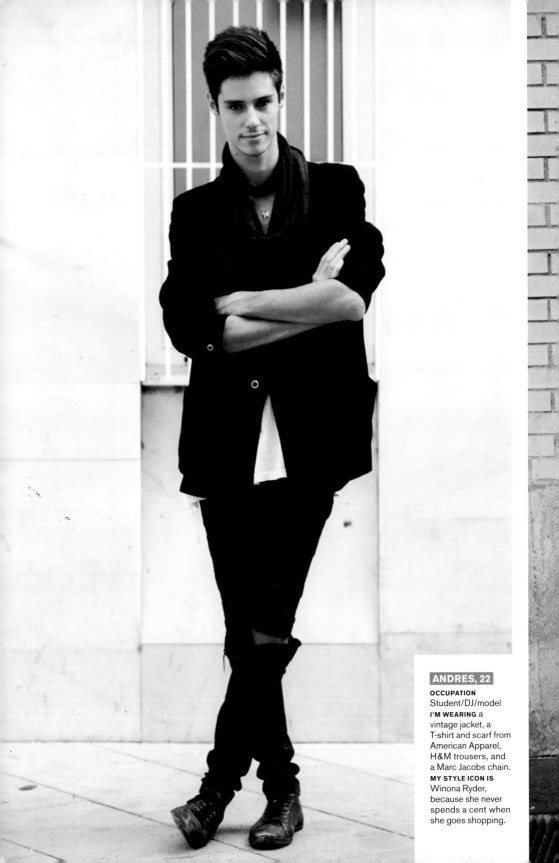

ANDRES, 22

OCCUPATION
Student/DJ/model
I'M WEARING a
vintage jacket, a
T-shirt and scarf from
American Apparel,
H&M trousers, and
a Marc Jacobs chain.
MY STYLE ICON IS
Winona Ryder,
because she never
spends a cent when
she goes shopping.

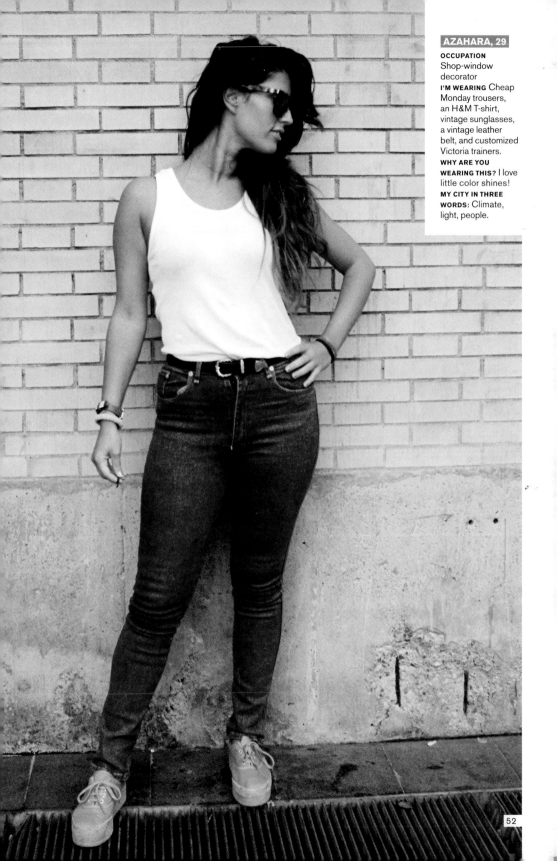

OCCUPATION
Shop-window
decorator
I'M WEARING Cheap
Monday trousers,
an H&M T-shirt,
vintage sunglasses,
a vintage leather
belt, and customized
Victoria trainers.
**WHY ARE YOU
WEARING THIS?** I love
little color shines!
**MY CITY IN THREE
WORDS:** Climate,
light, people.

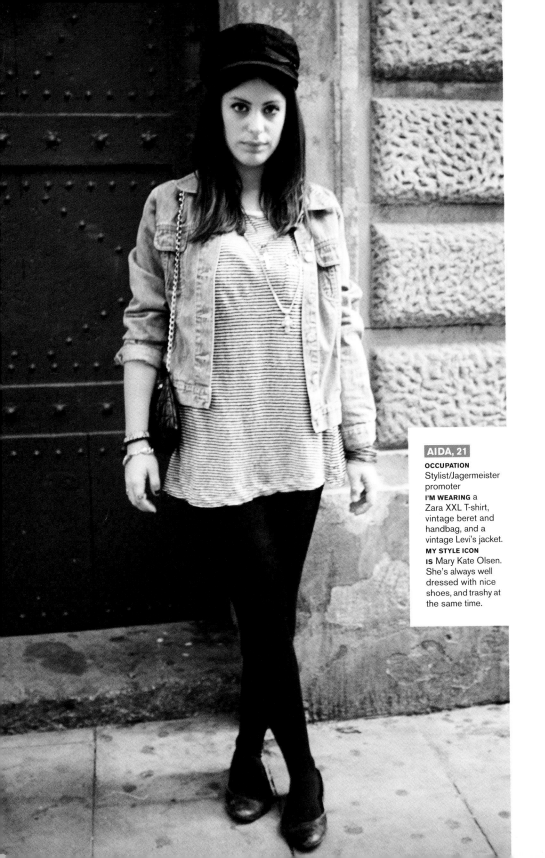

AIDA, 21

OCCUPATION
Stylist/Jagermeister
promoter
I'M WEARING a
Zara XXL T-shirt,
vintage beret and
handbag, and a
vintage Levi's jacket.
MY STYLE ICON
IS Mary Kate Olsen.
She's always well
dressed with nice
shoes, and trashy at
the same time.

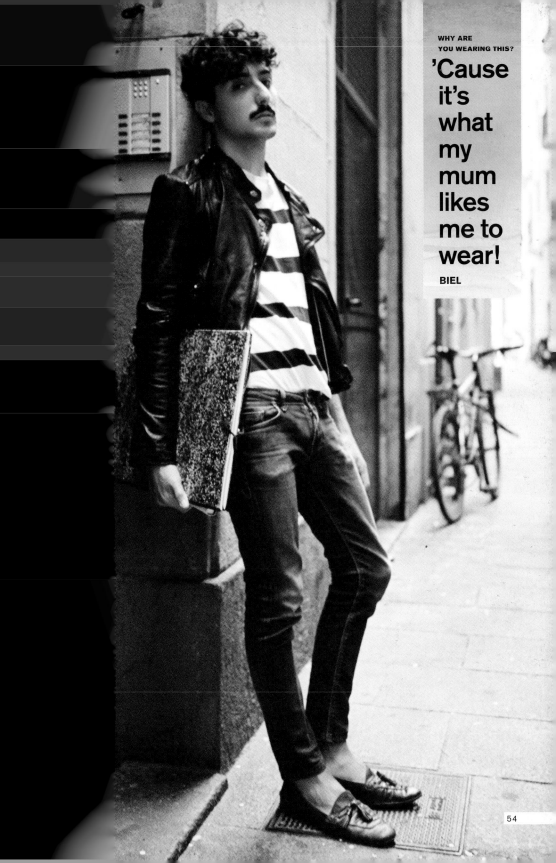

'Cause it's what my mum likes me to wear!

BIEL

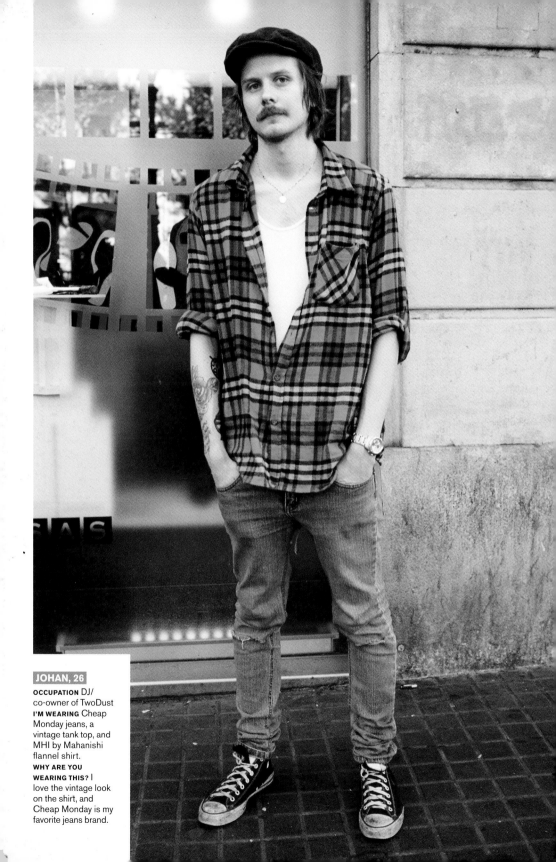

JOHAN, 26

OCCUPATION DJ/
co-owner of TwoDust
I'M WEARING Cheap
Monday jeans, a
vintage tank top, and
MHI by Mahanishi
flannel shirt.
**WHY ARE YOU
WEARING THIS?** I
love the vintage look
on the shirt, and
Cheap Monday is my
favorite jeans brand.

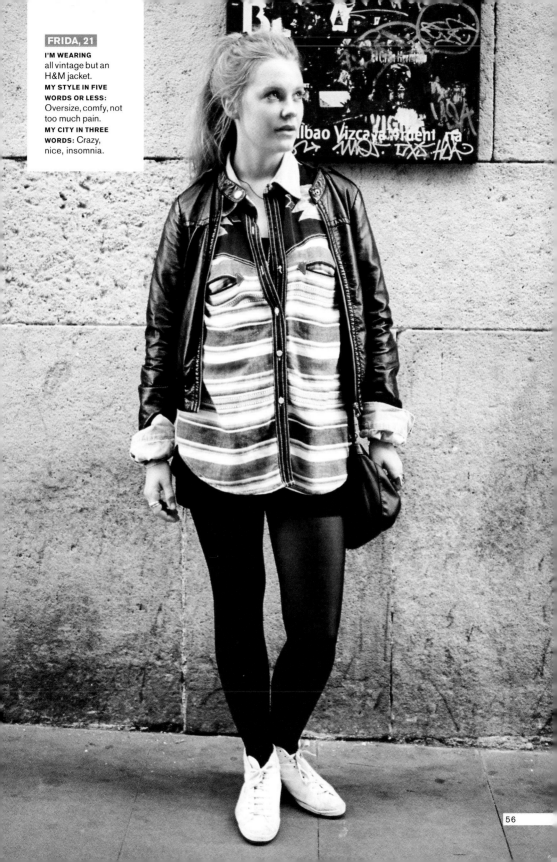

FRIDA, 21

I'M WEARING
all vintage but an
H&M jacket.
**MY STYLE IN FIVE
WORDS OR LESS:**
Oversize, comfy, not
too much pain.
**MY CITY IN THREE
WORDS:** Crazy,
nice, insomnia.

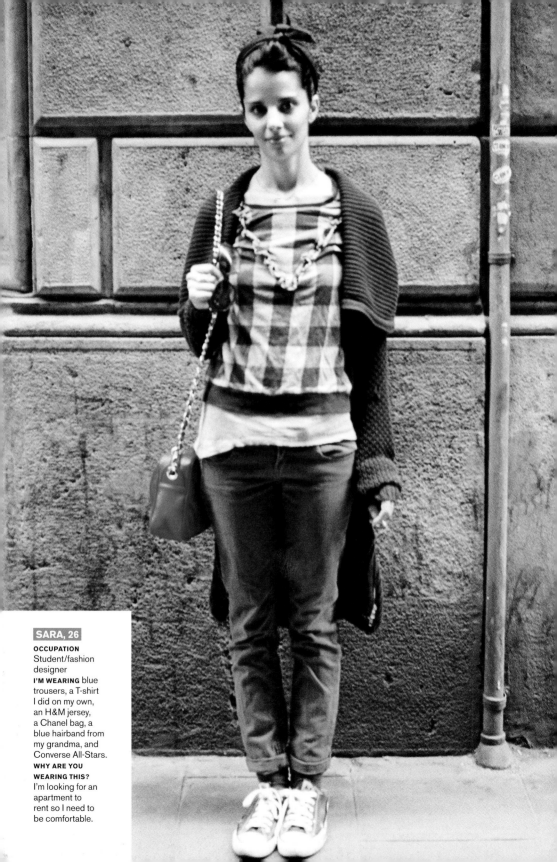

SARA, 26

OCCUPATION
Student/fashion
designer
I'M WEARING blue
trousers, a T-shirt
I did on my own,
an H&M jersey,
a Chanel bag, a
blue hairband from
my grandma, and
Converse All-Stars.
**WHY ARE YOU
WEARING THIS?**
I'm looking for an
apartment to
rent so I need to
be comfortable.

OCCUPATION
Student
I'M WEARING H&M
trousers, a T-shirt
and hat, a vintage
cardigan, Victoria
shoes, and
iPod headphones.
**WHY ARE YOU
WEARING THIS?**
Because I'm on my
way shopping and
I need some rhythm.
**MY STYLE ICON
IS** Alex Kapranos—
he is so cool!

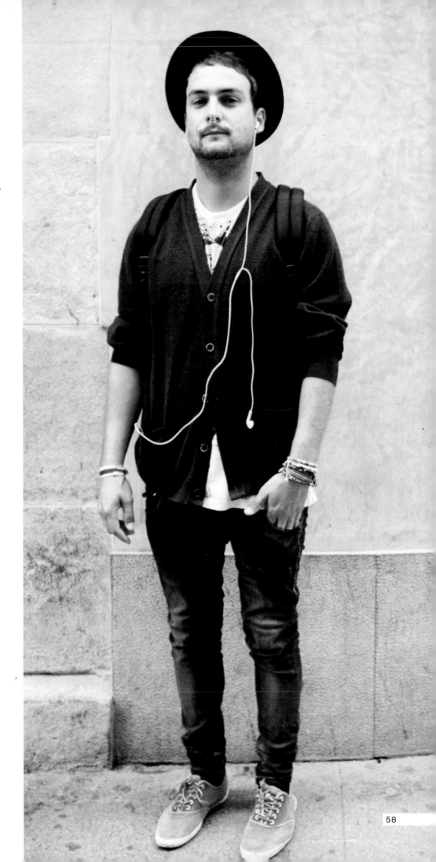

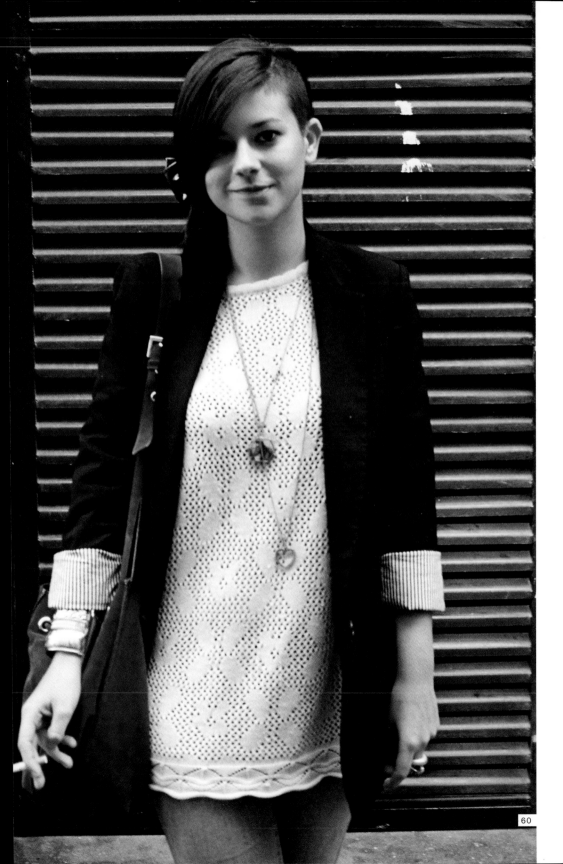

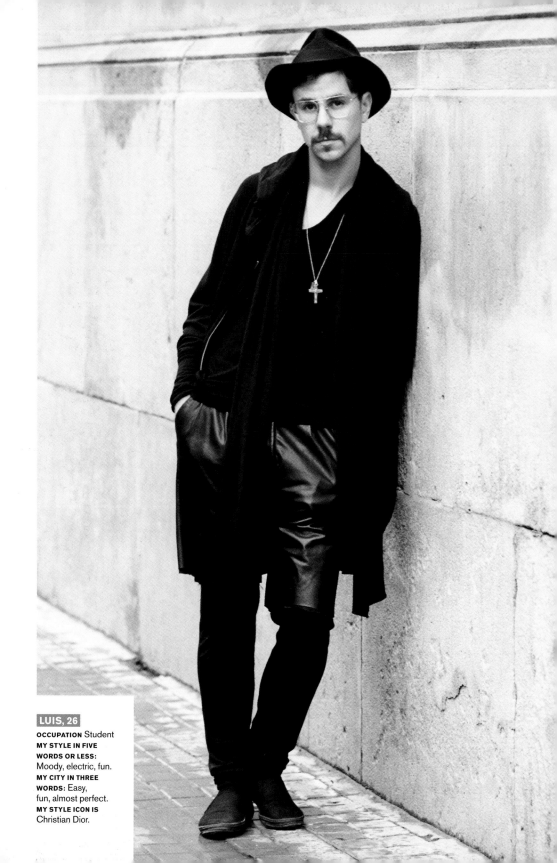

LUIS, 26

OCCUPATION Student
MY STYLE IN FIVE WORDS OR LESS: Moody, electric, fun.
MY CITY IN THREE WORDS: Easy, fun, almost perfect.
MY STYLE ICON IS Christian Dior.

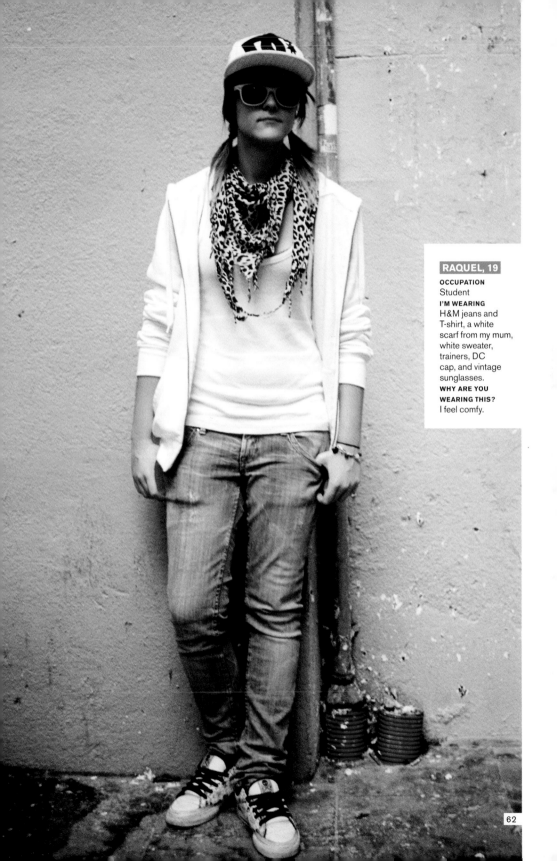

RAQUEL, 19

OCCUPATION
Student
I'M WEARING
H&M jeans and
T-shirt, a white
scarf from my mum,
white sweater,
trainers, DC
cap, and vintage
sunglasses.
**WHY ARE YOU
WEARING THIS?**
I feel comfy.

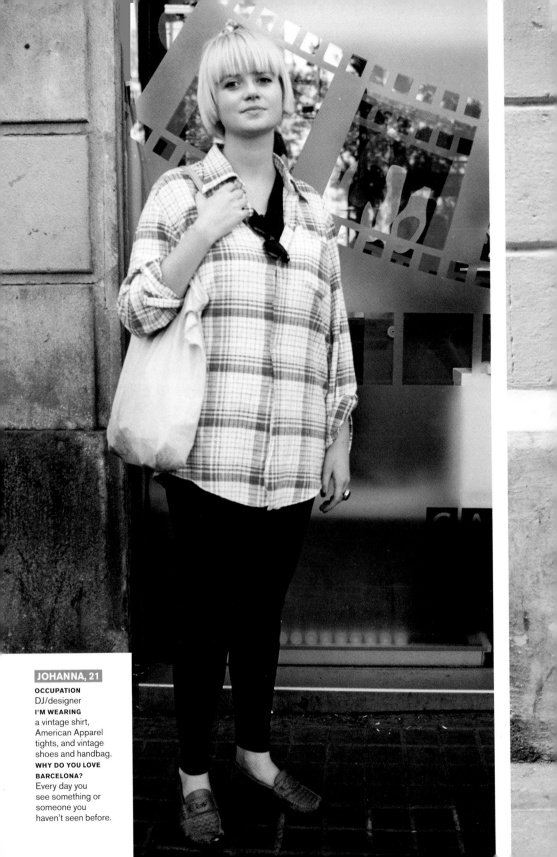

JOHANNA, 21

OCCUPATION
DJ/designer
I'M WEARING
a vintage shirt,
American Apparel
tights, and vintage
shoes and handbag.
**WHY DO YOU LOVE
BARCELONA?**
Every day you
see something or
someone you
haven't seen before.

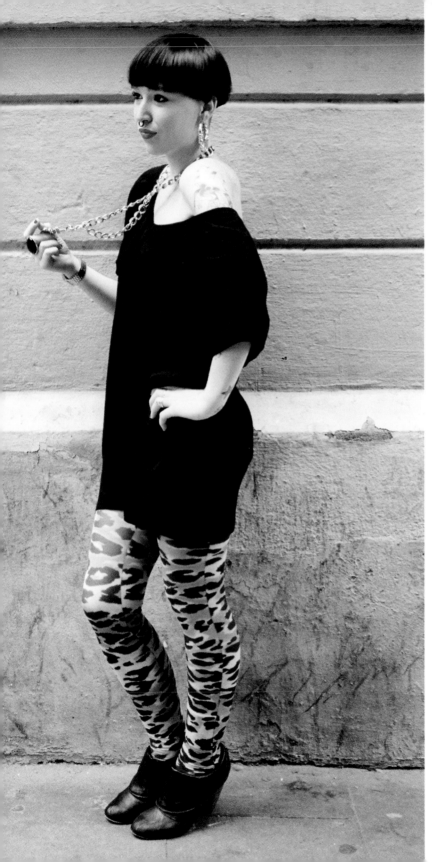

OCCUPATION
Fashion designer
I'M WEARING
vintage tights
and shoes, and an
H&M dress.
**MY STYLE IN FIVE
WORDS OR LESS:**
Risky, colored,
eclectic, funny.
**MY CITY IN
THREE WORDS:**
Cerveza un euro.

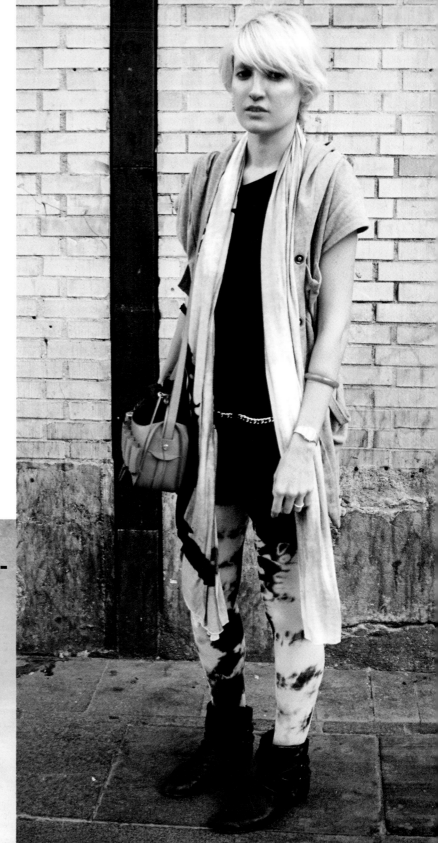

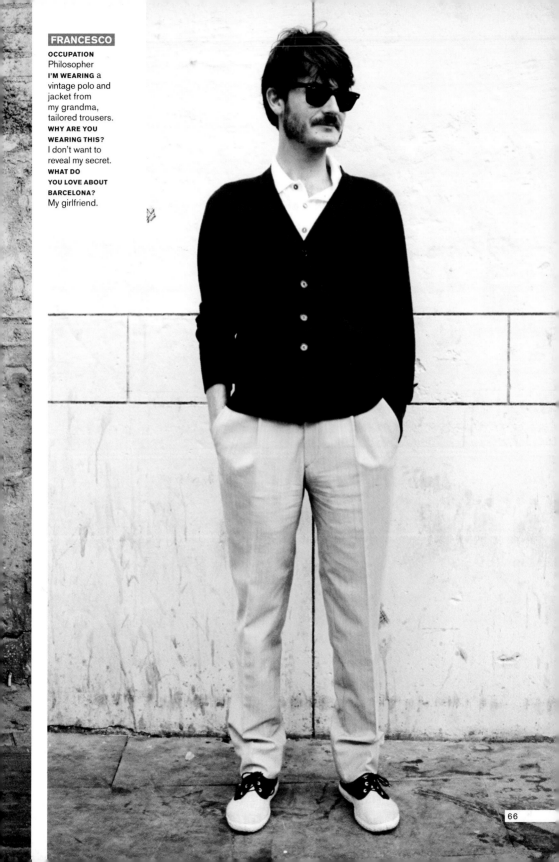

FRANCESCO

OCCUPATION
Philosopher
I'M WEARING a
vintage polo and
jacket from
my grandma,
tailored trousers.
**WHY ARE YOU
WEARING THIS?**
I don't want to
reveal my secret.
**WHAT DO
YOU LOVE ABOUT
BARCELONA?**
My girlfriend.

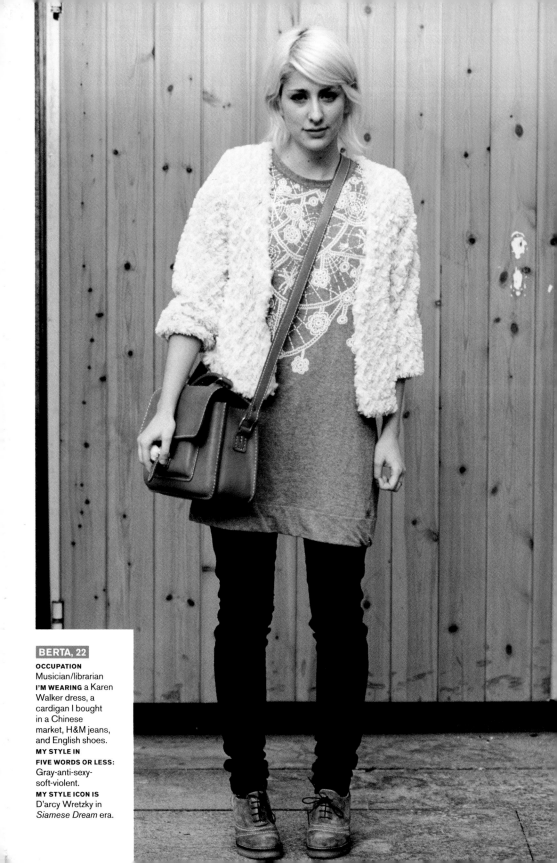

BERTA, 22

OCCUPATION
Musician/librarian
I'M WEARING a Karen
Walker dress, a
cardigan I bought
in a Chinese
market, H&M jeans,
and English shoes.
MY STYLE IN
FIVE WORDS OR LESS:
Gray-anti-sexy-
soft-violent.
MY STYLE ICON IS
D'arcy Wretzky in
Siamese Dream era.

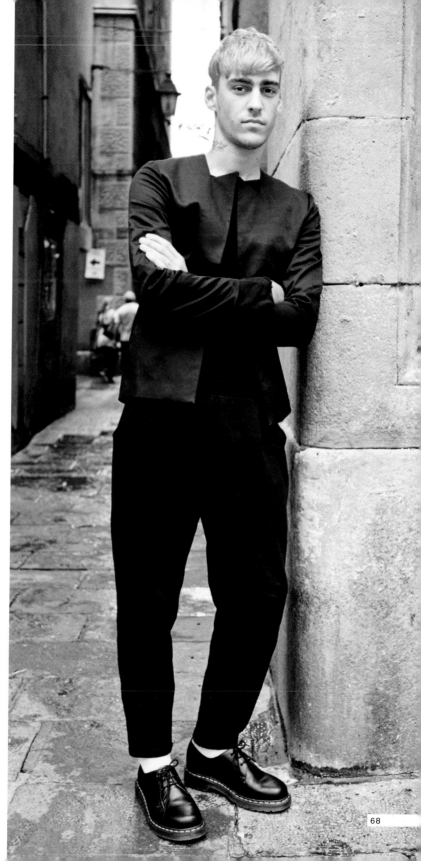

ABRAHAM, 23

OCCUPATION
Fashion designer
I'M WEARING a jacket
that I made on my
own, an American
Apparel T-shirt, David
Delfin trousers, and
Dr. Martens shoes.
**WHY ARE YOU
WEARING THIS?**
Today it's raining and
I hate when my
skinny jeans get wet.
**MY STYLE IN
FIVE WORDS OR LESS:**
Romantic, dark,
classic, *Sweeney
Todd*, Tim Burton.

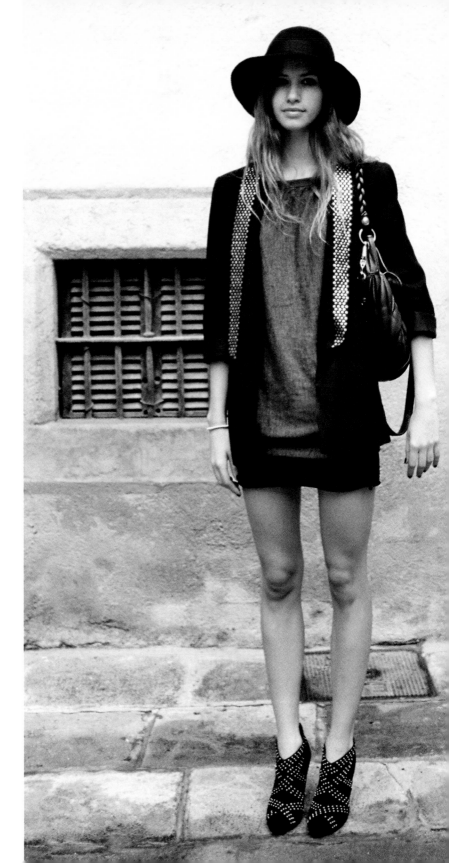

IRENE, 24

OCCUPATION Model
MY STYLE IN FIVE WORDS OR LESS: I like wearing new designer clothes, but I do not have a particular style. It's difficult to describe this in five words!
MY STYLE ICONS ARE maybe Erin Wasson or Alexander Wang because they are young and funny.

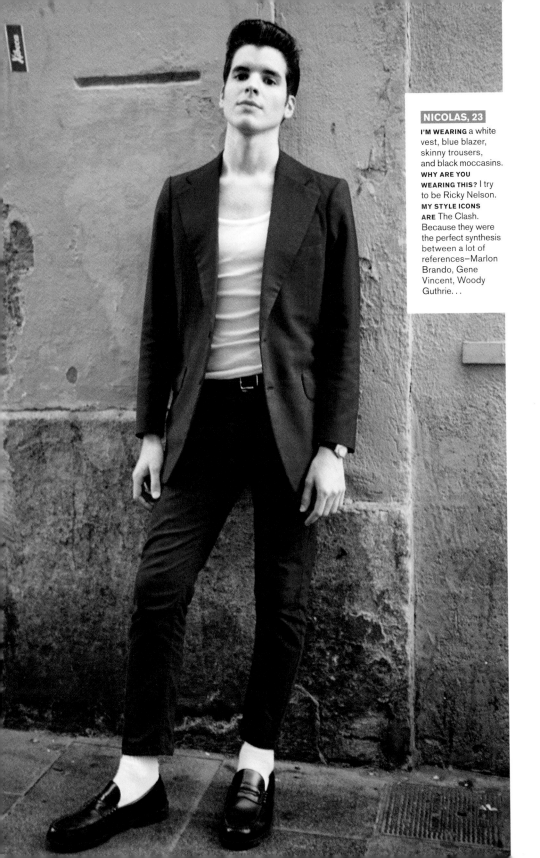

NICOLAS, 23

I'M WEARING a white vest, blue blazer, skinny trousers, and black moccasins. **WHY ARE YOU WEARING THIS?** I try to be Ricky Nelson. **MY STYLE ICONS ARE** The Clash. Because they were the perfect synthesis between a lot of references—Marlon Brando, Gene Vincent, Woody Guthrie. . .

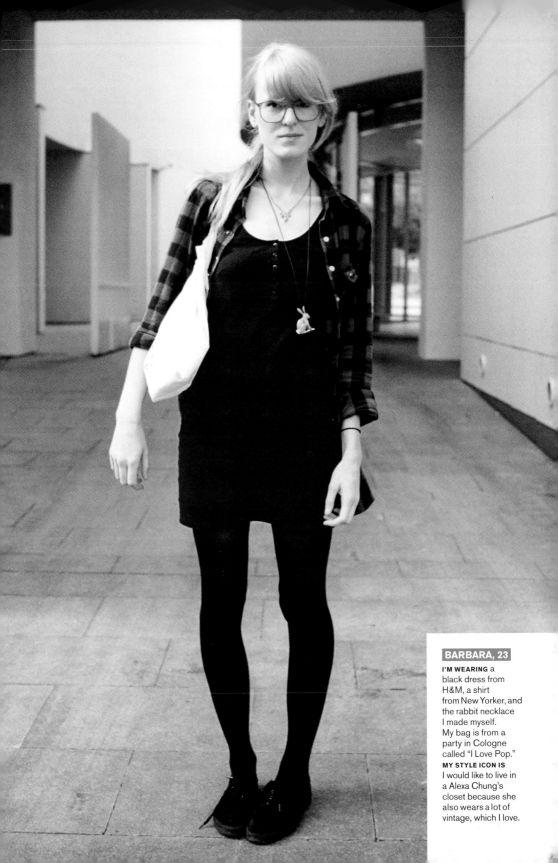

BARBARA, 23

I'M WEARING a black dress from H&M, a shirt from New Yorker, and the rabbit necklace I made myself. My bag is from a party in Cologne called "I Love Pop." **MY STYLE ICON IS** I would like to live in a Alexa Chung's closet because she also wears a lot of vintage, which I love.

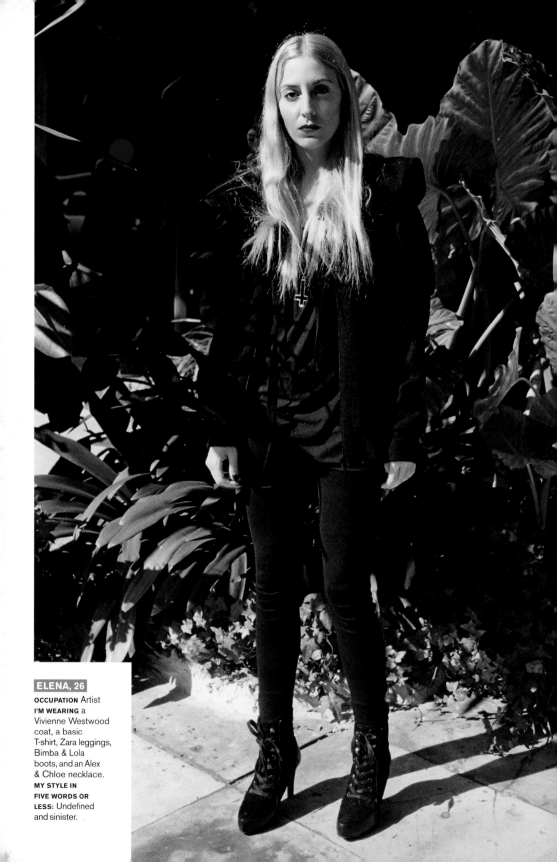

ELENA, 26

OCCUPATION Artist
I'M WEARING a
Vivienne Westwood
coat, a basic
T-shirt, Zara leggings,
Bimba & Lola
boots, and an Alex
& Chloe necklace.
**MY STYLE IN
FIVE WORDS OR
LESS:** Undefined
and sinister.

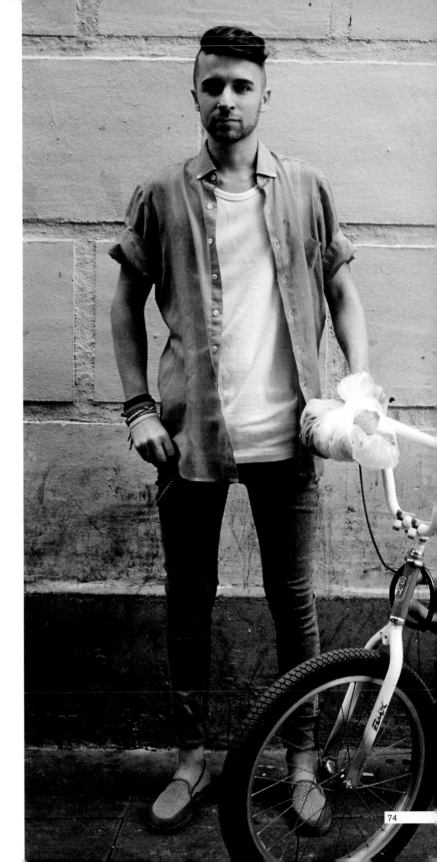

LUIS, 26

OCCUPATION
Designer
I'M WEARING a
vintage shirt and
shoes, a BH
California bike,
and an H&M
T-shirt and jeans.
**WHY ARE YOU
WEARING THIS?**
It feels comfy,
and I can go faster
with my bike.

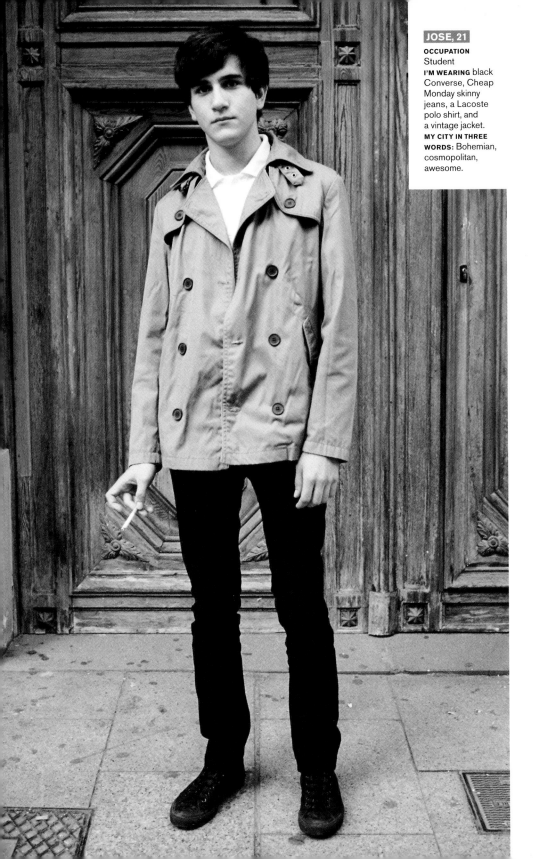

JOSE, 21

OCCUPATION
Student
I'M WEARING black
Converse, Cheap
Monday skinny
jeans, a Lacoste
polo shirt, and
a vintage jacket.
**MY CITY IN THREE
WORDS:** Bohemian,
cosmopolitan,
awesome.

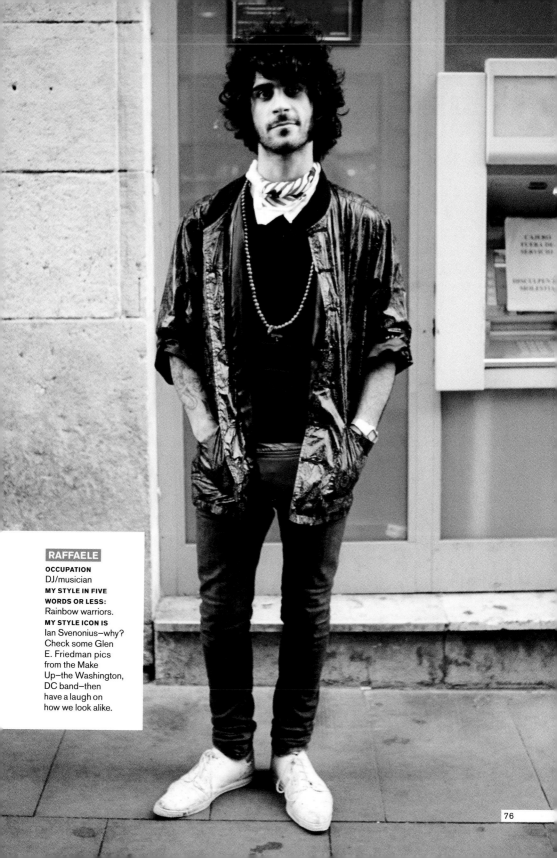

RAFFAELE

OCCUPATION
DJ/musician
MY STYLE IN FIVE WORDS OR LESS:
Rainbow warriors.
MY STYLE ICON IS
Ian Svenonius—why?
Check some Glen
E. Friedman pics
from the Make
Up—the Washington,
DC band—then
have a laugh on
how we look alike.

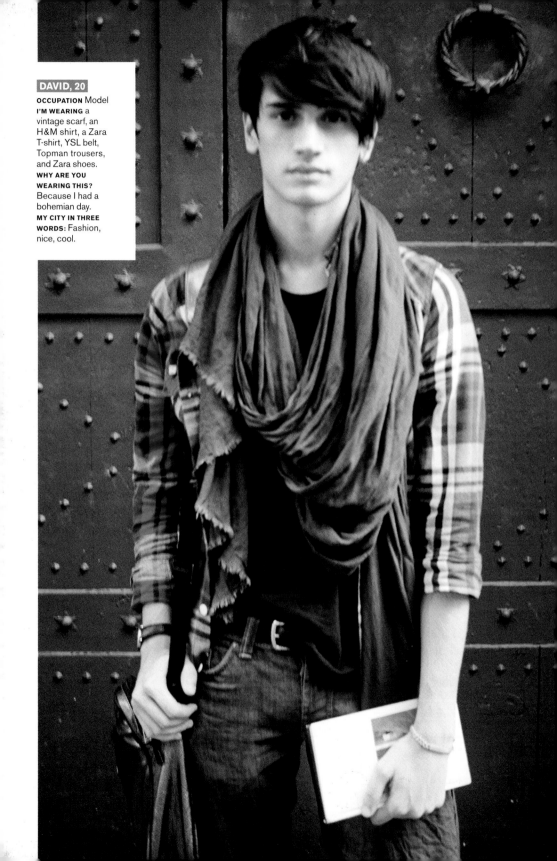

DAVID, 20

OCCUPATION Model
I'M WEARING a
vintage scarf, an
H&M shirt, a Zara
T-shirt, YSL belt,
Topman trousers,
and Zara shoes.
**WHY ARE YOU
WEARING THIS?**
Because I had a
bohemian day.
**MY CITY IN THREE
WORDS:** Fashion,
nice, cool.

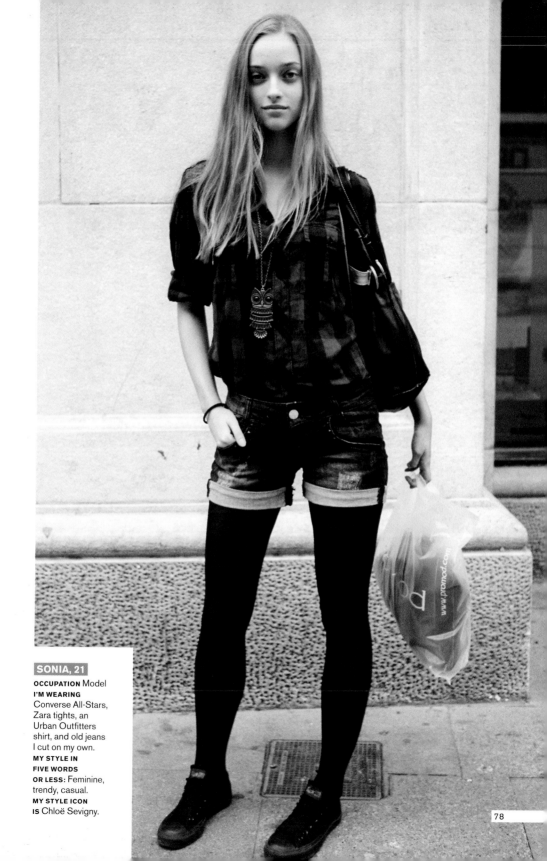

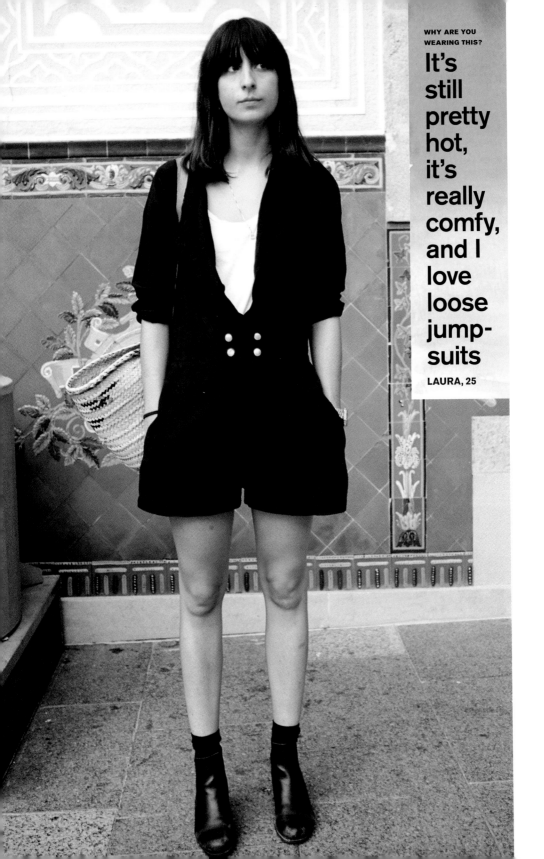

It's still pretty hot, it's really comfy, and I love loose jump-suits

LAURA, 25

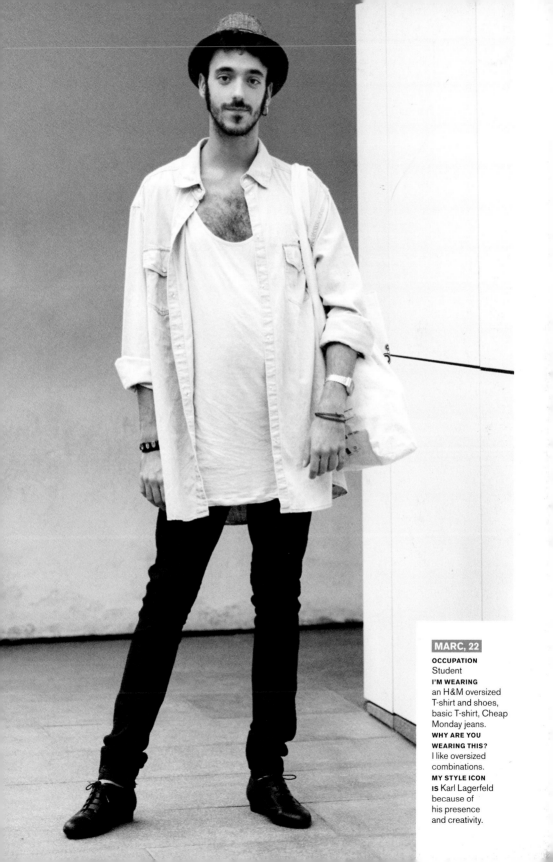

London seems permanently in the midst of a Cool Britannia moment: Even during the Empire's darkest days, the capital offered all comers the chance to transform themselves, fortified only by their own creativity and that revered national institution, the stiff upper lip. No event in the last hundred years has defined London's character the way the Blitz did, the eight months of aerial bombing the Germans believed would blast the British into submission. They were wrong, and seventy years later, East London kids dress up in World War II uniforms or hand-sewn 1940s-era dresses, stocking seams drawn down the backs of their legs, before heading out to one of Shoreditch's all-night Blitz parties.

London has always offered a revelatory mix of the old and the new, like Mohawked—or in the city's lingua franca, "Mohicaned"—punks awaiting a night bus in front of a seventeenth-century cathedral. Indeed, the country takes a national pride in moderation; to many, though, this can mean finding a balance between two extremes—the Stella McCartney coat over the Oxfam charity-shop dress (atop, of course, the M&S underwear). The ravenous scrums in Primark's Oxford Street flagship are only a few minutes' walk from the genteel designer stores of streets Bond and Bruton, the former the home of Mulberry, Jimmy Choo, and Nicole Farhi, and the latter where you'll find Matthew Williamson's shop just a few doors from McCartney's. Though McCartney took her studio to Paris years ago, she hasn't forgotten where she's from: Every Christmas, the facade of the shop is piled several stories high with holiday lights—combined with the interior's

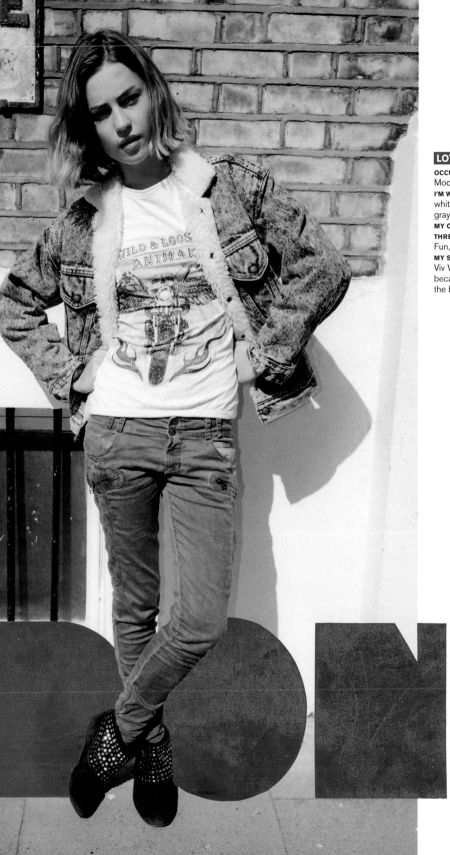

LOTTIE, 19

OCCUPATION
Model
I'M WEARING a
white T-shirt and
gray jeans.
**MY CITY IN
THREE WORDS:**
Fun, fun, fun.
MY STYLE ICON IS
Viv Westwood,
because she's
the best.

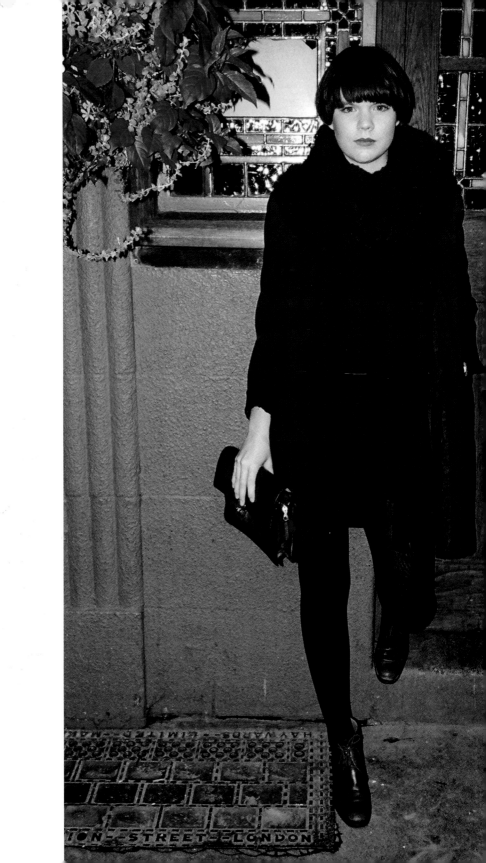

MOA

soft lighting and refined fixtures, it becomes the ultimate juxtaposition of British reserve (within) and London exuberance (without).

London was built out, rather than up, from the city's Roman center, save a strange cluster of skyscrapers in the east. It lacks a dominating visual focal point, which hints at the reality: There is no one place to be, no one path to follow in seeking fame, fortune, and material ubiquity. There is a sense that everyone who matters met everyone else who matters in primary school, or at a chip shop (like Agyness Deyn and Henry Holland), or at a pub like the Bricklayers Arms, a near-mythical Hoxton watering hole. Its owners went on to debut the equally mythic Christmastime pop-up restaurant The Reindeer, for which designer Giles Deacon created the tableware and ultra-stylist/LOVE editor (and Deacon ex-girlfriend) Katie Grand hosted the opening-night party. Though this is a country ever concerned with class, both economic and social, the fashion world has created a sort of everyone-knows-everyone-else nation-state, where the offspring of royalty—whether Windsor or rock—bow to the children of taxi drivers and plumbers.

In some ways, this makes for an important sense of gentility—an all-in-the-family interconnection, certainly seen in the shared effort to permanently cleave a place for London between New York and Paris on the Fashion Week calendar. In this diffuse network, eccentricity is both expected and accepted: Of course it makes sense that a working farm, in East London, supplies Prick Your Finger, a Bethnal Green knitting store, with woolly fleece from their very own sheep—which is spun, in-store, for the neighborhood's hipster crafters. Of course it makes sense that a restaurant called The Reindeer, which lasted for only twenty-eight days, should have one of the country's most important fashion designers make its tableware. Of course 2010 is not too late for neo-dandies in brogues and brooches, or mini-skirted mods, or those last remaining Camden punks in tartans and Doc Martens. In this sort of family, anything gos.

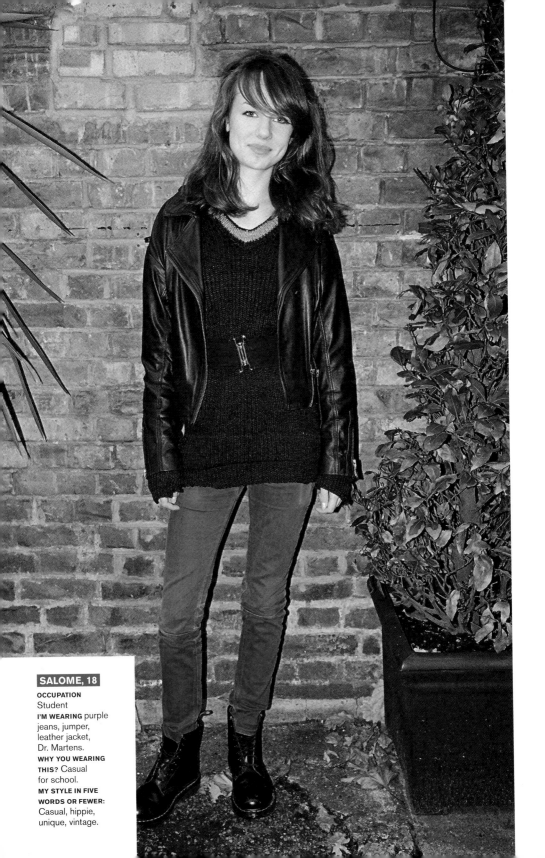

SALOME, 18

OCCUPATION
Student
I'M WEARING purple
jeans, jumper,
leather jacket,
Dr. Martens.
WHY YOU WEARING
THIS? Casual
for school.
MY STYLE IN FIVE
WORDS OR FEWER:
Casual, hippie,
unique, vintage.

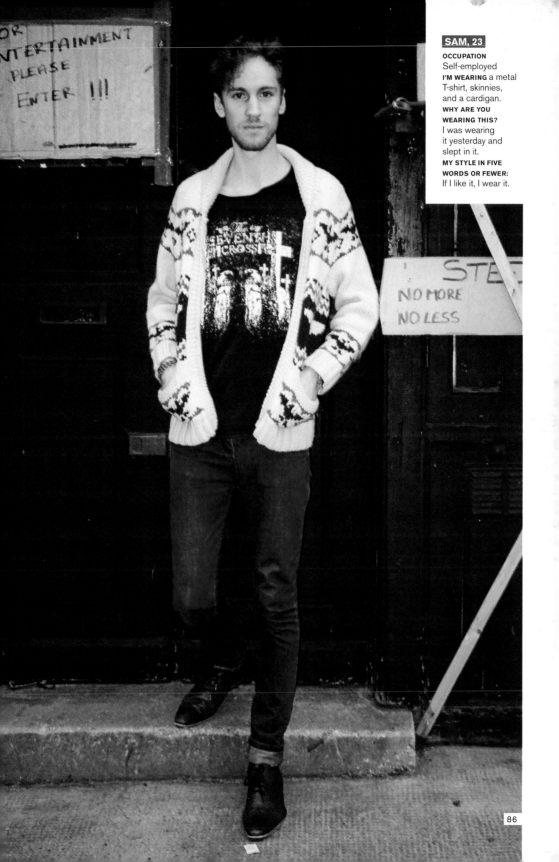

OCCUPATION
Self-employed
I'M WEARING a metal
T-shirt, skinnies,
and a cardigan.
**WHY ARE YOU
WEARING THIS?**
I was wearing
it yesterday and
slept in it.
**MY STYLE IN FIVE
WORDS OR FEWER:**
If I like it, I wear it.

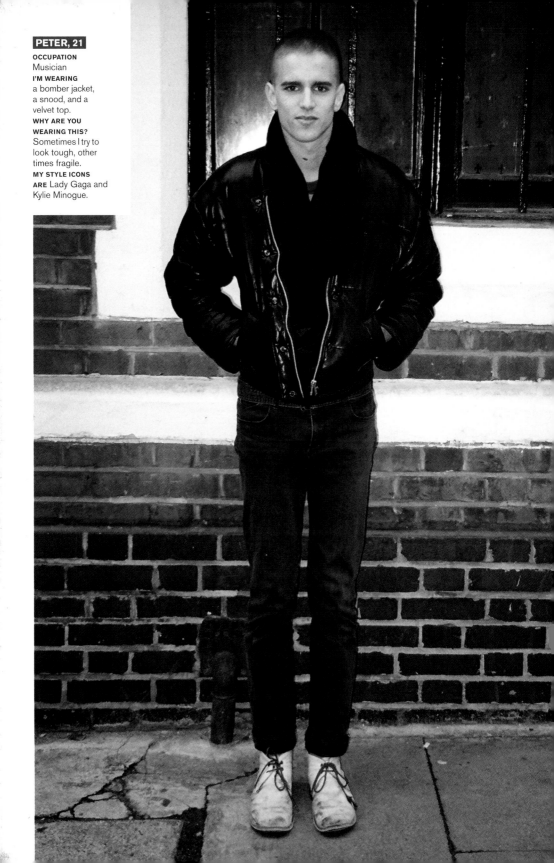

PETER, 21

OCCUPATION
Musician
I'M WEARING
a bomber jacket,
a snood, and a
velvet top.
**WHY ARE YOU
WEARING THIS?**
Sometimes I try to
look tough, other
times fragile.
**MY STYLE ICONS
ARE** Lady Gaga and
Kylie Minogue.

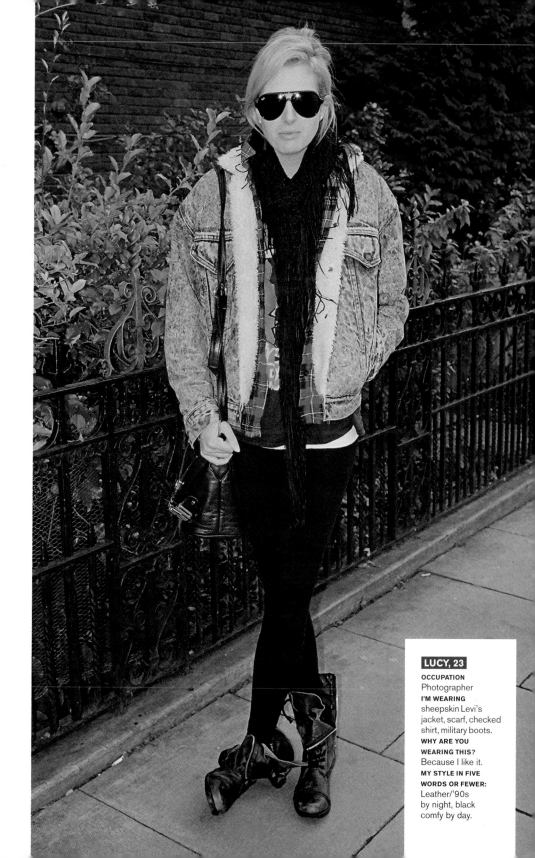

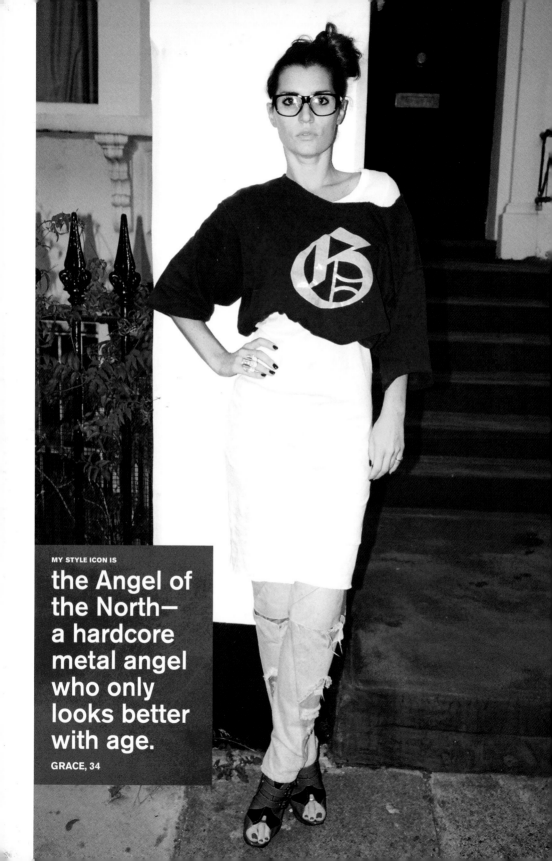

MY STYLE ICON IS

the Angel of the North— a hardcore metal angel who only looks better with age.

GRACE, 34

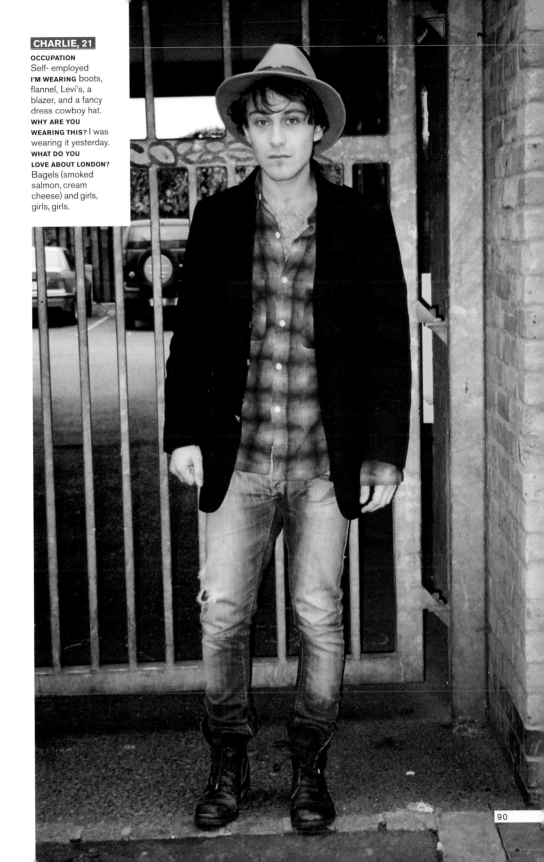

CHARLIE, 21

OCCUPATION
Self-employed
I'M WEARING boots,
flannel, Levi's, a
blazer, and a fancy
dress cowboy hat.
**WHY ARE YOU
WEARING THIS?** I was
wearing it yesterday.
**WHAT DO YOU
LOVE ABOUT LONDON?**
Bagels (smoked
salmon, cream
cheese) and girls,
girls, girls.

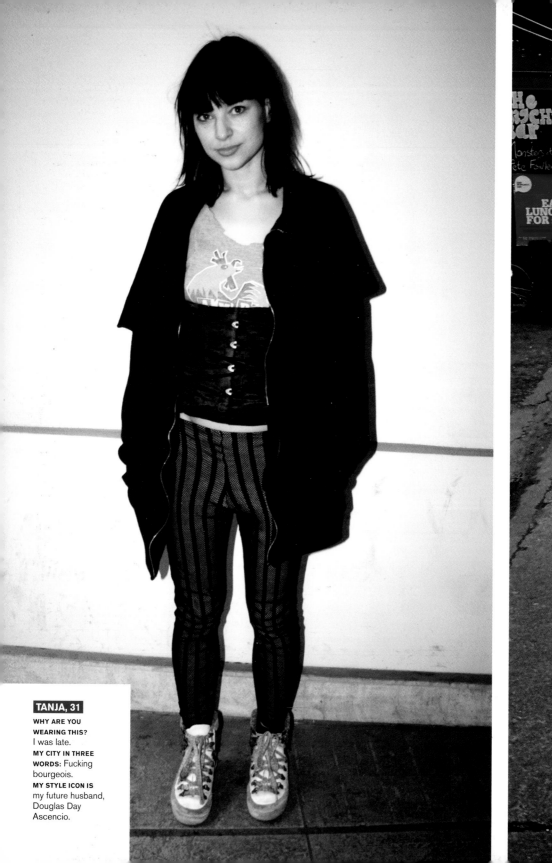

TANJA, 31

**WHY ARE YOU
WEARING THIS?**
I was late.
**MY CITY IN THREE
WORDS:** Fucking
bourgeois.
MY STYLE ICON IS
my future husband,
Douglas Day
Ascencio.

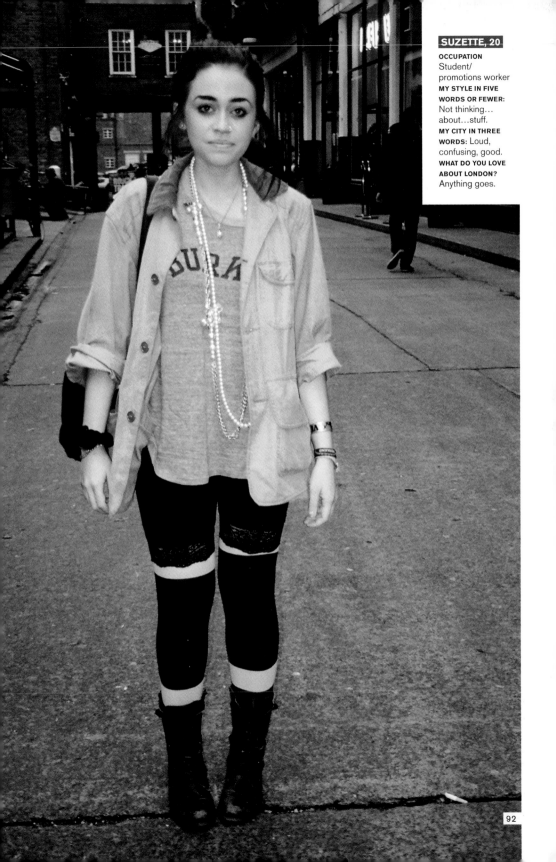

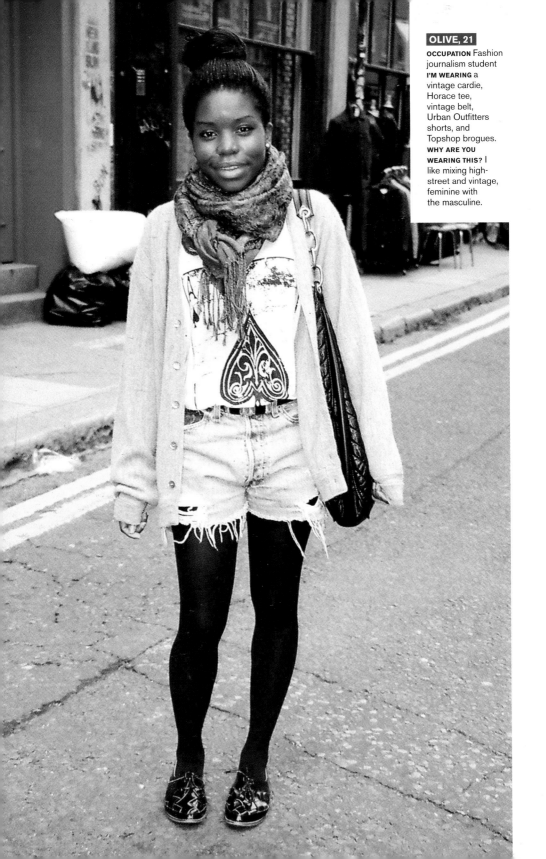

OLIVE, 21

OCCUPATION Fashion journalism student **I'M WEARING** a vintage cardie, Horace tee, vintage belt, Urban Outfitters shorts, and Topshop brogues. **WHY ARE YOU WEARING THIS?** I like mixing high-street and vintage, feminine with the masculine.

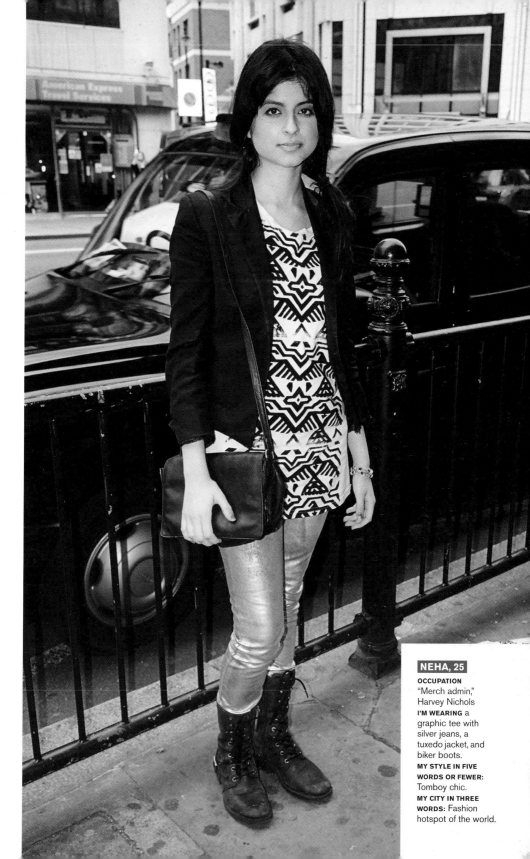

NEHA, 25

OCCUPATION "Merch admin," Harvey Nichols

I'M WEARING a graphic tee with silver jeans, a tuxedo jacket, and biker boots.

MY STYLE IN FIVE WORDS OR FEWER: Tomboy chic.

MY CITY IN THREE WORDS: Fashion hotspot of the world.

ALEX, 23

OCCUPATION
Hairstylist
I'M WEARING
black clothes, an
orange beanie hat.
MY STYLE ICON
IS Alison Mosshart
—she is sexy.

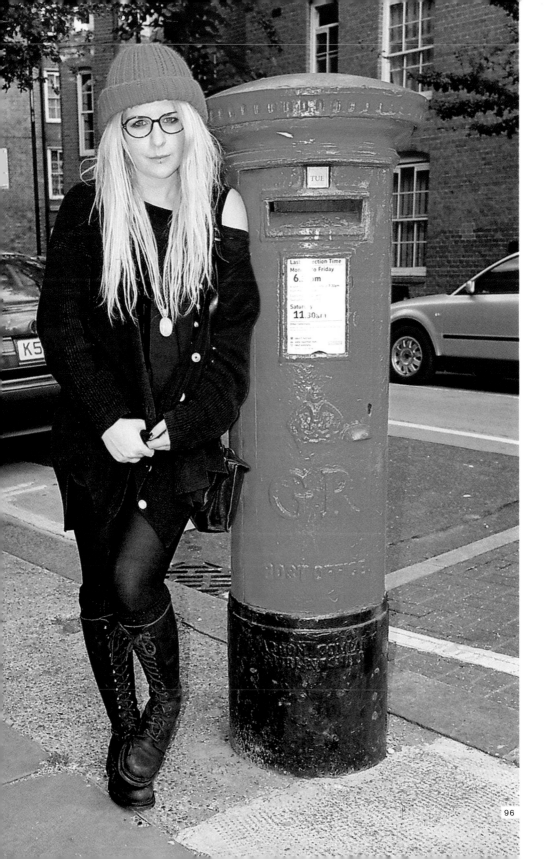

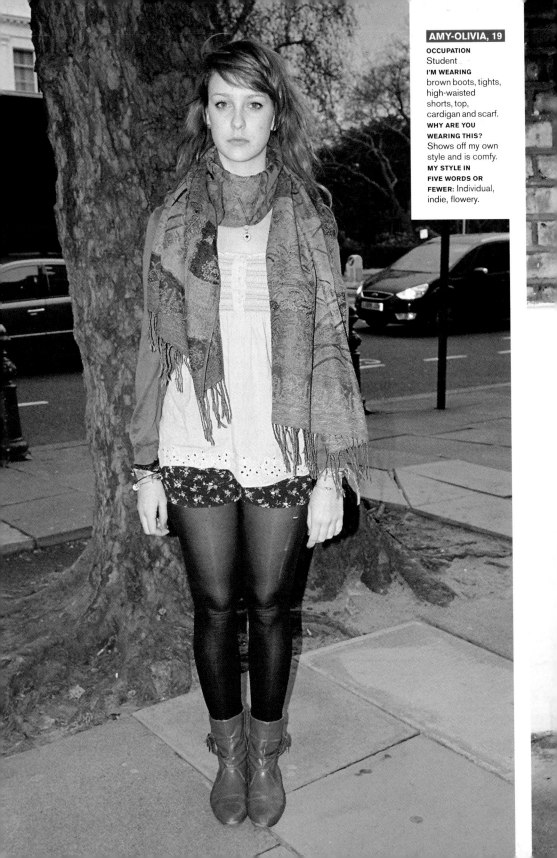

AMY-OLIVIA, 19

OCCUPATION
Student
I'M WEARING
brown boots, tights,
high-waisted
shorts, top,
cardigan and scarf.
WHY ARE YOU
WEARING THIS?
Shows off my own
style and is comfy.
MY STYLE IN
FIVE WORDS OR
FEWER: Individual,
indie, flowery.

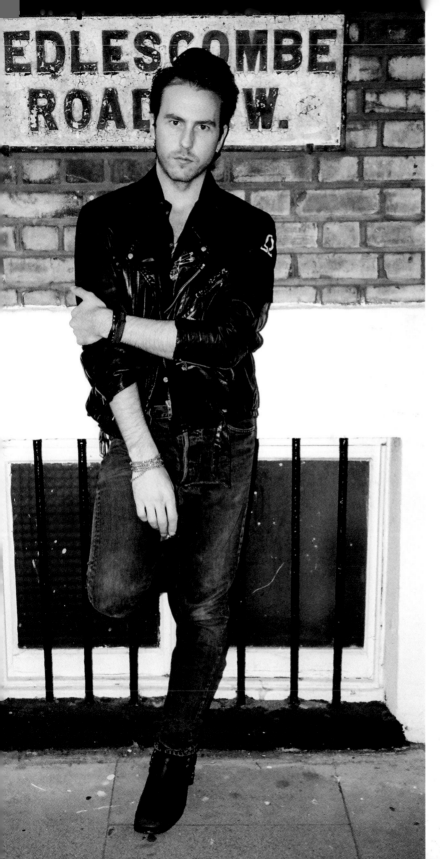

BENN, 27

OCCUPATION
Synthesizer
I'M WEARING
motorcycle boots,
black Levi's jeans,
a black Raf Simons
shirt, and my
black leather jacket.
**MY STYLE IN FIVE
WORDS OR FEWER:**
Conceived in
a chrome dream.

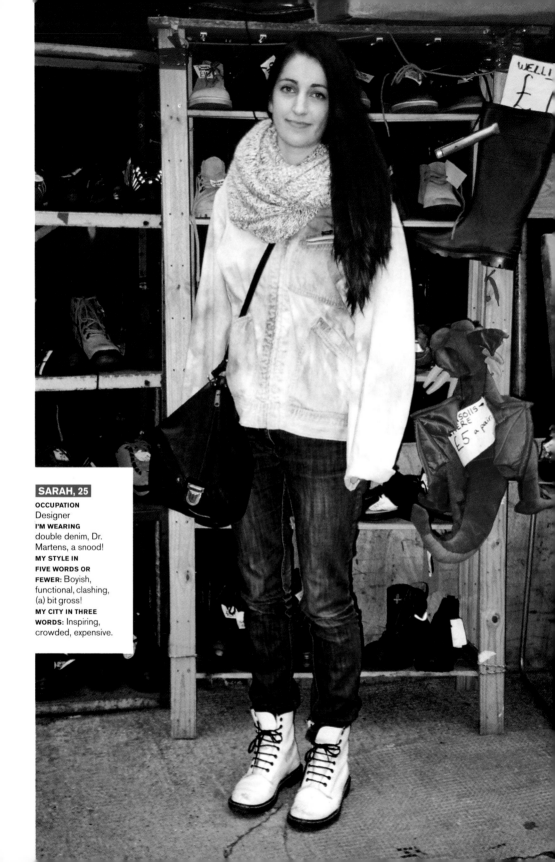

SARAH, 25

OCCUPATION
Designer
I'M WEARING
double denim, Dr.
Martens, a snood!
**MY STYLE IN
FIVE WORDS OR
FEWER:** Boyish,
functional, clashing,
(a) bit gross!
**MY CITY IN THREE
WORDS:** Inspiring,
crowded, expensive.

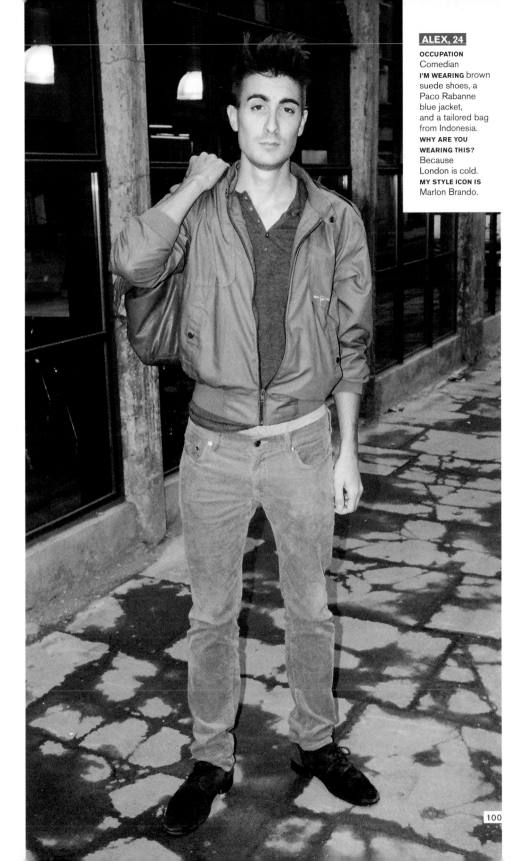

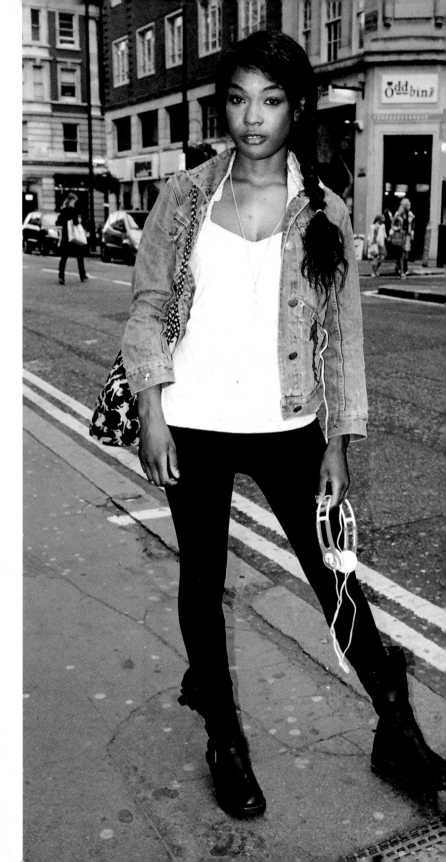

FLEUR, 21

OCCUPATION
Fashion PR
I'M WEARING a
jacket from ASOS,
an H&M vest,
leggings and shoes
from Topshop.
**WHY ARE YOU
WEARING IT?** Work!
**MY CITY IN THREE
WORDS:** Happening,
gray, sunny.

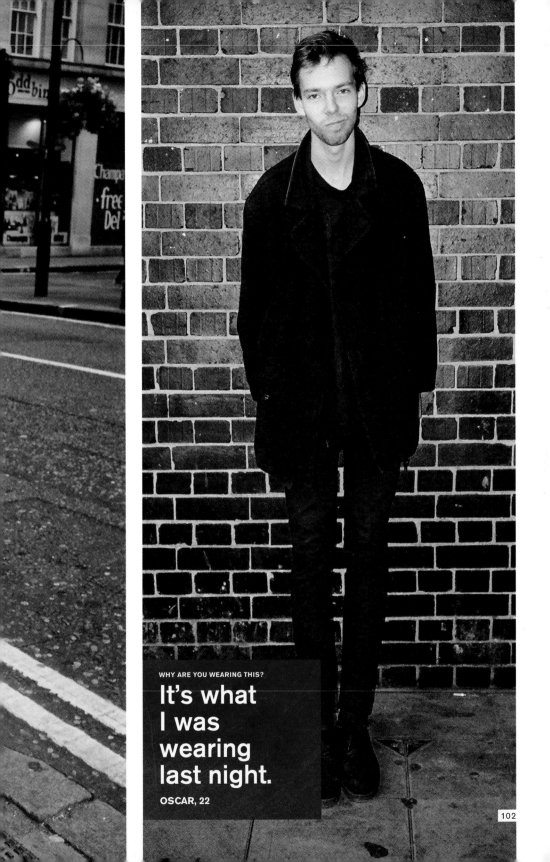

WHY ARE YOU WEARING THIS?

It's what I was wearing last night.

OSCAR, 22

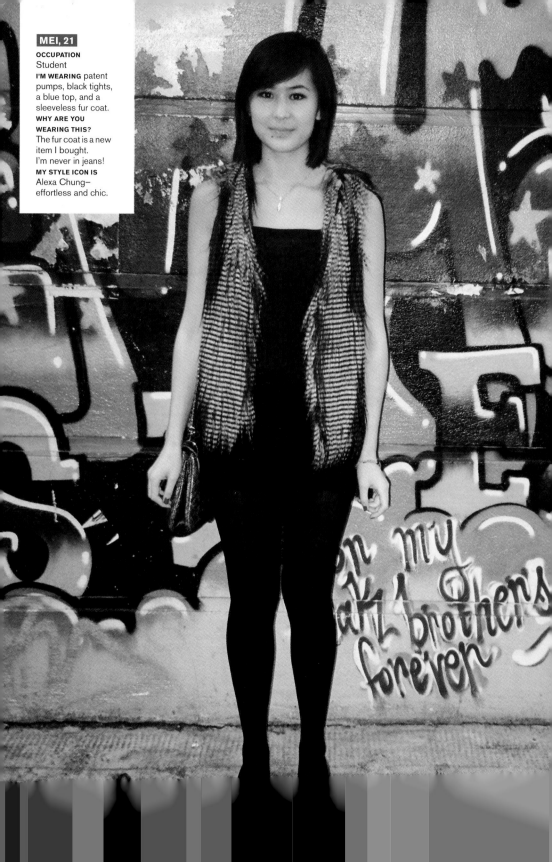

MEI, 21

OCCUPATION
Student
I'M WEARING patent pumps, black tights, a blue top, and a sleeveless fur coat.
WHY ARE YOU WEARING THIS?
The fur coat is a new item I bought. I'm never in jeans!
MY STYLE ICON IS Alexa Chung— effortless and chic.

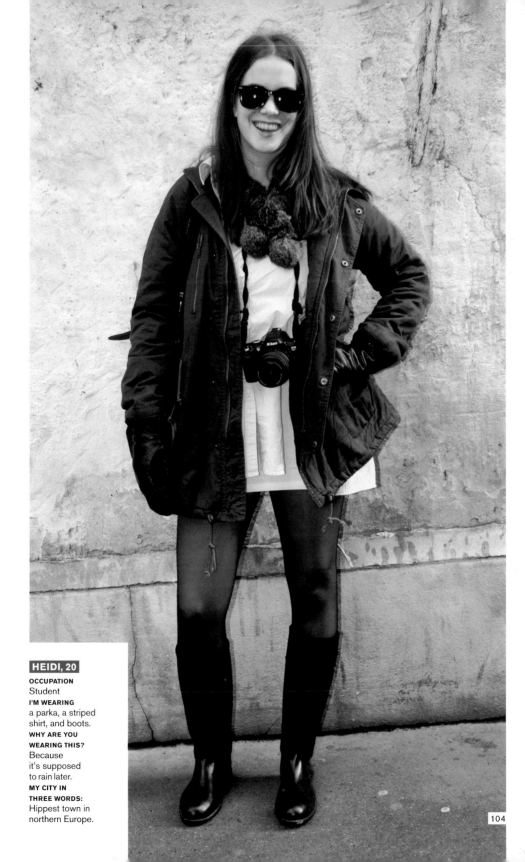

HEIDI, 20

OCCUPATION
Student
I'M WEARING
a parka, a striped
shirt, and boots.
**WHY ARE YOU
WEARING THIS?**
Because
it's supposed
to rain later.
**MY CITY IN
THREE WORDS:**
Hippest town in
northern Europe.

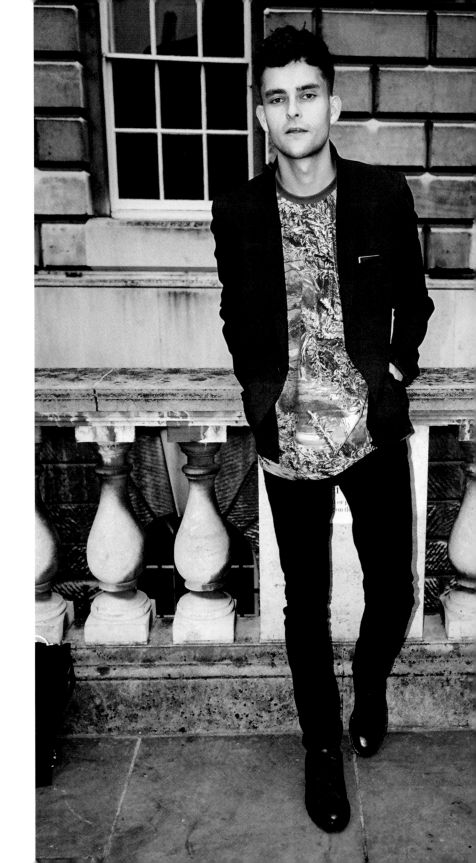

GREG, 25

OCCUPATION
Fashion assistant
I'M WEARING a
navy blazer, camo
T-shirt, black jeans,
and boots.
**WHY ARE YOU
WEARING THIS?**
It's smart/casual
for London
Fashion Week.
**MY STYLE IN FIVE
WORDS OR FEWER:**
Smart hooligan.

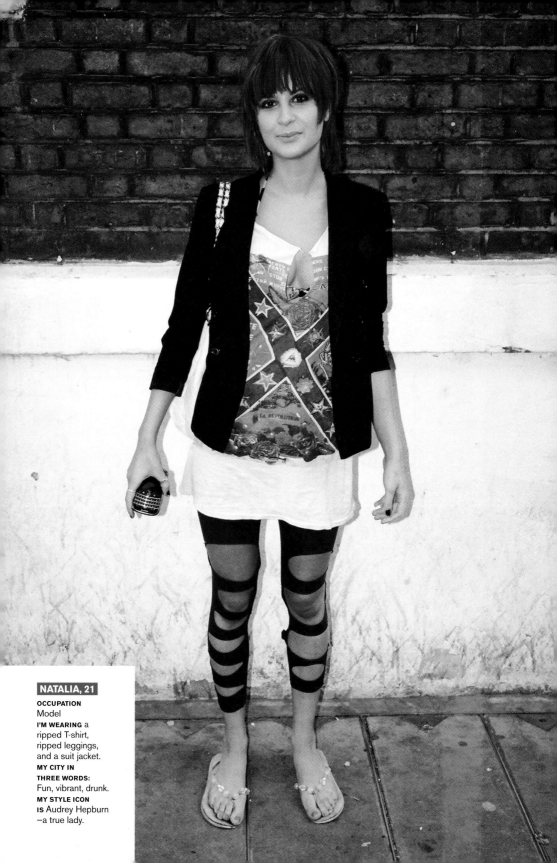

NATALIA, 21

OCCUPATION
Model

I'M WEARING a
ripped T-shirt,
ripped leggings,
and a suit jacket.

**MY CITY IN
THREE WORDS:**
Fun, vibrant, drunk.

**MY STYLE ICON
IS** Audrey Hepburn
—a true lady.

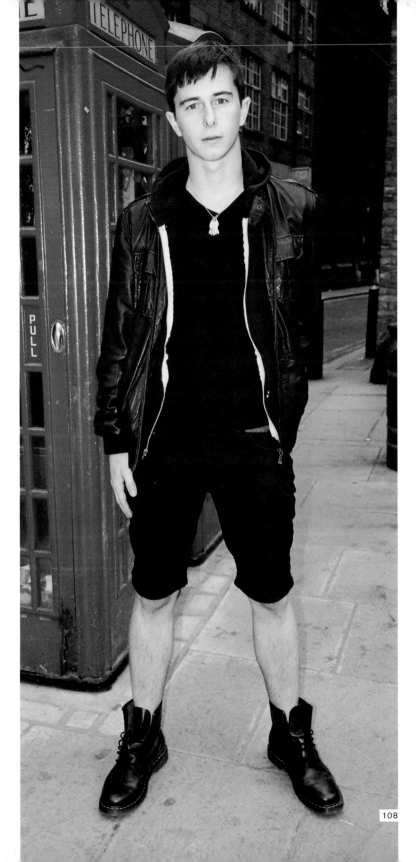

GEORGE, 20
OCCUPATION Artist
I'M WEARING
shorts and
a leather jacket.
MY STYLE IN FIVE
WORDS OR LESS:
Christian rock.
MY STYLE ICON IS
Chet Baker.

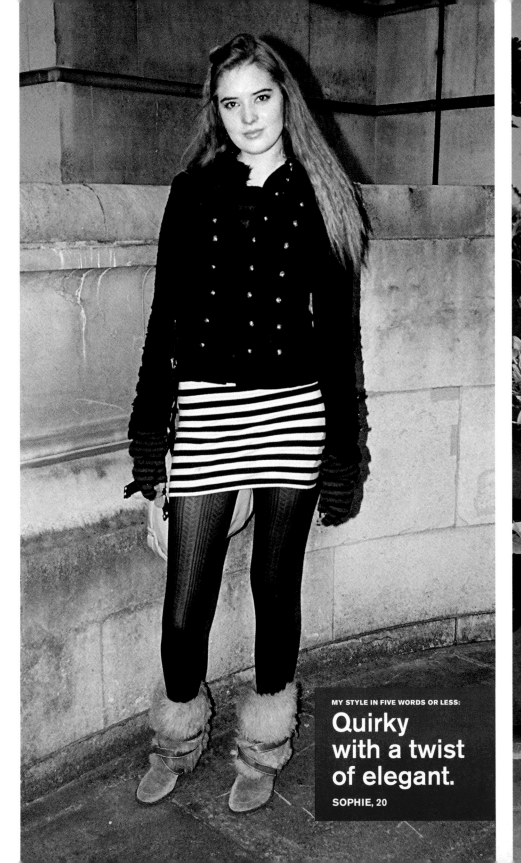

MY STYLE IN FIVE WORDS OR LESS:

**Quirky
with a twist
of elegant.**

SOPHIE, 20

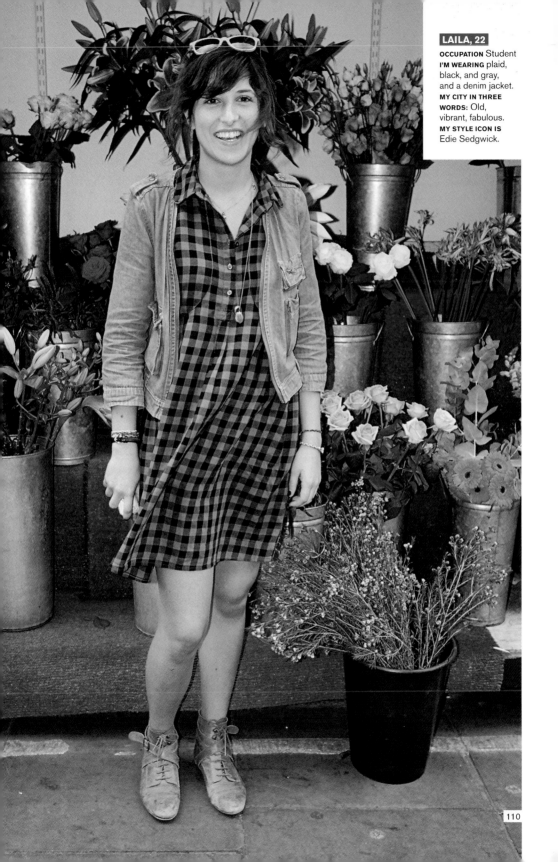

OCCUPATION Student
I'M WEARING plaid, black, and gray, and a denim jacket.
MY CITY IN THREE WORDS: Old, vibrant, fabulous.
MY STYLE ICON IS Edie Sedgwick.

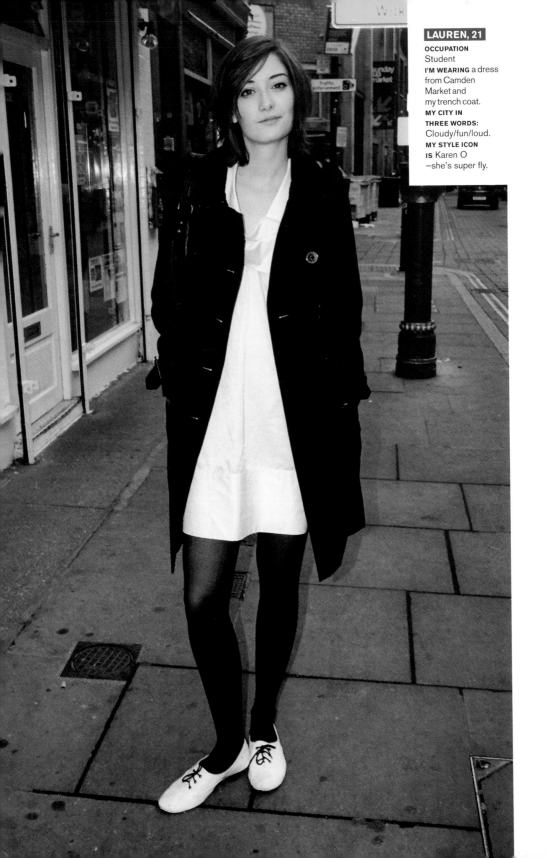

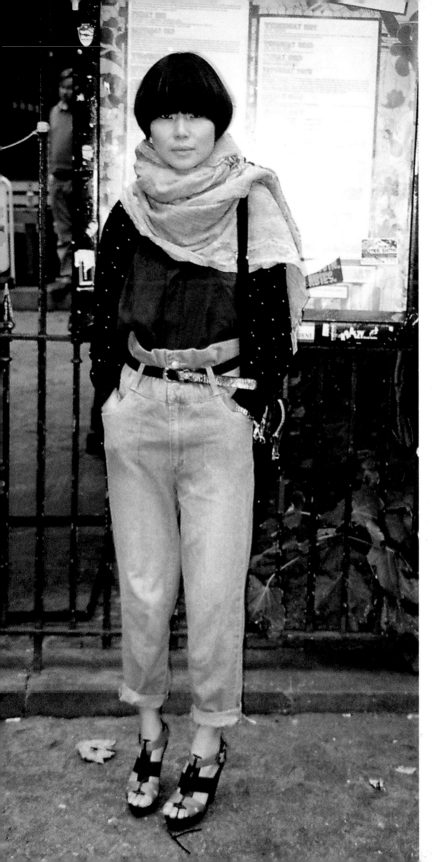

SOH
**WHY ARE YOU
WEARING THIS?**
Cold!
**MY STYLE IN FIVE
WORDS OR LESS:**
I wear what I like.
**MY CITY IN
THREE WORDS:**
Busy, busy, busy.

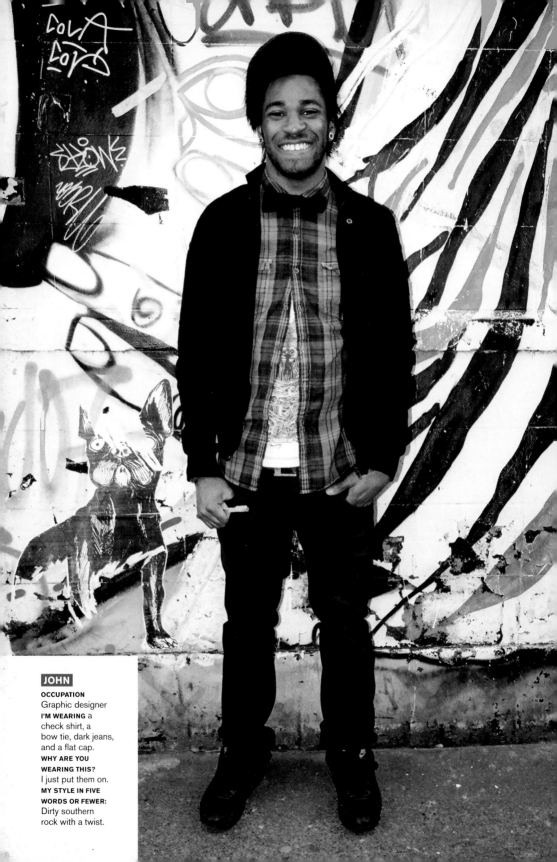

JOHN

OCCUPATION
Graphic designer
I'M WEARING a
check shirt, a
bow tie, dark jeans,
and a flat cap.
WHY ARE YOU
WEARING THIS?
I just put them on.
MY STYLE IN FIVE
WORDS OR FEWER:
Dirty southern
rock with a twist.

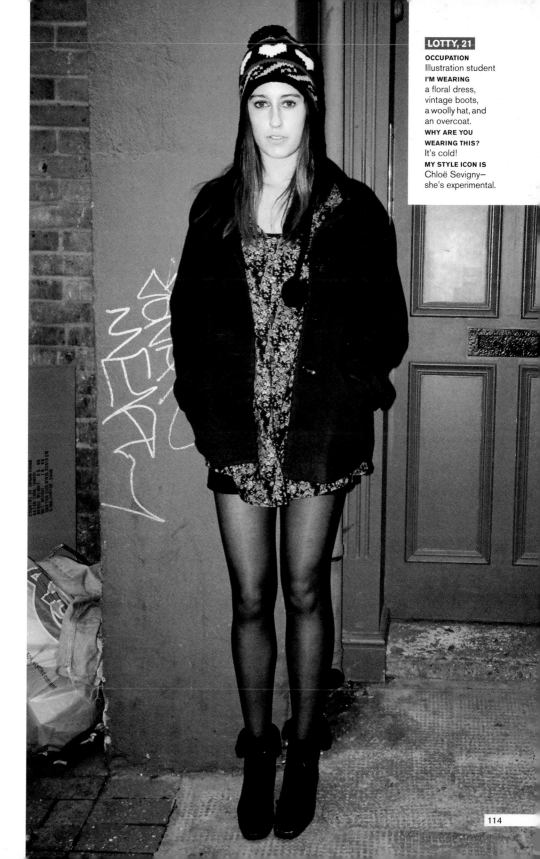

LOTTY, 21

OCCUPATION
Illustration student
I'M WEARING
a floral dress,
vintage boots,
a woolly hat, and
an overcoat.
WHY ARE YOU
WEARING THIS?
It's cold!
MY STYLE ICON IS
Chloë Sevigny—
she's experimental.

There is no better meeting place between worlds old and new than Montreal, a uniquely European city in America. (In Canada, obviously, but go with us here.) French is the lingua franca, by law and practice, and the city's street fashion similarly reflects as much a Parisian sensibility as it does a frontier spirit. This is very much a city that has embraced the motherland's belief in the art of the act: the tilt of the cap, the warp and the weft of the woolen cape, and, most important of all, the drape of the scarf. When French luxury brand Hermès produced "Jouez Avec Votre Carré Hermès" ("Playtime With Your Hermès Scarf"), a two-part, 26-page booklet illustrating two dozen lessons in that particularly French art of arranging the scarf, Montreal understood this tutelage uniquely among its North American counterparts. It's as much a blessing or birthright as it would be in the Bastille.

Montreal is, though, also a powerfully (North) American place. Like all the best, Montreal is a city of neighborhoods—Mile End, St.-Henri, Le Plateau, Petite-Patrie—and each of those, in turn, is filled with artists and musicians and the assorted other creative types perhaps most commonly described as bohemians. And

KARINE, 29

OCCUPATION
Editor-in-chief,
Naked Eye magazine
I'M WEARING
a vintage Comme
des Garçons pink
leather jacket, Also
shoes, Oakley
frogskin sunglasses,
skinny jeans, a silk
top, Uranium chain,
The Hundredshoodie,
and Defy jewelry.
MY STYLE ICON IS
my mom—she
has effortless style.

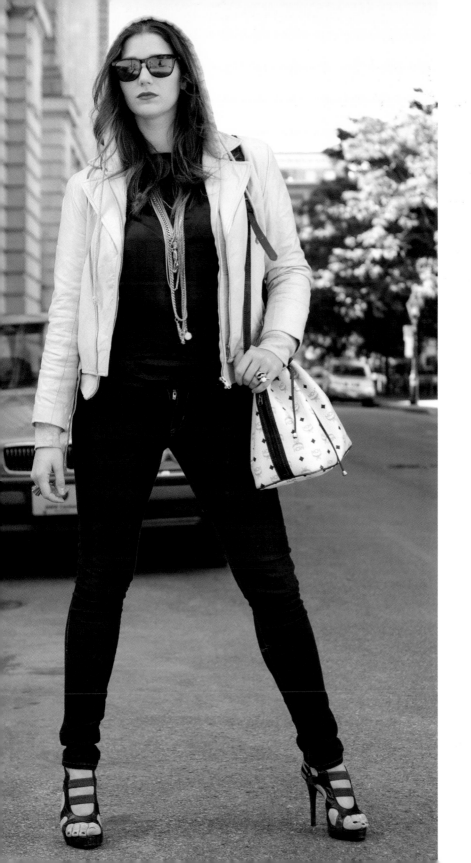

it is on it's streets that, crucially, the differences between Montreal street fashion and its Old World equivalent become clear—because this is, after all, the frontier. Things here are not so codified, so studiously discreet in their elegance; there is, instead, a defiantly New World sort of exuberance, an anything-can-happen joie de vivre that confounds stuffiness or studiedness. This is a rare trait, and not only in comparison to Europe. Montreal is cheap, at least compared to New York or London, and there are benefits to the Canadian system of social safety nets. It is easy to be brave when you have an inexpensive apartment in an elegantly weathered neighborhood—and free health care. If that bravery is expressed in skinny jeans and vintage rompers, or fuchsia tights and the ultimate Montreal accessory—snow-proof boots—then so be it.

Whatever its noisier neighbors to the south might believe, Montreal is one of the continent's most creative cities, and it has been a magnet for iconoclastic artists for decades. This is, after all, where Arcade Fire's Win Butler made his home after growing up in Texas, and after meeting wife and bandmate Régine Chassagne at the city's McGill University. (Rufus Wainwright grew up here too, friends with Montreal native Leonard Cohen.) The city's fashion scene is no less eclectic, and its Mode & Design festival each June is a gathering point for designers from across Canada, on a runway dubbed the "TransCanada." (Apparently, in North America, national pride is not unique to the United States.)

It is a curious thing, sitting so squarely between two cultures and two continents. There are clear benefits to creating something—a look, an artwork, a band, a movie —in such an evolutionarily distinct place: There are few blueprints to trace, few rules to follow. It is not enough to simply be about the label here, like it might be in another francophone city we can think of. There is also a passion for rough-hewn individuality—but with a gentleness and grace not always in evidence in the cities to the south. Montreal's street style, and the vintage shops and designer boutiques of the neighborhoods above that sustain it— like Unicorn and Tavan & Mitto and Preloved—betray a telling truth: Montreal is that perfect hybrid, taking freely from both its old relations and its present neighbors to form a future all its own. Are you ready to move yet?

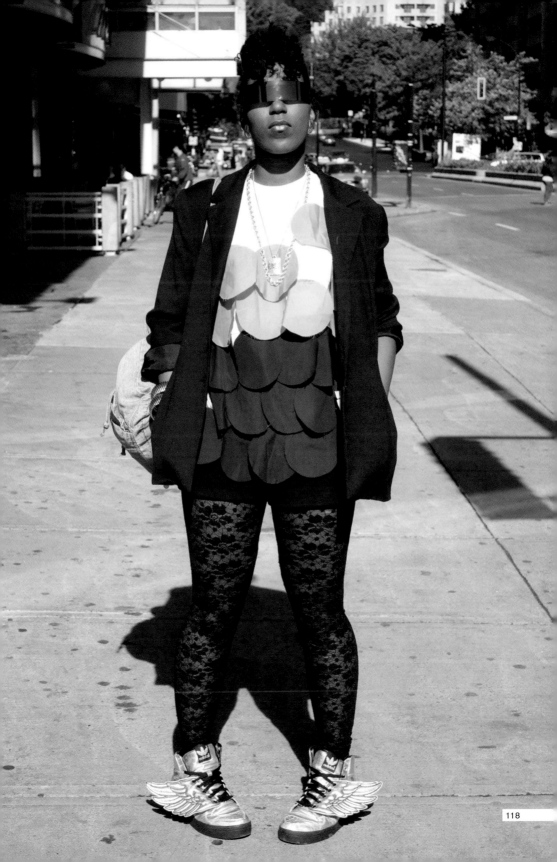

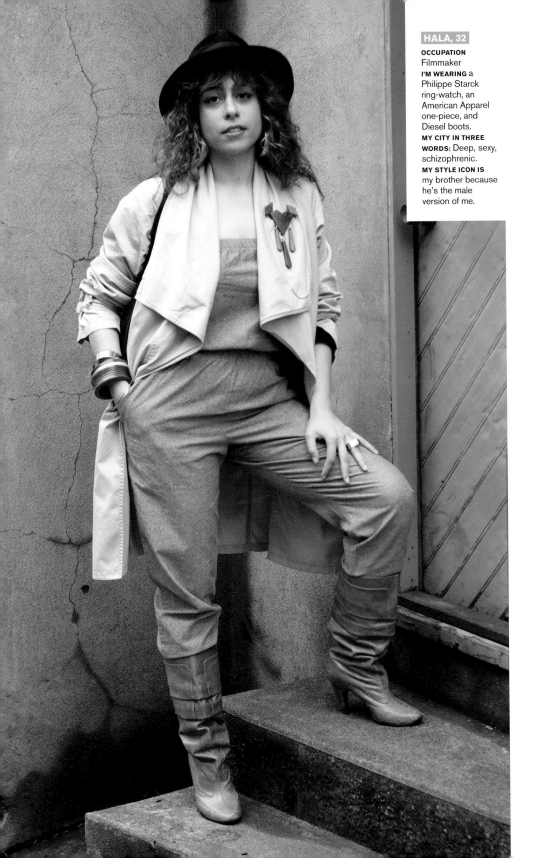

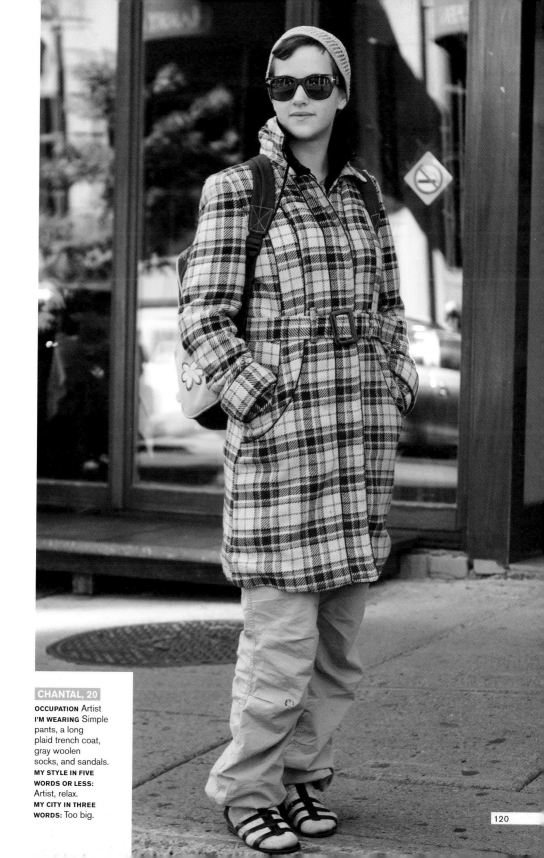

CHANTAL, 20

OCCUPATION Artist
I'M WEARING Simple
pants, a long
plaid trench coat,
gray woolen
socks, and sandals.
**MY STYLE IN FIVE
WORDS OR LESS:**
Artist, relax.
**MY CITY IN THREE
WORDS:** Too big.

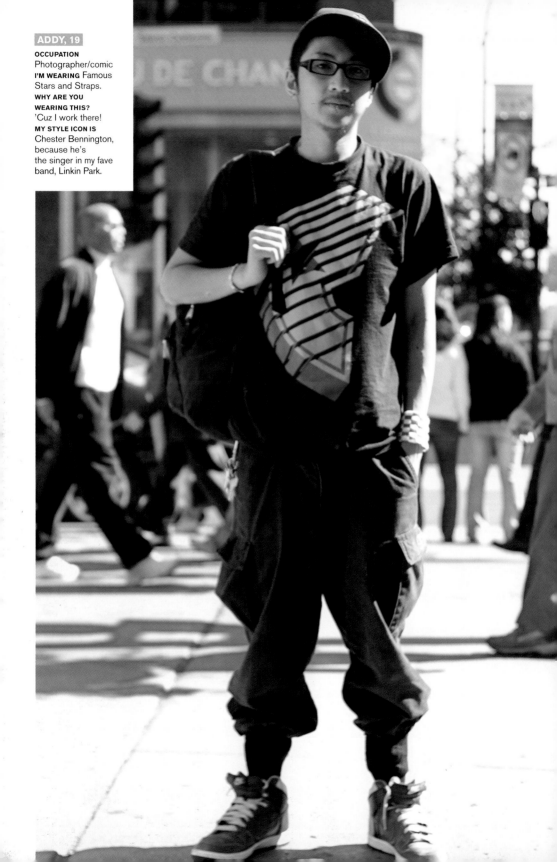

ADDY, 19

OCCUPATION
Photographer/comic
I'M WEARING Famous
Stars and Straps.
WHY ARE YOU
WEARING THIS?
'Cuz I work there!
MY STYLE ICON IS
Chester Bennington,
because he's
the singer in my fave
band, Linkin Park.

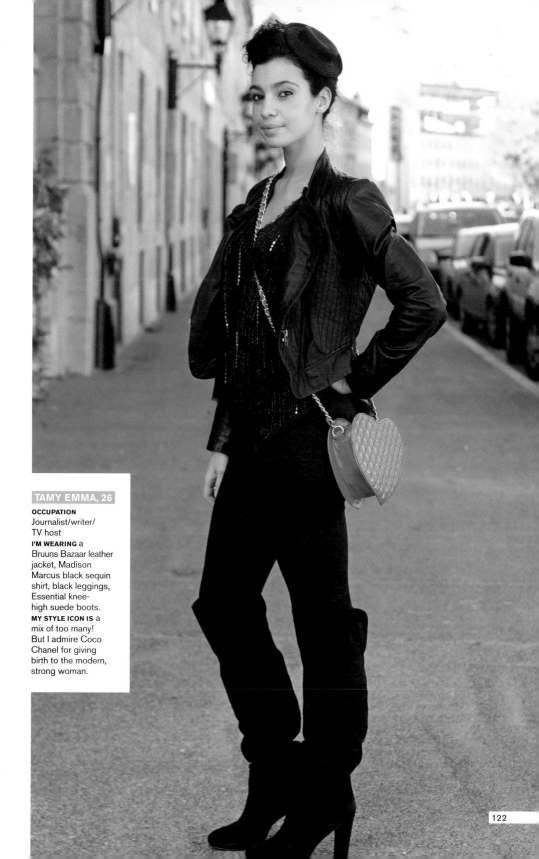

TAMY EMMA, 26

OCCUPATION
Journalist/writer/
TV host
I'M WEARING a
Bruuns Bazaar leather
jacket, Madison
Marcus black sequin
shirt, black leggings,
Essential knee-
high suede boots.
MY STYLE ICON IS a
mix of too many!
But I admire Coco
Chanel for giving
birth to the modern,
strong woman.

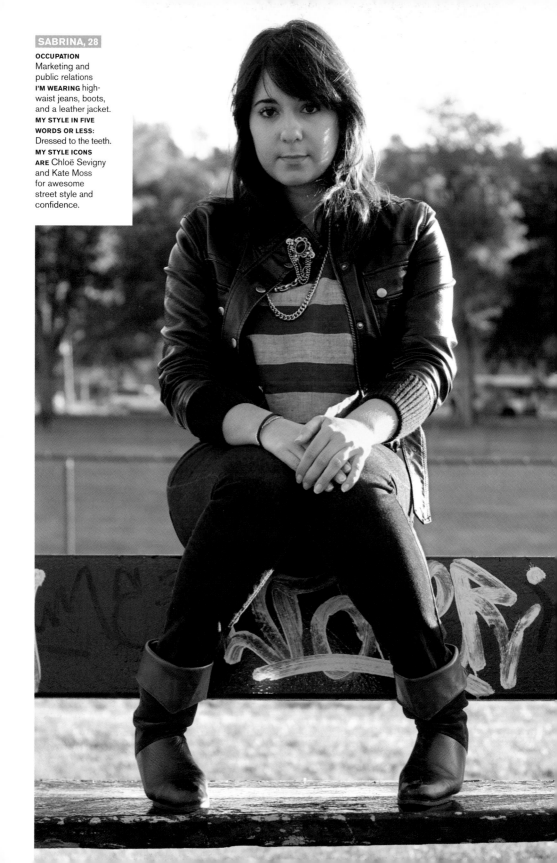

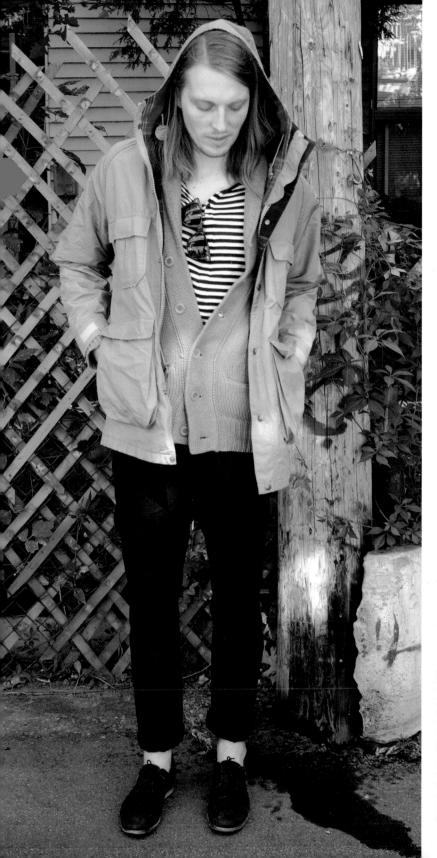

TYLER, 27

OCCUPATION Retail
I'M WEARING Rokin
shoes, velour pants,
a velour shirt, a
Filippa K sweater,
and a vintage
Woolrich jacket.
**MY STYLE IN FIVE
WORDS OR LESS:**
Wake up get dressed.
MY STYLE ICON IS
Mineki Yamada—best
style in the west.

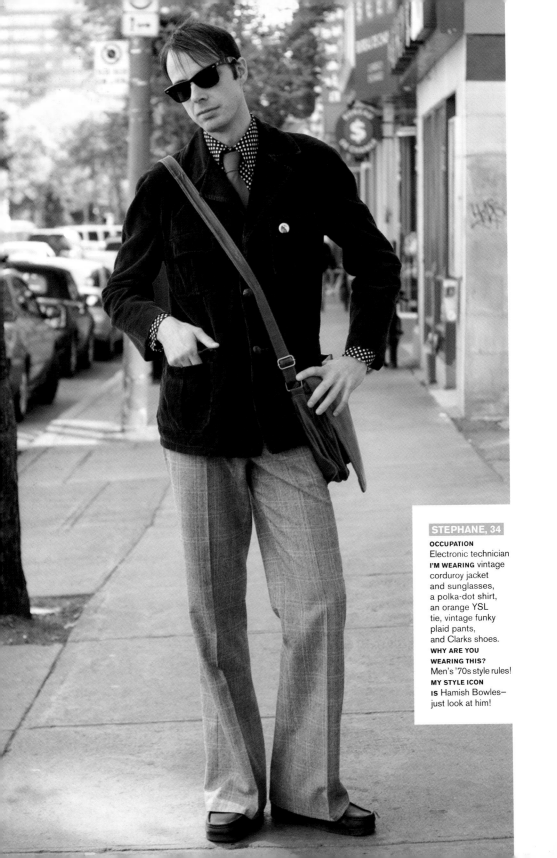

STEPHANE, 34

OCCUPATION
Electronic technician
I'M WEARING vintage
corduroy jacket
and sunglasses,
a polka-dot shirt,
an orange YSL
tie, vintage funky
plaid pants,
and Clarks shoes.
**WHY ARE YOU
WEARING THIS?**
Men's '70s style rules!
**MY STYLE ICON
IS** Hamish Bowles—
just look at him!

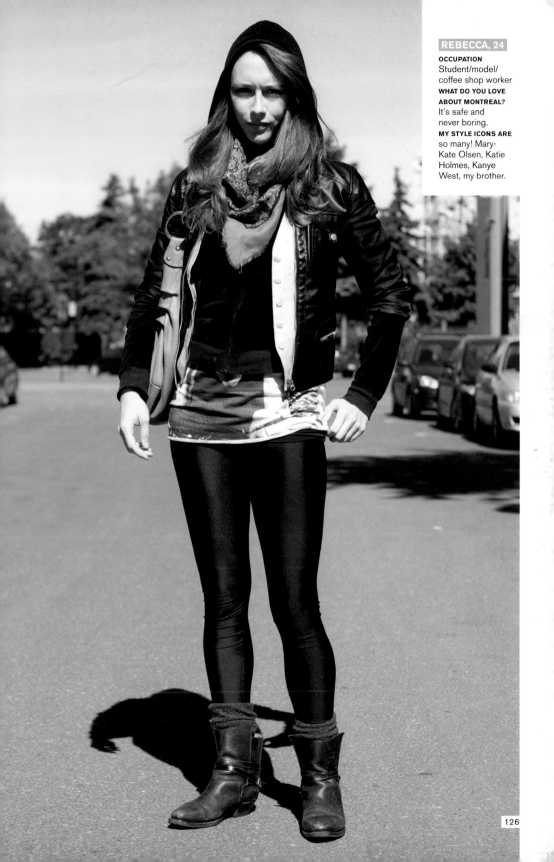

REBECCA, 24

OCCUPATION
Student/model/
coffee shop worker
**WHAT DO YOU LOVE
ABOUT MONTREAL?**
It's safe and
never boring.
MY STYLE ICONS ARE
so many! Mary-
Kate Olsen, Katie
Holmes, Kanye
West, my brother.

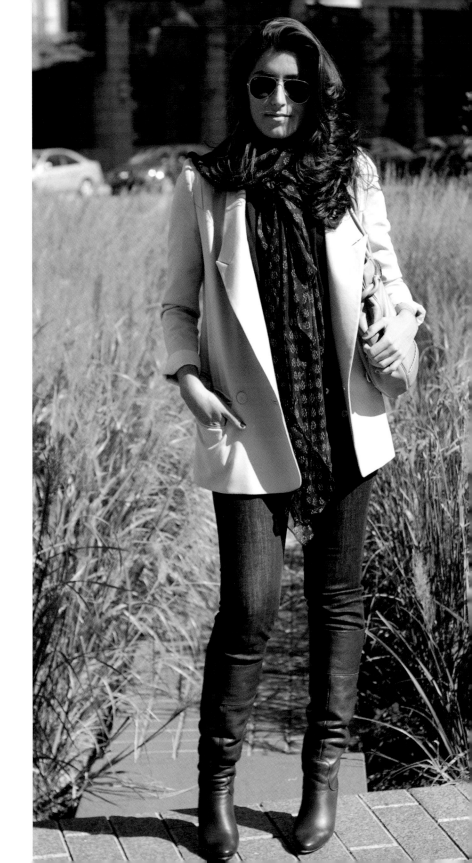

MEERA, 24

OCCUPATION Student

I'M WEARING an Erin Brinie blazer, black leather boots, Seven jeans, a Fluxus vest, a vintage scarf, and Apriati jewelry.

WHY ARE YOU WEARING THIS? Protection from the elements.

MY STYLE ICON IS Stella McCartney— she embodies the thinking woman's sexy.

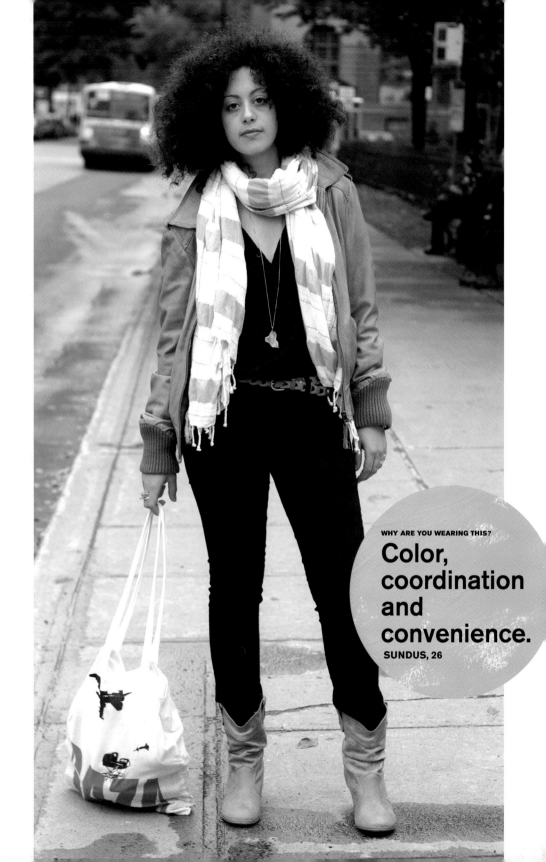

WHY ARE YOU WEARING THIS?

Color, coordination and convenience.

SUNDUS, 26

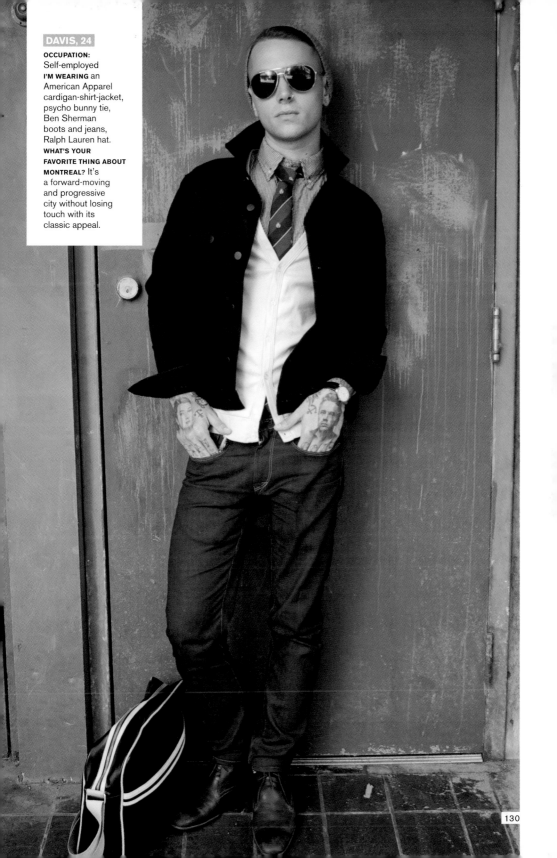

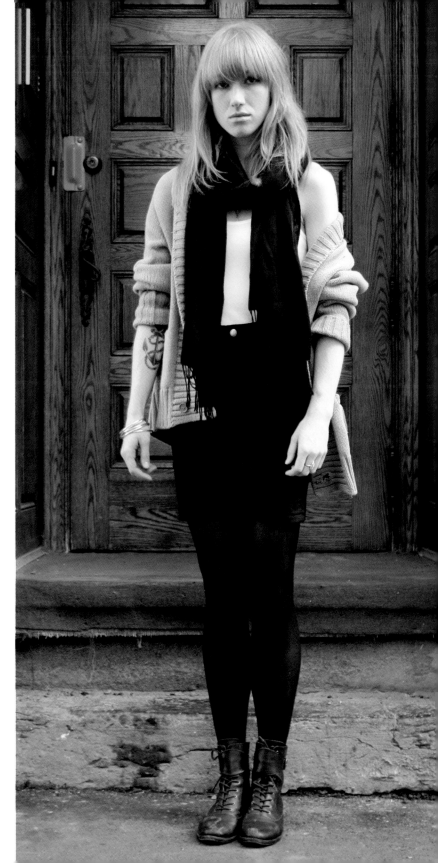

MEGHAN, 25

OCCUPATION Future store owner
I'M WEARING boots, a denim skirt, and H&M tank, a pashmina, a Wesc sweater, my grandmother's ring, and my boyfriend's bracelets.
WHY ARE YOU WEARING THIS? I love black, being comfortable, and incorporating pieces that remind me of people I love.

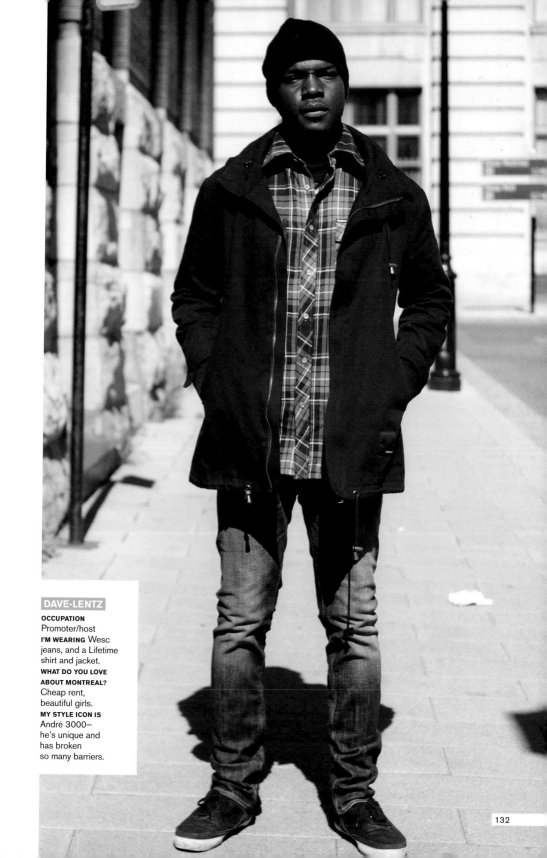

DAVE·LENTZ

OCCUPATION
Promoter/host
I'M WEARING Wesc
jeans, and a Lifetime
shirt and jacket.
**WHAT DO YOU LOVE
ABOUT MONTREAL?**
Cheap rent,
beautiful girls.
MY STYLE ICON IS
André 3000—
he's unique and
has broken
so many barriers.

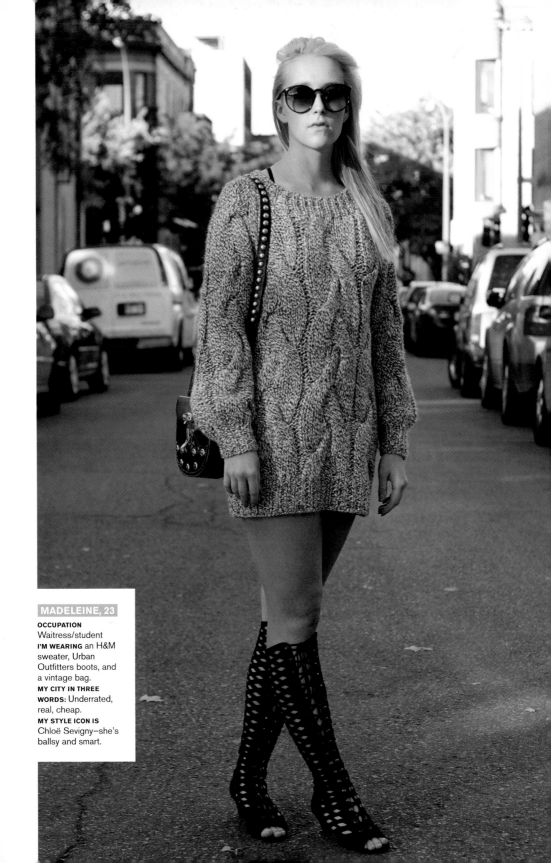

MADELEINE, 23

OCCUPATION
Waitress/student
I'M WEARING an H&M
sweater, Urban
Outfitters boots, and
a vintage bag.
**MY CITY IN THREE
WORDS:** Underrated,
real, cheap.
MY STYLE ICON IS
Chloë Sevigny—she's
ballsy and smart.

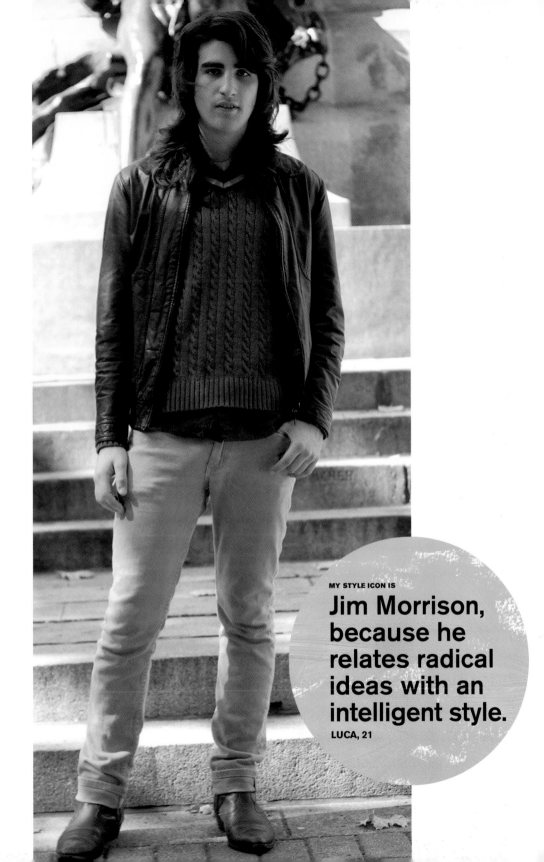

MY STYLE ICON IS
Jim Morrison, because he relates radical ideas with an intelligent style.
LUCA, 21

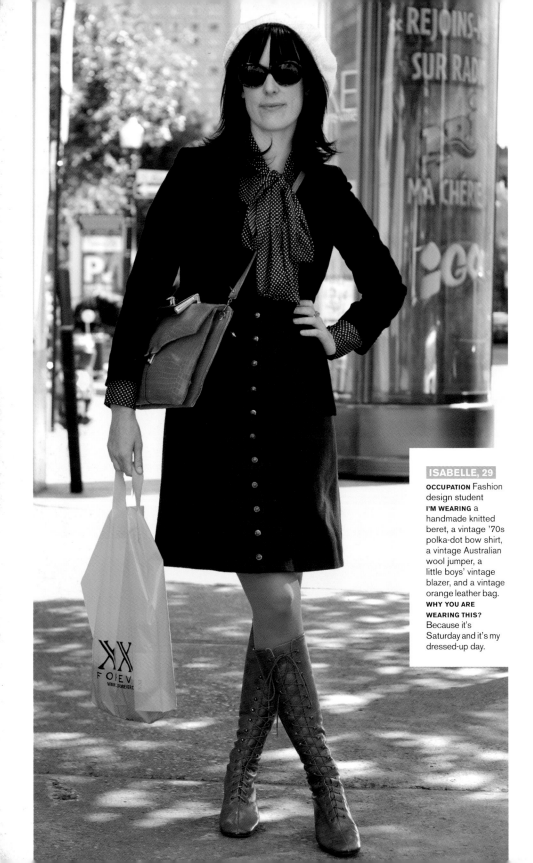

ISABELLE, 29

OCCUPATION Fashion design student
I'M WEARING a handmade knitted beret, a vintage '70s polka-dot bow shirt, a vintage Australian wool jumper, a little boys' vintage blazer, and a vintage orange leather bag.
WHY YOU ARE WEARING THIS? Because it's Saturday and it's my dressed-up day.

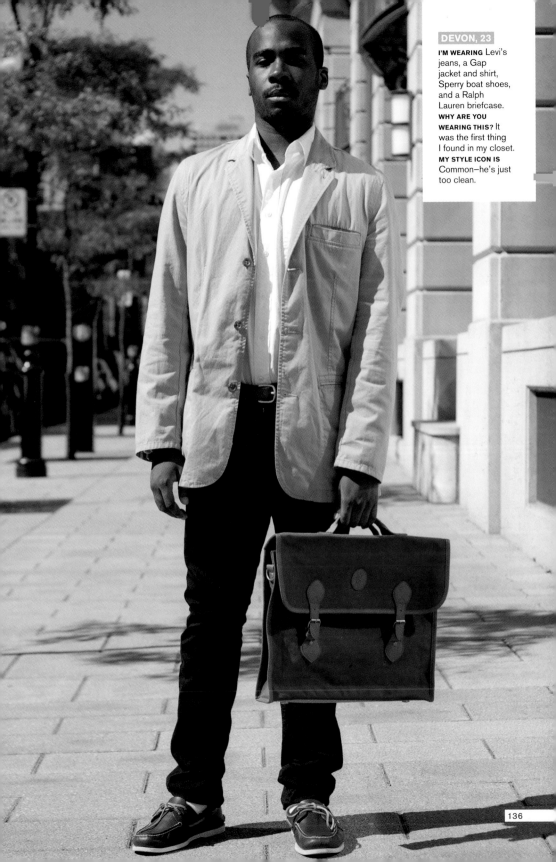

I'M WEARING Levi's jeans, a Gap jacket and shirt, Sperry boat shoes, and a Ralph Lauren briefcase. **WHY ARE YOU WEARING THIS?** It was the first thing I found in my closet. **MY STYLE ICON IS** Common–he's just too clean.

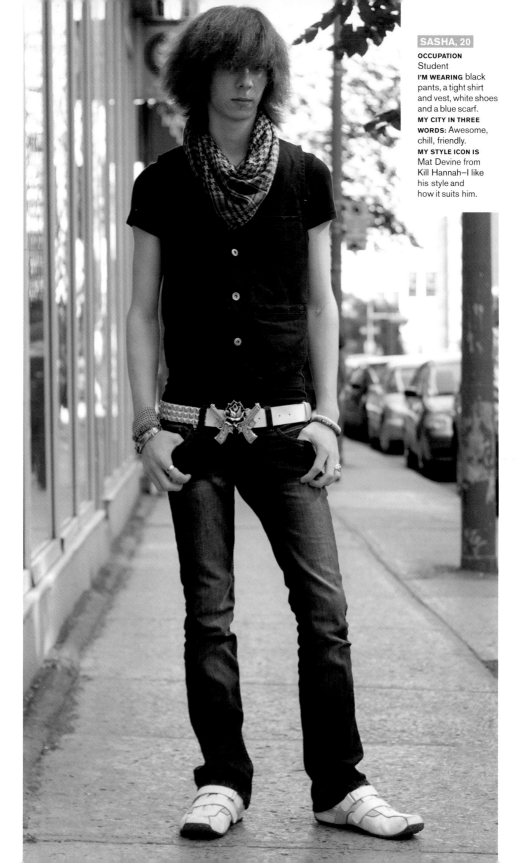

SASHA, 20

OCCUPATION
Student
I'M WEARING black
pants, a tight shirt
and vest, white shoes
and a blue scarf.
**MY CITY IN THREE
WORDS:** Awesome,
chill, friendly.
MY STYLE ICON IS
Mat Devine from
Kill Hannah–I like
his style and
how it suits him.

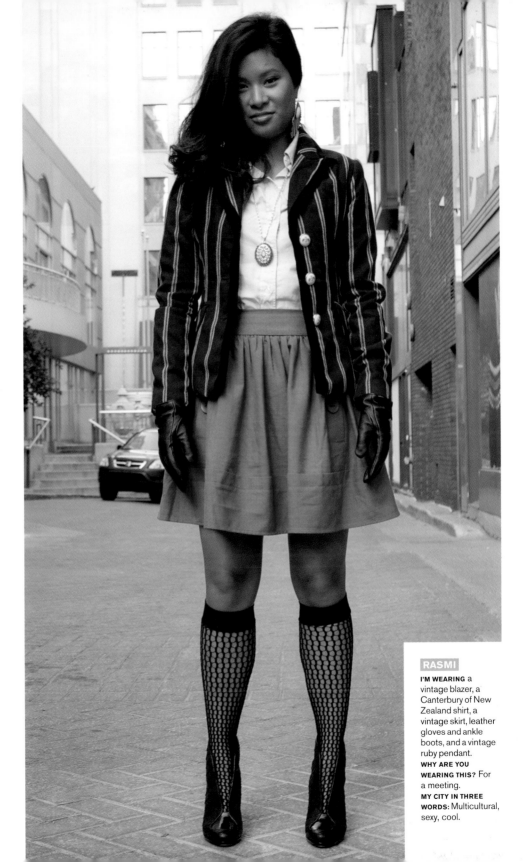

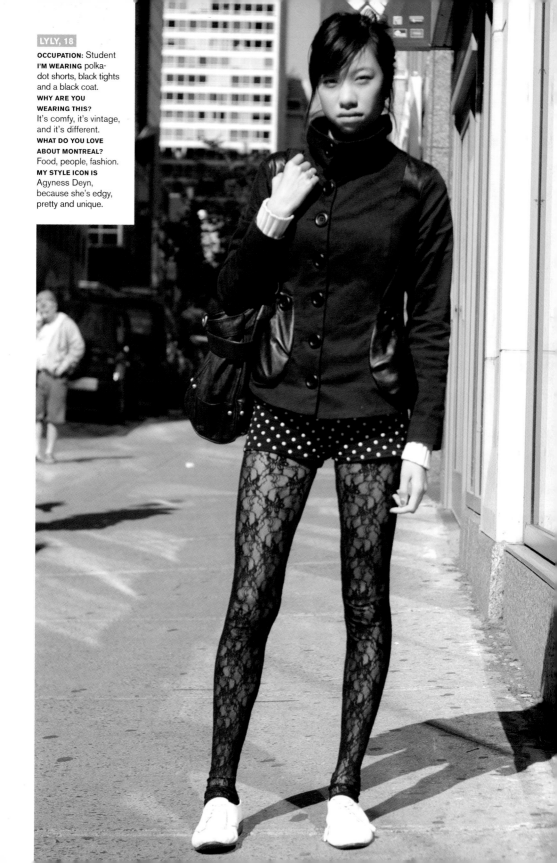

LYLY, 18

OCCUPATION: Student
I'M WEARING polka-dot shorts, black tights and a black coat.
WHY ARE YOU WEARING THIS?
It's comfy, it's vintage, and it's different.
WHAT DO YOU LOVE ABOUT MONTREAL?
Food, people, fashion.
MY STYLE ICON IS Agyness Deyn, because she's edgy, pretty and unique.

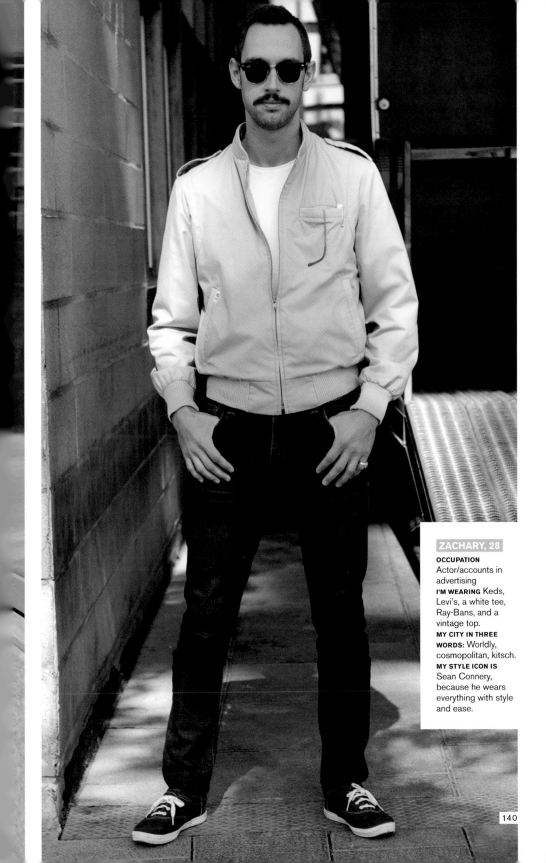

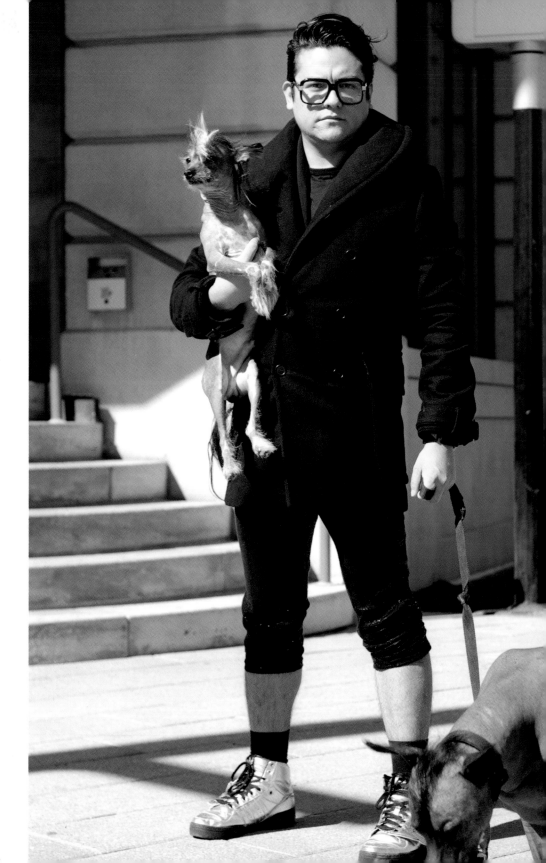

GIBRAN, 30

OCCUPATION
Creative director
at Bunk3r TV

I'M WEARING
Jeremy Scott,
Adidas, Fendi, and
American Apparel.

**MY STYLE IN FIVE
WORDS OR LESS:**
Eclectic, black,
with a little touch
of exoticism.

**WHAT DO YOU LOVE
ABOUT MONTREAL?**
Fashionistas,
music, and the
modern buildings.

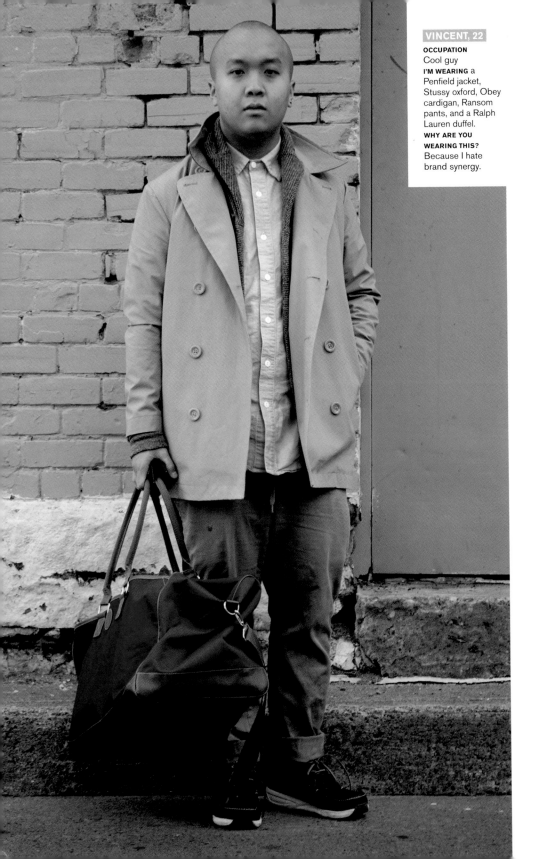

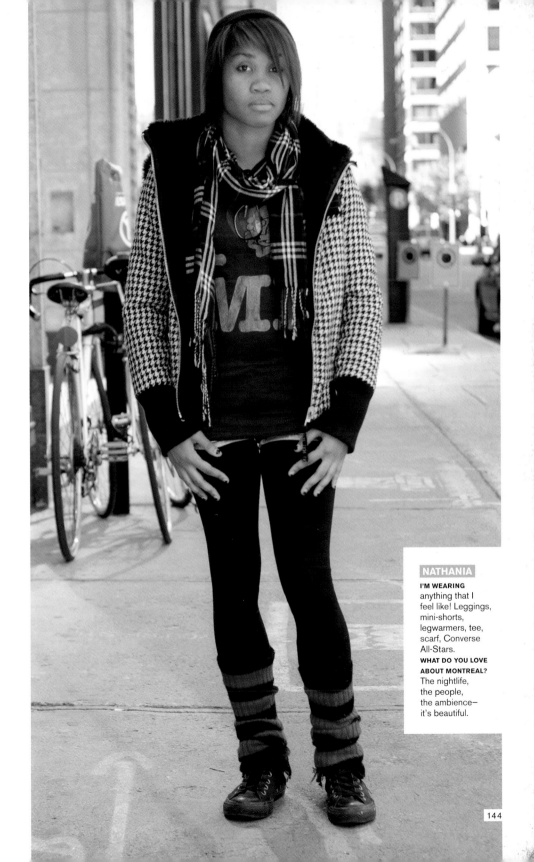

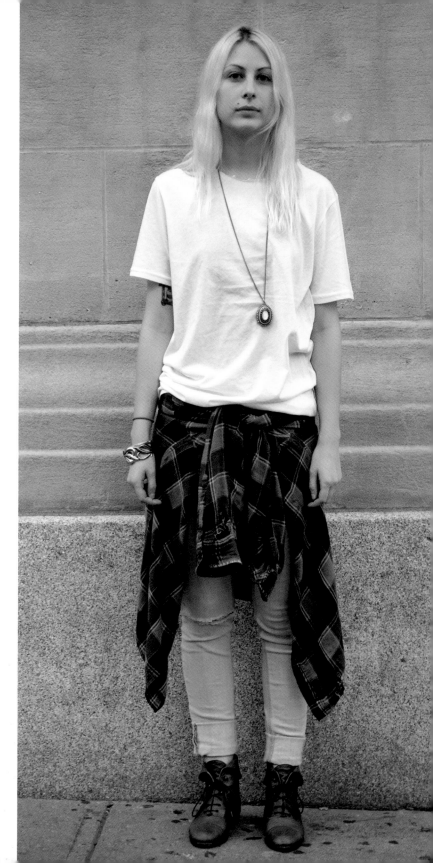

TARA, 21

OCCUPATION Retail
I'M WEARING vintage
Bang On T-shirt, an
H&M necklace,
and vintage boots.
**WHY ARE YOU
WEARING THIS?**
I had to work.
**MY STYLE IN FIVE
WORDS OR LESS:**
Thoughtless,
grunge, the '90s.

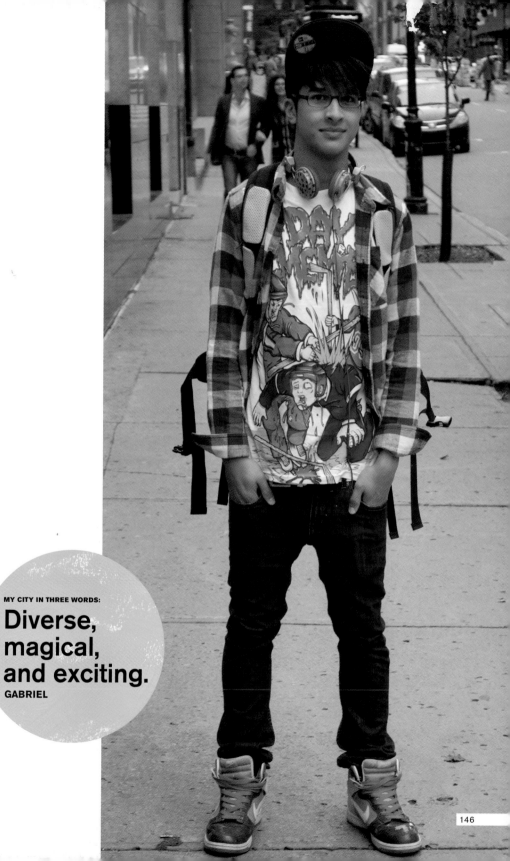

MY CITY IN THREE WORDS:
Diverse, magical, and exciting.
GABRIEL

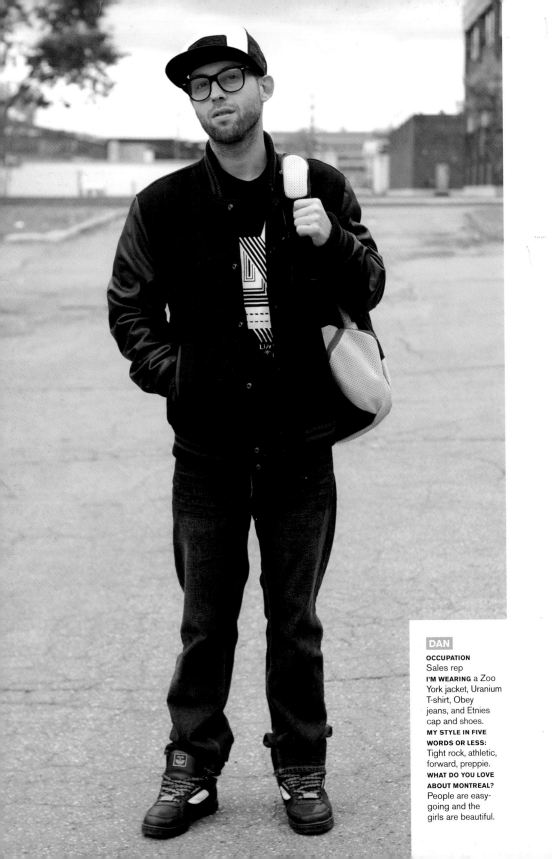

DAN

OCCUPATION
Sales rep
I'M WEARING a Zoo
York jacket, Uranium
T-shirt, Obey
jeans, and Etnies
cap and shoes.
**MY STYLE IN FIVE
WORDS OR LESS:**
Tight rock, athletic,
forward, preppie.
**WHAT DO YOU LOVE
ABOUT MONTREAL?**
People are easy-
going and the
girls are beautiful.

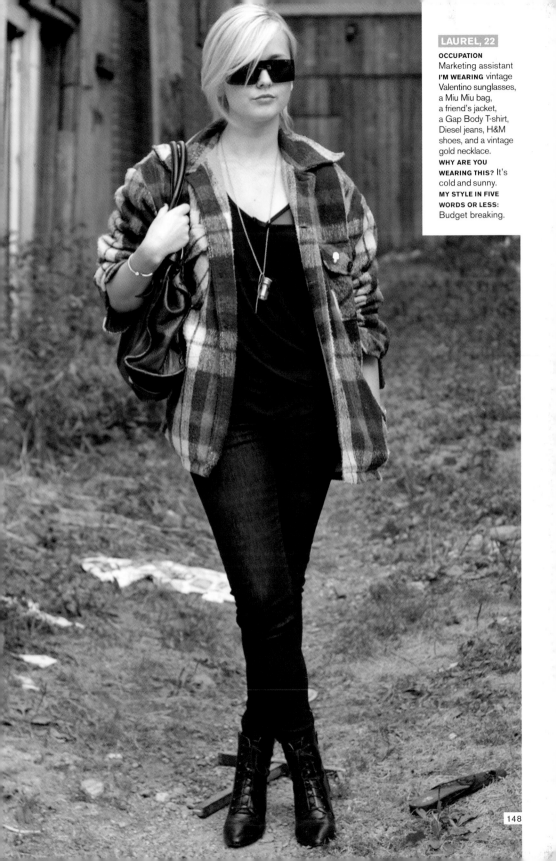

LAUREL, 22

OCCUPATION
Marketing assistant
I'M WEARING vintage
Valentino sunglasses,
a Miu Miu bag,
a friend's jacket,
a Gap Body T-shirt,
Diesel jeans, H&M
shoes, and a vintage
gold necklace.
**WHY ARE YOU
WEARING THIS?** It's
cold and sunny.
**MY STYLE IN FIVE
WORDS OR LESS:**
Budget breaking.

Say the words "Scandinavian design" and an image emerges, of blond woods and clean lines, white Billy bookcases and the primary colors of both IKEA and Marimekko. It is an ethos devoted to forms led by function, but those shapes can soar when their hard-nosed Protestant creators deem it appropriate: Witness the curvilinear shapes of Terminal 5 at Kennedy Airport and the Gateway Arch in St. Louis, both designed by the same Finnish architect and two examples of iconic Scandinavian design, the region's most lasting form of overseas colonialism. One rumor credits IKEA with manufacturing the beds on which half of Europe's babies are conceived—a salacious fact of furnishings that one imagines the firm's Swedish owners find altogether too much information.

Stockholm style both reflects and nimbly evolves that image. Unlike London or New York, Stockholm is not

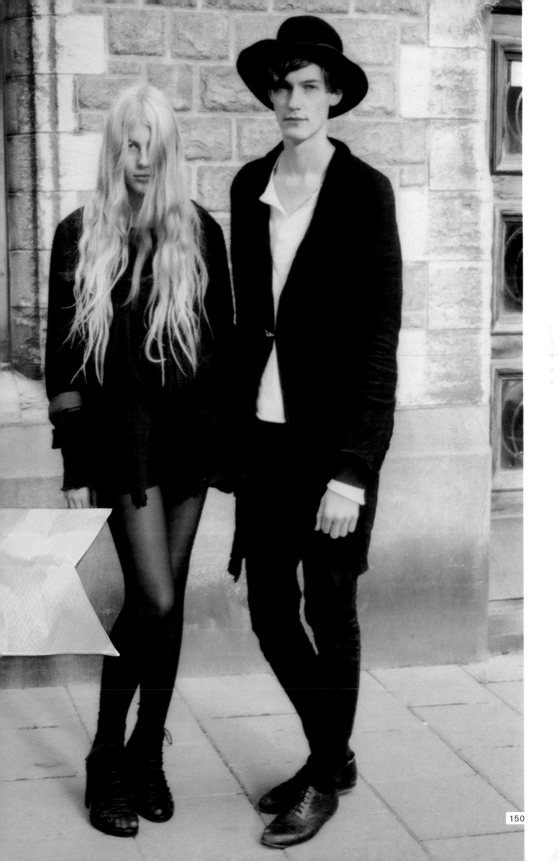

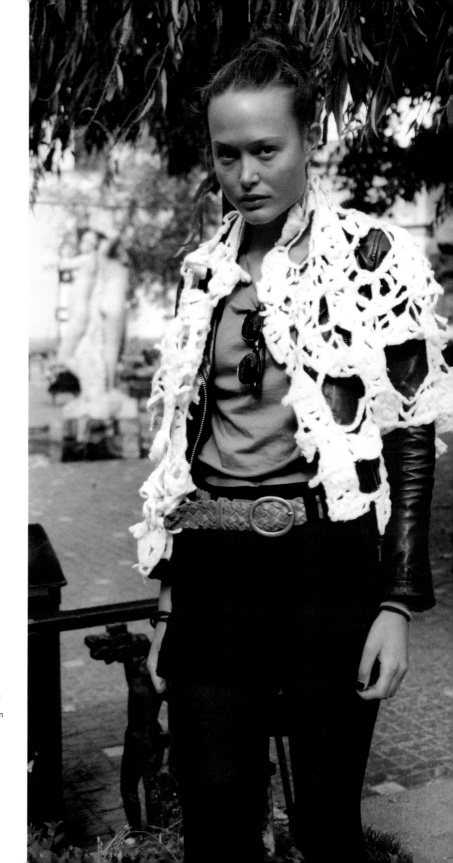

GRETA, 21

I'M WEARING black
shoes from Minelli,
shorts from H&M,
a green T-shirt from
Urban Outfitters,
and a brown
belt from H&M.
**MY CITY IN THREE
WORDS:** I love it!
MY STYLE ICON IS
my mom and
her sister. I have
always loved what
they are wearing.

a city of immigrants, aside from the influx of Iraqi refugees that makes up the city's third biggest ethnic group, after Swedes and Finns. Stockholm is a small city, with a population of just over 800,000 living on the fourteen islands that comprise the city and the innermost part of the Stockholm archipelago. It is a reliably homogenous place, offering ample evidence of the archetypical Swedish beauty, all blond hair and blue eyes—though there are plenty of exceptions to this stock-image rule.

There is little evidence of the endemic crime or poverty that is part of big-city living in the United States or elsewhere in Europe; the governing idea of the Swedish state is not the accumulation of personal wealth but the distribution of shared fortune, and while this means that there are fewer entrepreneurial superstars—there's no Swedish analogue for Bill Gates and Steve Jobs— there are, similarly, fewer pockets of desperation and hopelessness. Elsewhere, that desperation can power the creative engine: the grit in the oyster that allows for the pearl. The Swedish designer's palette is a different one, taking inspiration from a love of function and an appreciation for the natural world that surrounds them —the sandy archipelago, where many spend their summer weekends; the fir trees of the northern forests; and, of course, the winter cold. They can also look to the cultural tribes they call their own: the skinny-jeaned rockers, the city's clusters of goths, the DJs and artists of SoFo—south of Folkungagatan, the neighborhood on Södermalm with the capital's best array of galleries, cafes, and cafe/galleries serving reindeer meatballs and Hell lagers from the Jämtland Brewery in Östersund.

The city's best designers are famous for their clarity of vision: No one does low-cost skinny jeans for hipsters like Cheap Monday, or limited-edition parkas like Whyred, led by a trio of designers who all began their careers at ubiquitous hometown phenomenon H&M. And speaking of: No other brand in the world has mastered cheap-chic like the former Hennes & Moritz—Hennes means "hers"; the masculine Moritz was the name of a Stockholm hunting-supply shop—and it's a label common to nearly every Swedish closet. There is, indeed, a sense of consonance here, and the local art of dressing rests on an innate understanding of the revelatory grace note: the oversized gold zipper on the storm-gray jacket, the lemon-yellow scarf worn against a backdrop of navy and black. The beauty of Stockholm street fashion is a mastery of a shared foundation—the Acne top, the Filippa K skirt, the Nudie jeans, the H&M necklace, the burly winter coat—and a shared gift for transcending it.

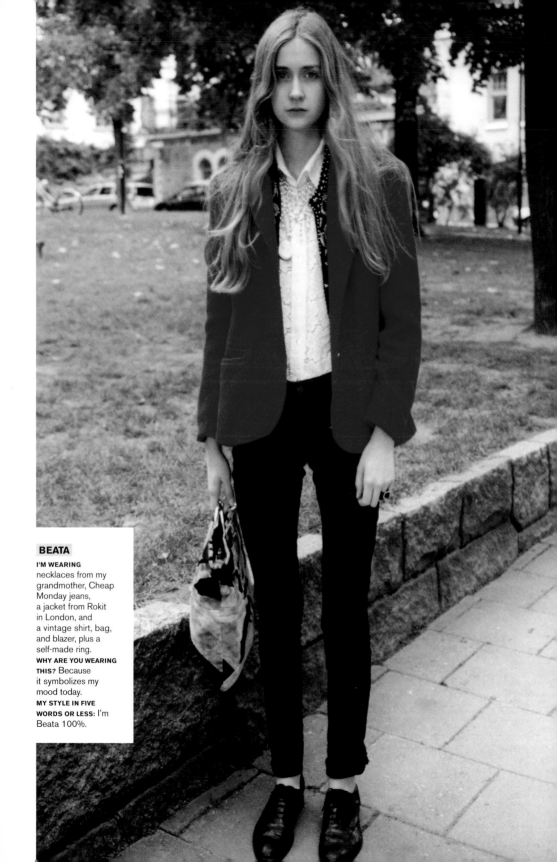

BEATA

I'M WEARING
necklaces from my
grandmother, Cheap
Monday jeans,
a jacket from Rokit
in London, and
a vintage shirt, bag,
and blazer, plus a
self-made ring.
**WHY ARE YOU WEARING
THIS?** Because
it symbolizes my
mood today.
**MY STYLE IN FIVE
WORDS OR LESS:** I'm
Beata 100%.

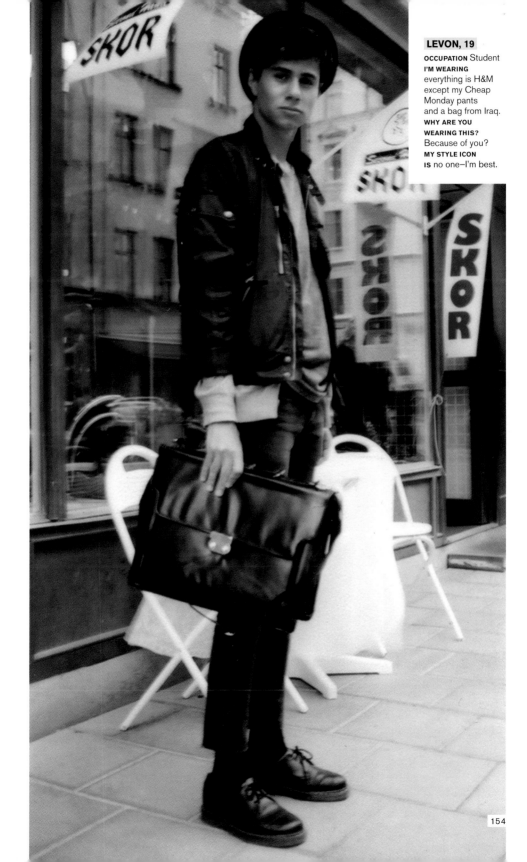

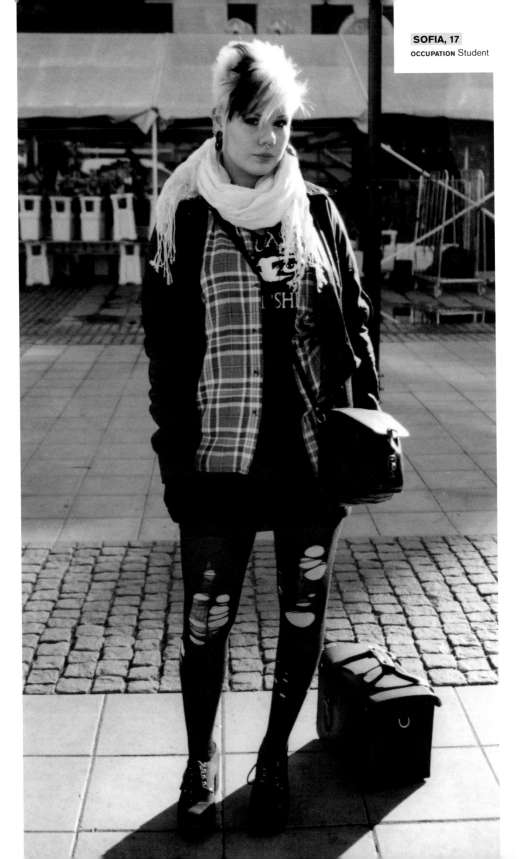

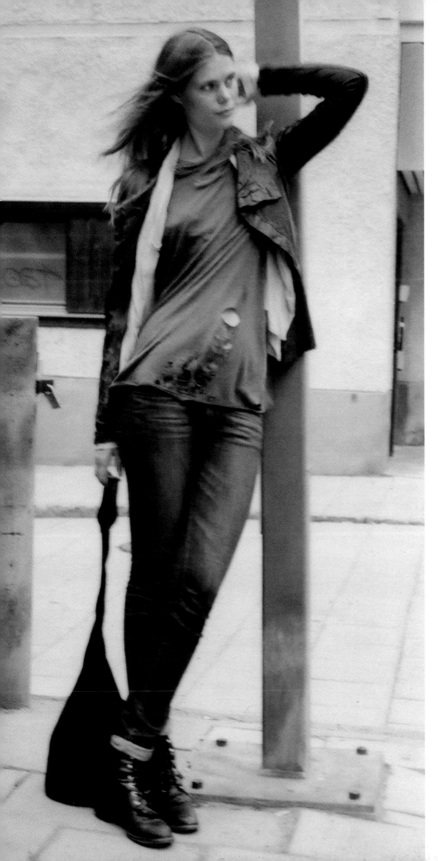

ADINA

OCCUPATION
Model/artist
I'M WEARING
an ooooold T-shirt,
a Rick Owens
jacket, and shoes
from a flea market
in Los Angeles.
**WHY ARE YOU
WEARING THIS?**
Just because I can.

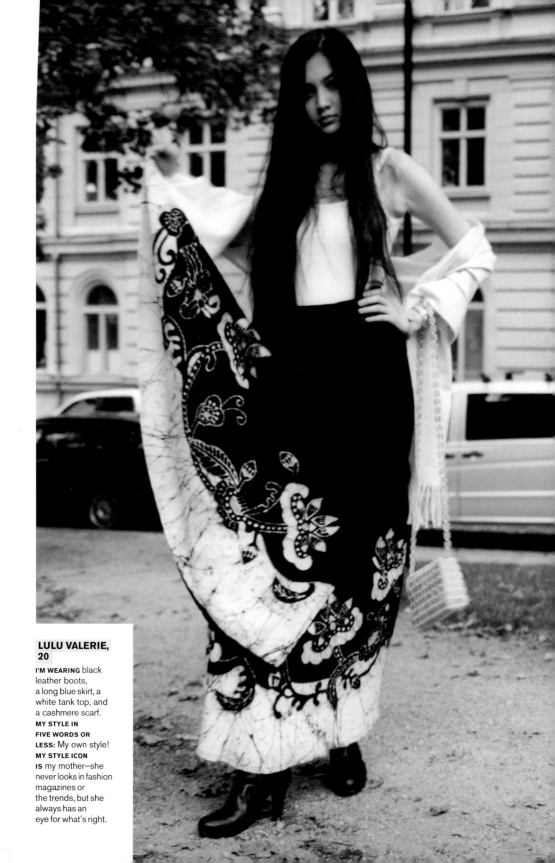

**LULU VALERIE,
20**

I'M WEARING black
leather boots,
a long blue skirt, a
white tank top, and
a cashmere scarf.
**MY STYLE IN
FIVE WORDS OR
LESS:** My own style!
**MY STYLE ICON
IS** my mother—she
never looks in fashion
magazines or
the trends, but she
always has an
eye for what's right.

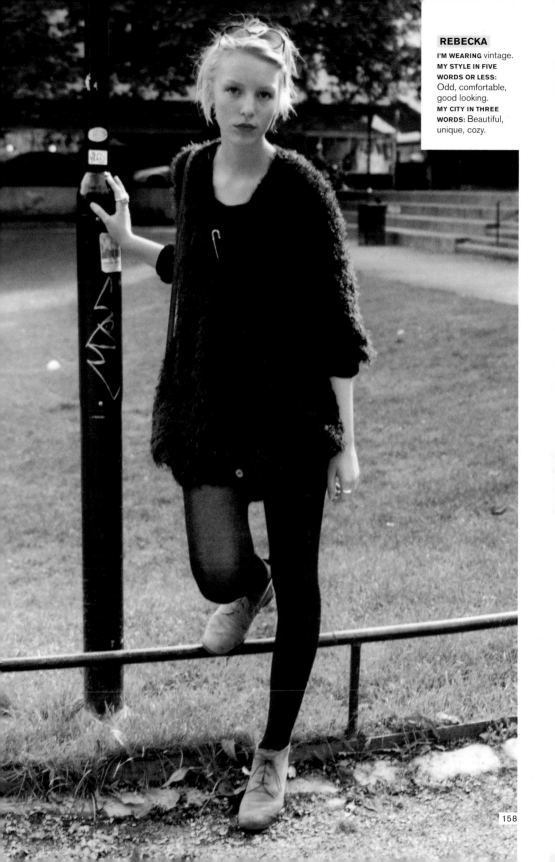

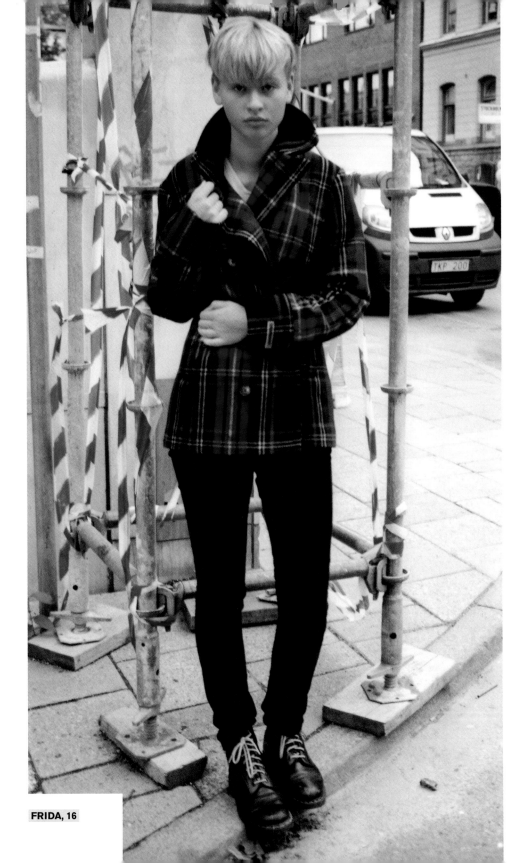

FRIDA, 16

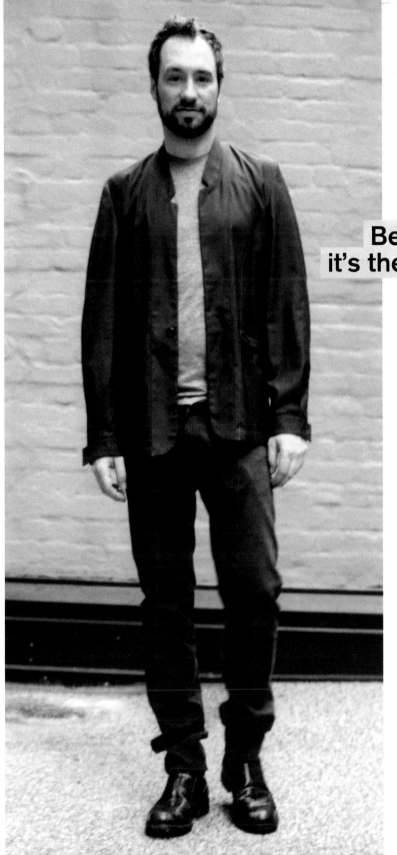

Because
it's the way I
see it.

RICHARD, 37

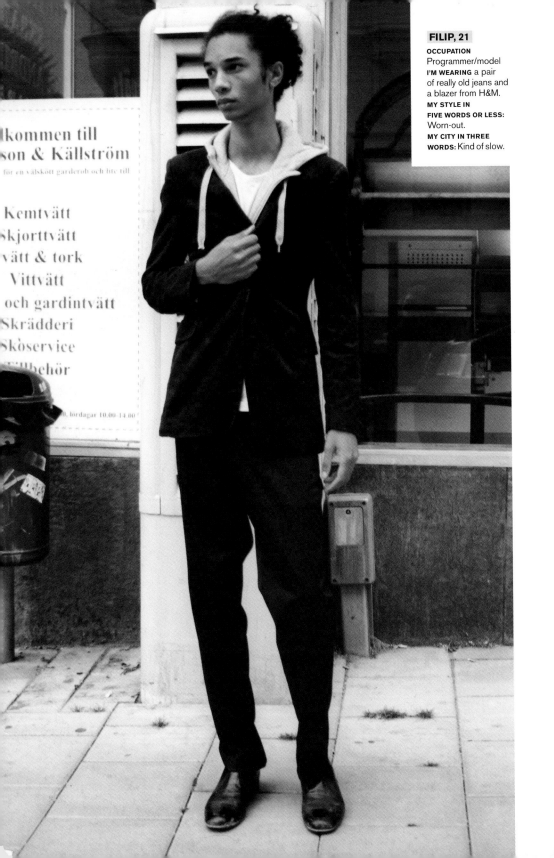

kommen till
son & Källström
för en välskött garderob och lite till

Kemtvätt
Skjorttvätt
vätt & tork
Vittvätt
och gardintvätt
Skrädderi
Sköservice
tillbehör

0, lördagar 10.00-14.00

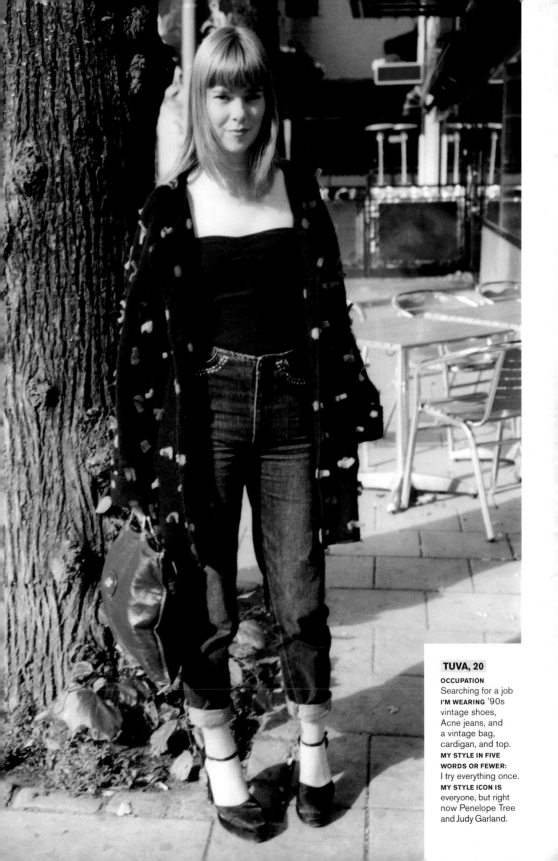

TUVA, 20

OCCUPATION
Searching for a job
I'M WEARING '90s
vintage shoes,
Acne jeans, and
a vintage bag,
cardigan, and top.
**MY STYLE IN FIVE
WORDS OR FEWER:**
I try everything once.
MY STYLE ICON IS
everyone, but right
now Penelope Tree
and Judy Garland.

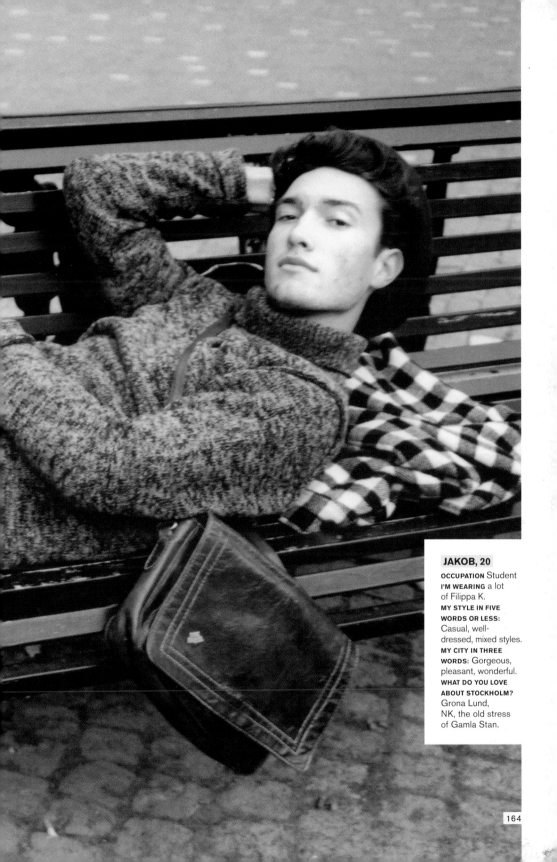

JAKOB, 20

OCCUPATION Student
I'M WEARING a lot
of Filippa K.
**MY STYLE IN FIVE
WORDS OR LESS:**
Casual, well-
dressed, mixed styles.
**MY CITY IN THREE
WORDS:** Gorgeous,
pleasant, wonderful.
**WHAT DO YOU LOVE
ABOUT STOCKHOLM?**
Grona Lund,
NK, the old stress
of Gamla Stan.

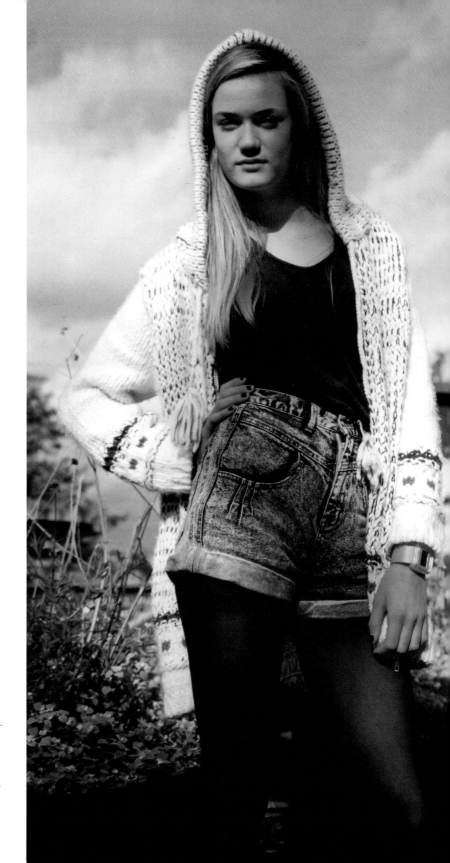

FRIDA, 17

OCCUPATION High
school student
I'M WEARING shorts
from Gina Tricot,
shoes from Turkey,
a T-shirt from
Weekday, and
a jumper from Zara.
**MY STYLE IN FIVE
WORDS OR LESS:**
Colorful, relaxed,
denim, mixed!
**WHAT DO YOU LOVE
ABOUT STOCKHOLM?**
The different
styles and sorts
of people.

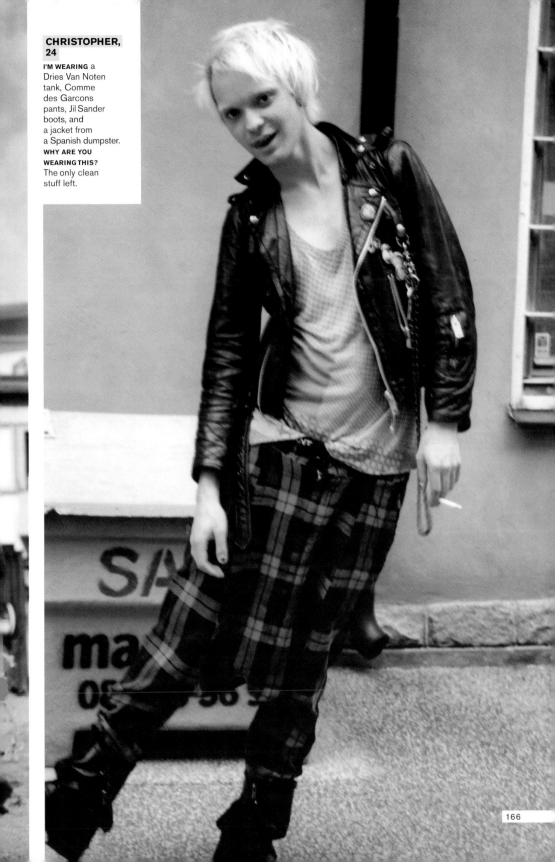

CHRISTOPHER, 24

I'M WEARING a Dries Van Noten tank, Comme des Garcons pants, Jil Sander boots, and a jacket from a Spanish dumpster. **WHY ARE YOU WEARING THIS?** The only clean stuff left.

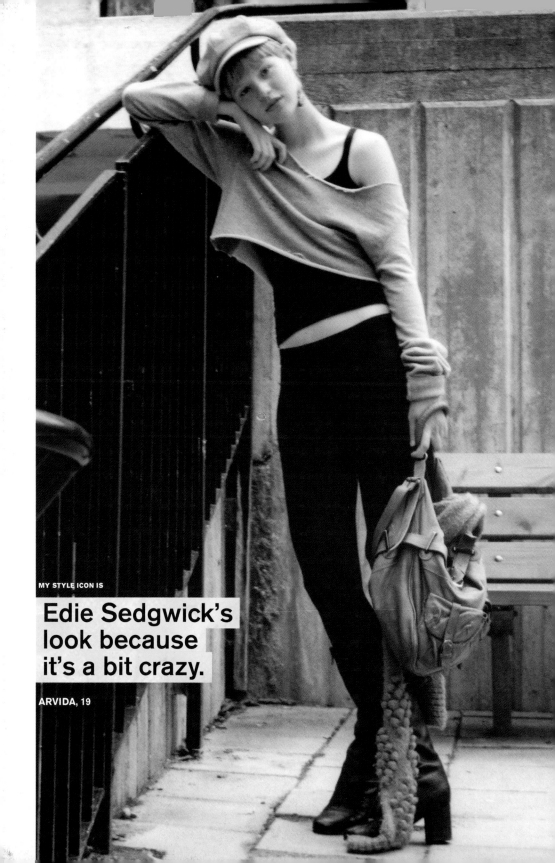

MY STYLE ICON IS

Edie Sedgwick's look because it's a bit crazy.

ARVIDA, 19

OSCAR, 20

I'M WEARING
a vintage jacket
and Cheap
Monday jeans.
MY STYLE
IN FIVE WORDS
OR LESS: Delicious,
dandylicious,
ashtray.
MY CITY IN THREE
WORDS: Snow,
stones, trees.

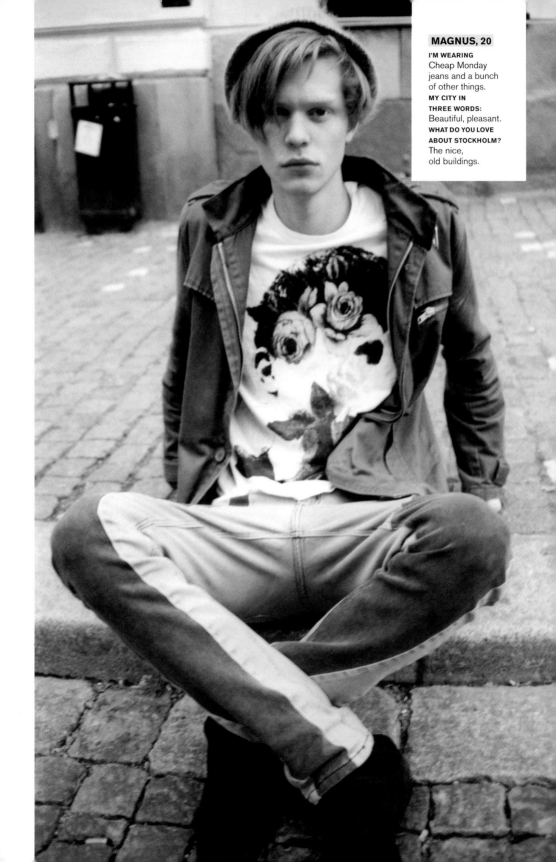

MAGNUS, 20
I'M WEARING
Cheap Monday
jeans and a bunch
of other things.
MY CITY IN
THREE WORDS:
Beautiful, pleasant.
WHAT DO YOU LOVE
ABOUT STOCKHOLM?
The nice,
old buildings.

CORA, 26
MY STYLE ICON IS
Kate Moss.

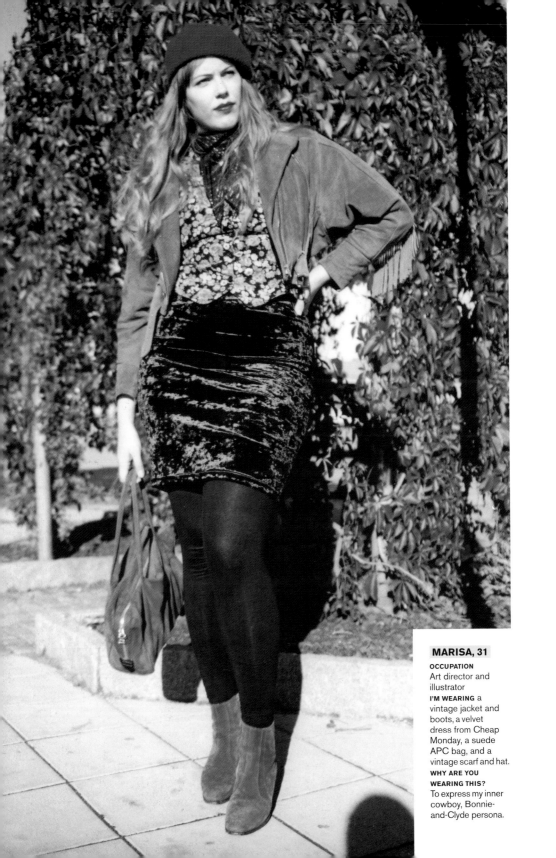

MARISA, 31

OCCUPATION
Art director and
illustrator
I'M WEARING a
vintage jacket and
boots, a velvet
dress from Cheap
Monday, a suede
APC bag, and a
vintage scarf and hat.
**WHY ARE YOU
WEARING THIS?**
To express my inner
cowboy, Bonnie-
and-Clyde persona.

FILLIPA, 27

MARIA, 18

OCCUPATION Student
I'M WEARING blue
jeans, a blouse, and
high heels.
**MY CITY IN THREE
WORDS:** Nice, homey,
and beautiful.
**MY STYLE ICON
IS** Kate Moss. I love
her. She is so cool.

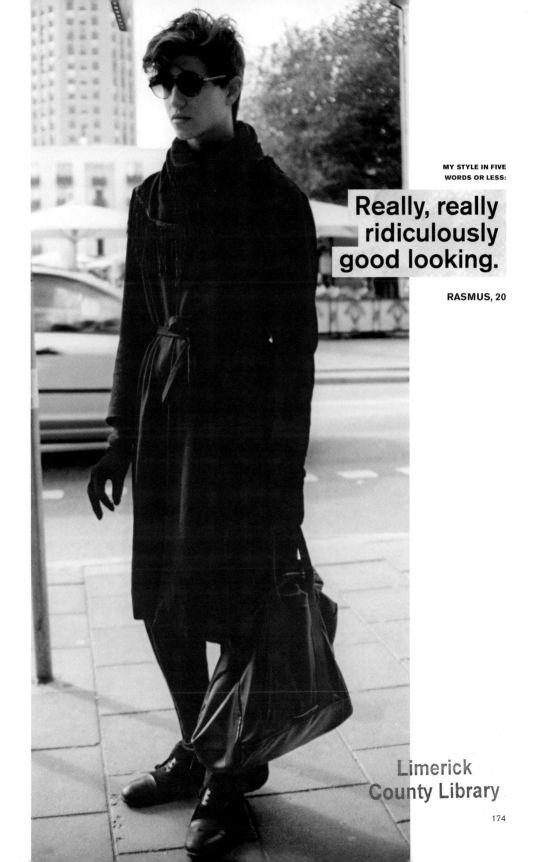

Really, really ridiculously good looking.

RASMUS, 20

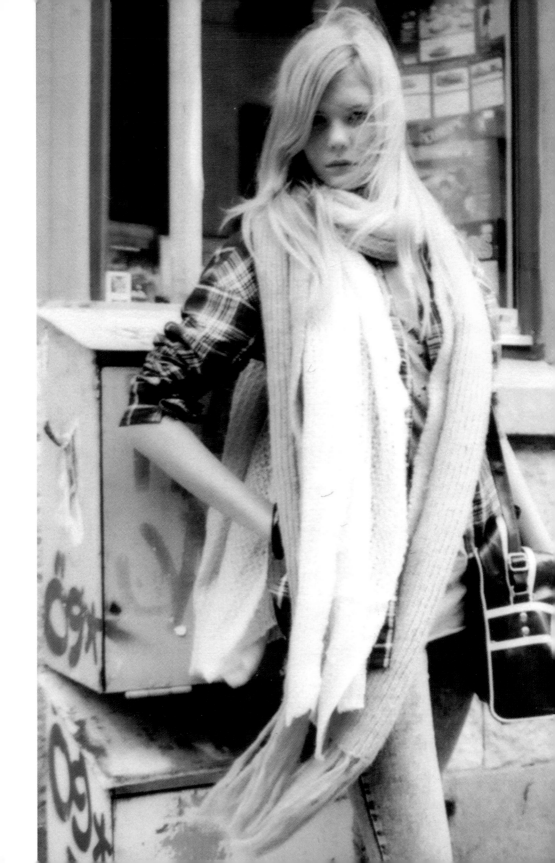

JOSEFINA

OCCUPATION
Student/model
I'M WEARING
Gina Tricot.
**MY CITY IN
THREE WORDS:**
Nice, big, cold.

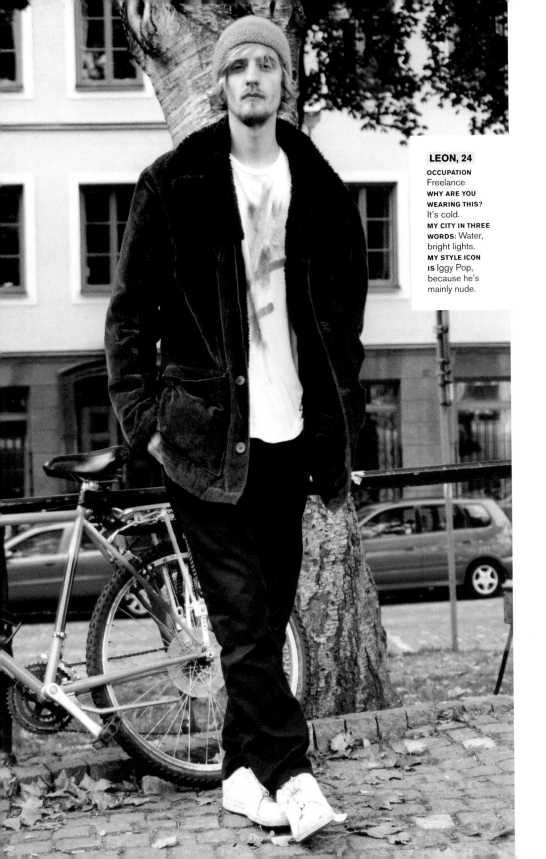

LEON, 24
OCCUPATION
Freelance
WHY ARE YOU
WEARING THIS?
It's cold.
MY CITY IN THREE
WORDS: Water,
bright lights.
MY STYLE ICON
IS Iggy Pop,
because he's
mainly nude.

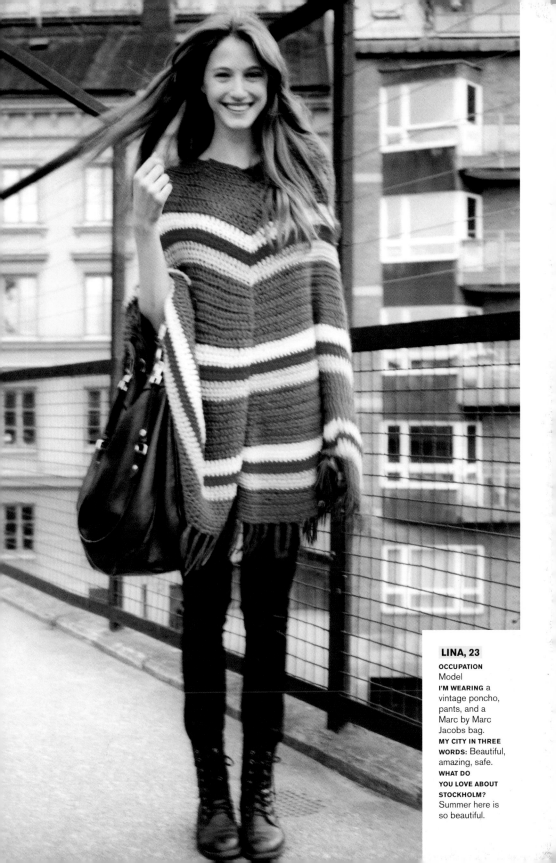

LINA, 23

OCCUPATION
Model
I'M WEARING a
vintage poncho,
pants, and a
Marc by Marc
Jacobs bag.
**MY CITY IN THREE
WORDS:** Beautiful,
amazing, safe.
**WHAT DO
YOU LOVE ABOUT
STOCKHOLM?**
Summer here is
so beautiful.

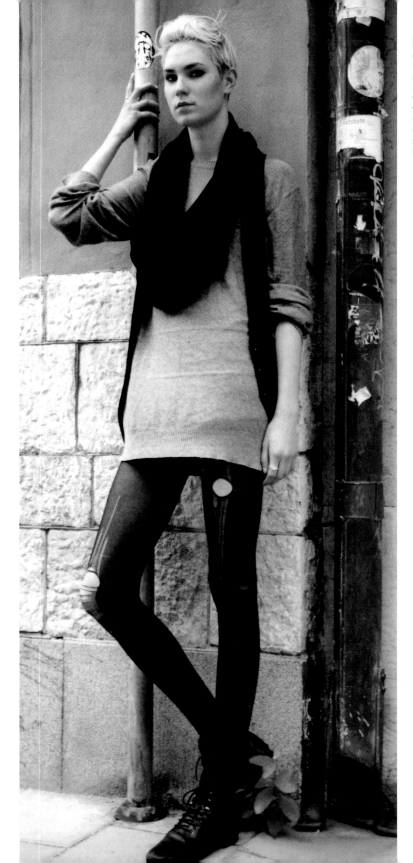

MARIE, 20

OCCUPATION
Photographer
I'M WEARING H&M
and Sixtyseven.
WHAT ARE YOU
WEARING THIS?
Casual.
MY STYLE IN
FIVE WORDS OR
LESS: Androgyne.

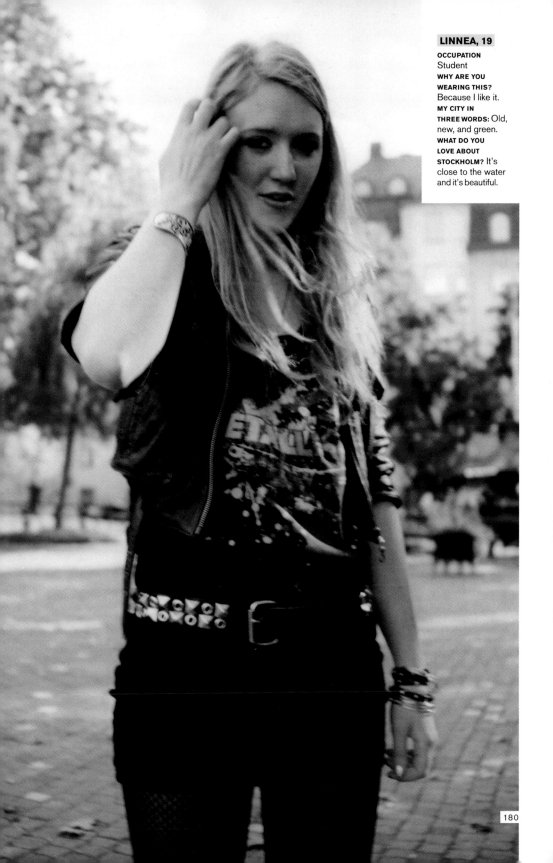

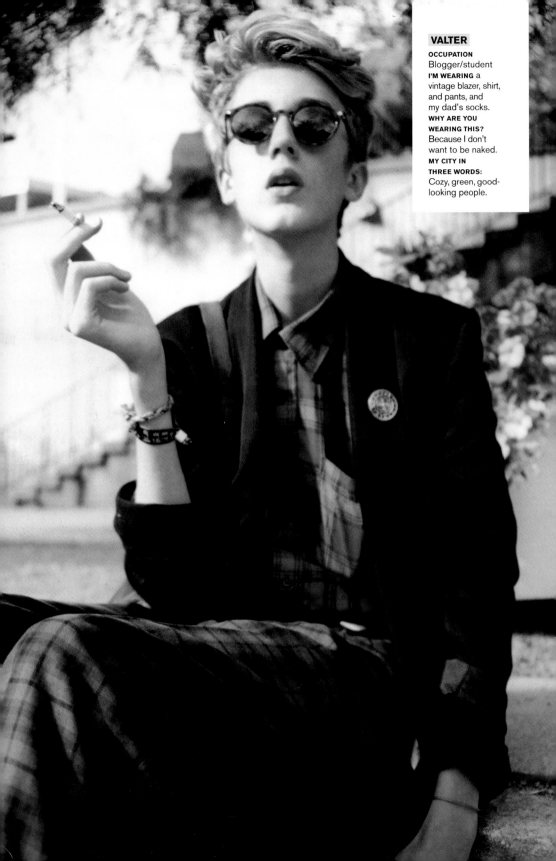

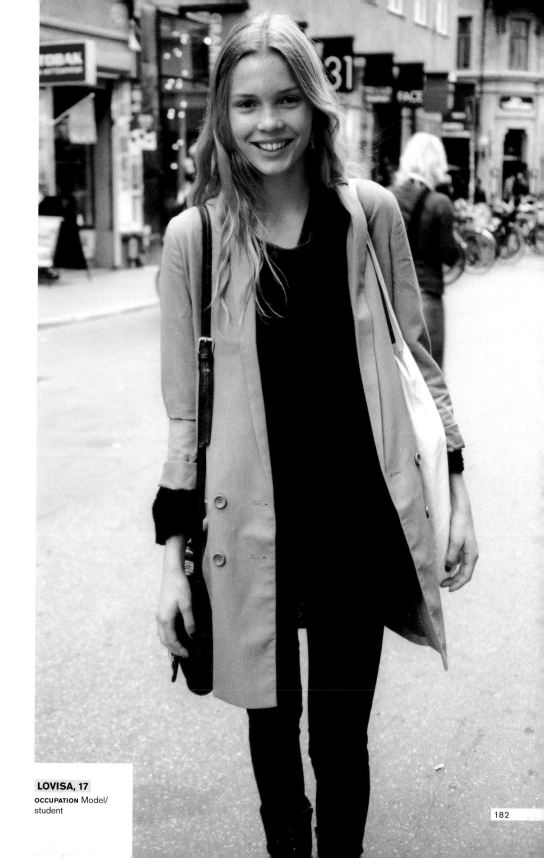

LOVISA, 17

OCCUPATION Model/
student

TOK

NYLON loves Tokyo: There's a reason it's home to our biggest foreign edition, *NYLON Japan*, brilliantly curated by its own homegrown editorial staff. Tokyo may not be a traditional fashion capital like Paris or Milan, but how could it be? It's Tokyo. It would never put up a fight for third place on September's short list of fashion weeks, muscling in somewhere between New York and London. It's Tokyo: It could hardly limit itself to a single week of sartorial extravagance. Tokyo is made of fashion, to the point where the two elements are so intertwined that they have become indistinguishable.

Paris may have its doyennes and its other attendant disciples of fashion, but they are exactly that: fashionable creatures living in a museum city. That is not quite the deal with Tokyo. Its sidewalks are not the runways—the blank backdrops—they can occasionally be elsewhere; consider them, and those who make their way atop them —to school, to work, to Harajuku or Shibuya or Roppongi— as part of an ever-evolving art installation. Concept-minded designers like Yohji Yamamoto, Junya Watanabe, and Issey Miyake make sense here as they wouldn't anywhere else.

As difficult as the tribes can be for a *gaijin* to parse, they've roamed these streets for ages, each with their own rules and ideologies: the Gothic Lolitas and their temperamental opposites, the *kogals*; the bleach-blond *ganguro* and the inevitable Harajuku girls. Of course, seconds after the stereotype look is finally decoded, it shifts into something else, recombining its genetic code among and between the others so that the look of the moment—to the extent that one can be defined—is ever shifting, though no less striking for

MADEMOISELLE YULIA, 23

OCCUPATION DJ/ Giza designer/singer
I'M WEARING a jacket, T-shirt, and Giza bag.
WHY ARE YOU WEARING THIS? Love the color.
WHAT DO YOU LOVE ABOUT TOKYO? I can get whatever in an instant.

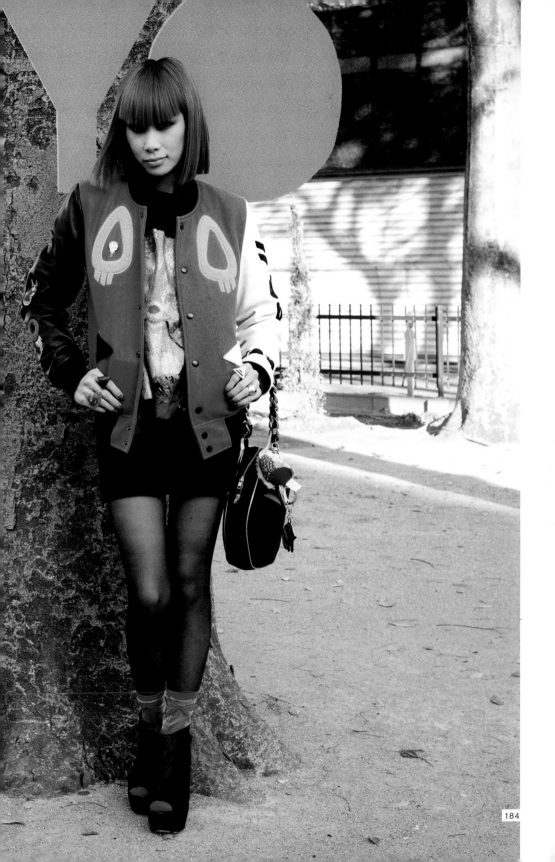

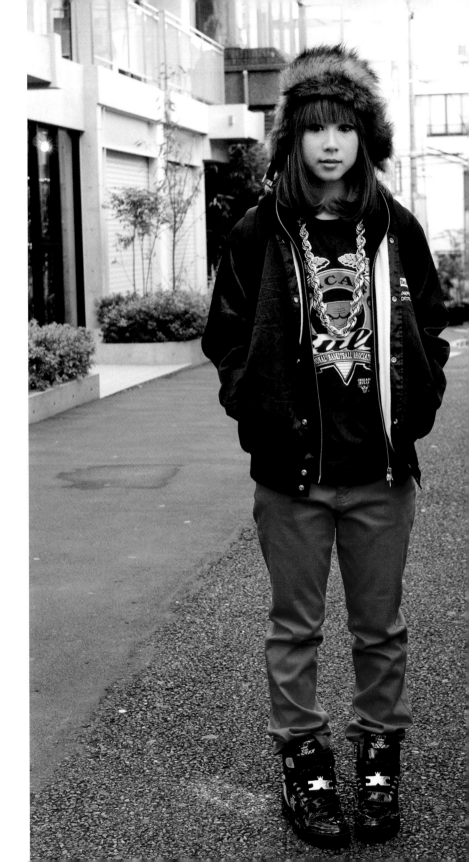

being constantly in flux. Japanese street fashion is such a force that it's perhaps the only one so unique, so indelible, that it's actually visible in other cities. Walk through the right sort of neighborhood in London, Paris, or New York, and you might see a pack of young Japanese travelers—they look like no one else does, which we suppose is entirely the point.

There's a reason Japan is called the land of the rising sun, and there's more to the nomenclature than the fact that everyone there is using cell phones most of us won't see in shops for another two years. It's Tomorrowland made real, and not least in the sense that it has become a sort of otherworldly birthing place for trends about to make their way around the world—or not, like those infamous trompe l'oeil T-shirts displaying the illustrated image of a naked backside, a sartorial tweak on an often conservative culture that only seems to make sense in Japan. When we visit Tokyo—on absolute sensory overload, stumbling with jet lag, thinking incessantly of Scarlett Johansson in *Lost in Translation*—we can't help but be seduced by the madness of it all. It convinces us that up is down, that an overnight, eight-hour wait for a $100 limited-edition Bape T-shirt is a reasonable way to spend an evening, and all the better for being cheaper than a hotel.

Speaking of: We love every issue of *NYLON* equally —but we have a special place in our hearts for our *NYLON Guys* cover story on Bape's general-in-chief Nigo, in which he showed us around his ridiculous, over-the-top, unbelievable home, filled to bursting with artwork (by KAWS), hip-hop paraphernalia, and dolls (like a Colonel Sanders figurine). He is Tokyo to us: a brilliant, unstoppable force of creativity. We can't do much but sit back and see what he conjures up. And so it is with Tokyo street fashion, the world's best source for what's new, and what's next.

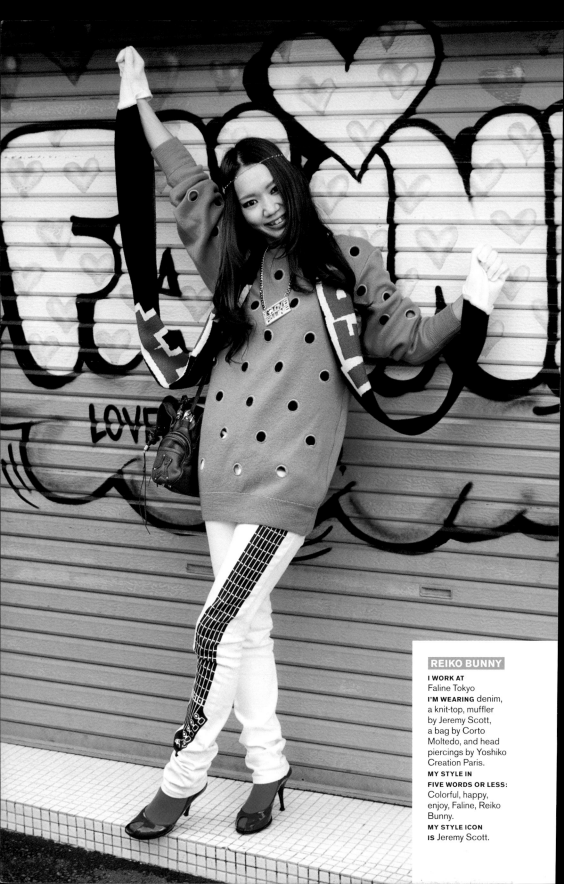

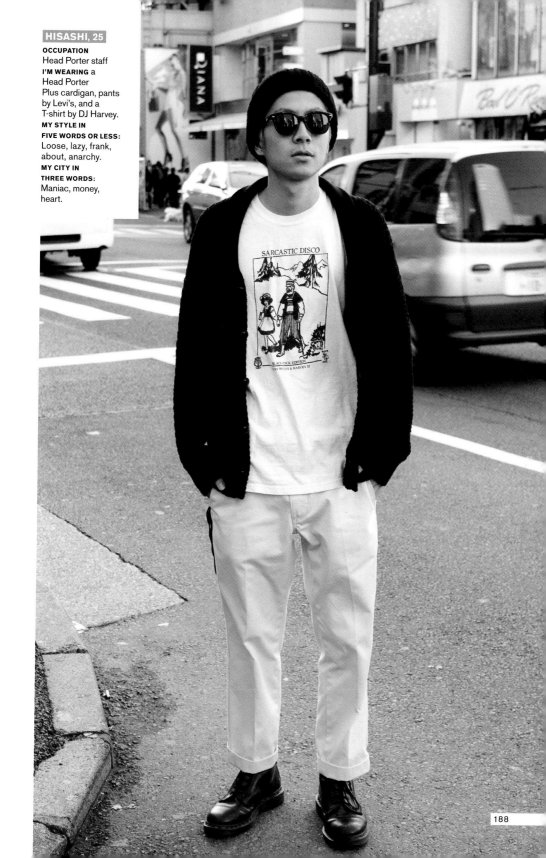

HISASHI, 25

OCCUPATION
Head Porter staff
I'M WEARING a
Head Porter
Plus cardigan, pants
by Levi's, and a
T-shirt by DJ Harvey.
MY STYLE IN
FIVE WORDS OR LESS:
Loose, lazy, frank,
about, anarchy.
MY CITY IN
THREE WORDS:
Maniac, money,
heart.

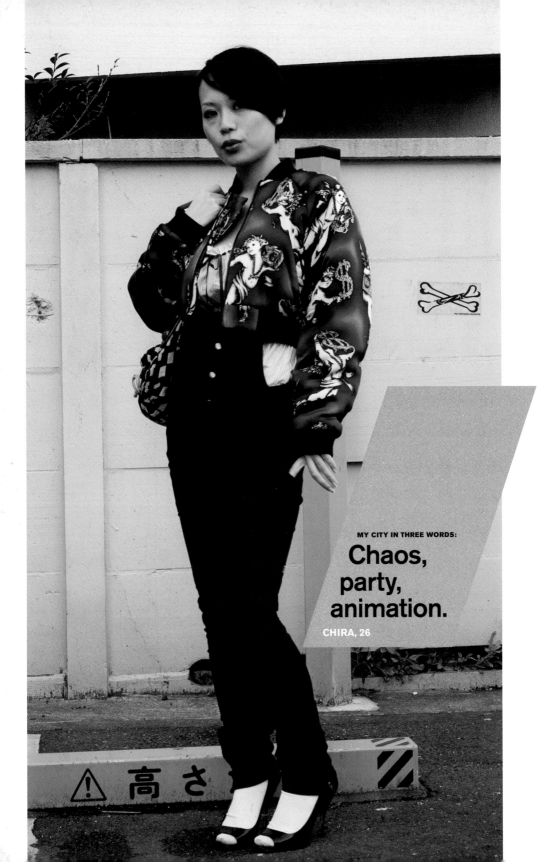

MY CITY IN THREE WORDS:

Chaos,
party,
animation.

CHIRA, 26

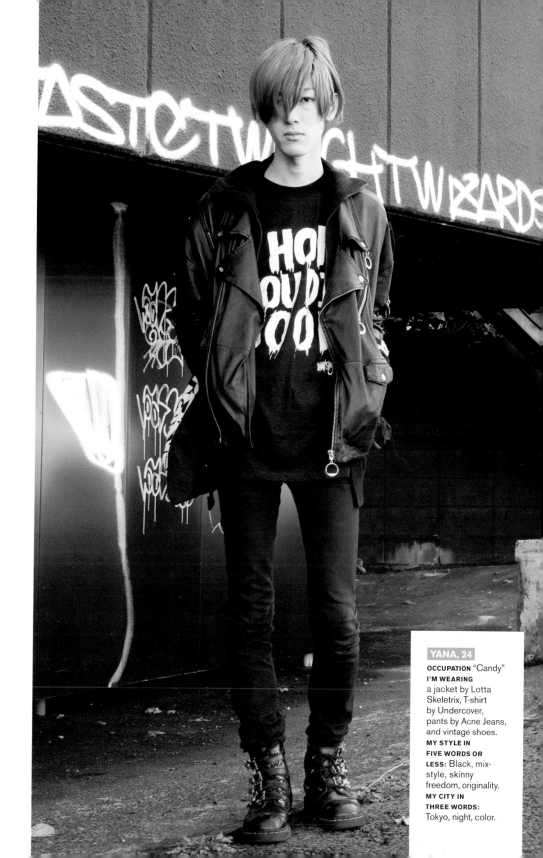

YANA, 24

OCCUPATION "Candy"
I'M WEARING
a jacket by Lotta
Skeletrix, T-shirt
by Undercover,
pants by Acne Jeans,
and vintage shoes.
**MY STYLE IN
FIVE WORDS OR
LESS:** Black, mix-
style, skinny
freedom, originality.
**MY CITY IN
THREE WORDS:**
Tokyo, night, color.

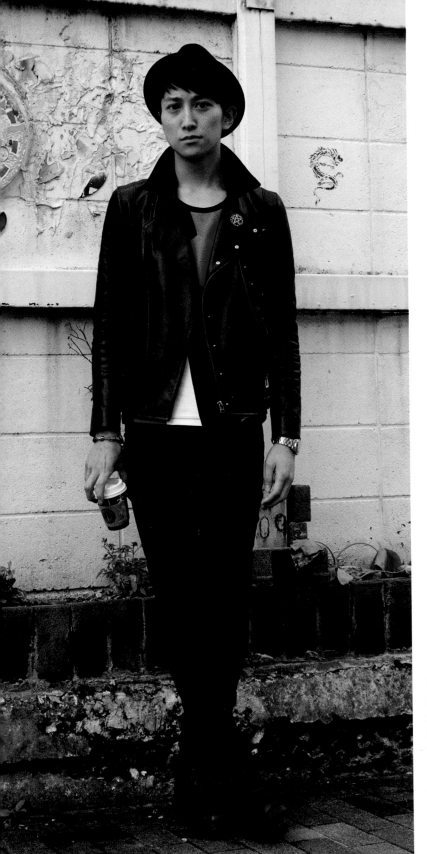

2BOY, 28

OCCUPATION
"MilkBoy"/DJ
I'M WEARING MilkBoy
and Yoshio Kubo.
WHY ARE YOU
WEARING THIS?
On the way home
from the studio.
MY STYLE IN FIVE
WORDS OR LESS:
Black, rock,
DJ, insomnia, one.

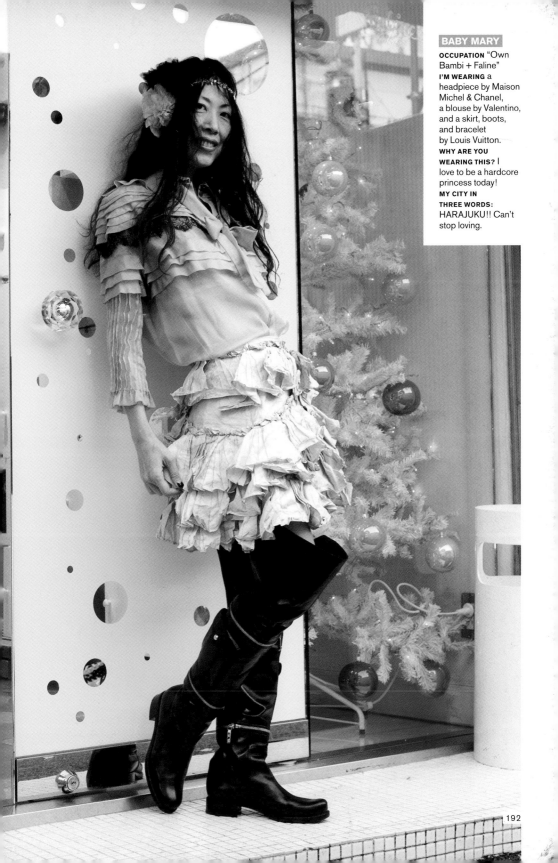

BABY MARY

OCCUPATION "Own Bambi + Faline"
I'M WEARING a headpiece by Maison Michel & Chanel, a blouse by Valentino, and a skirt, boots, and bracelet by Louis Vuitton.
WHY ARE YOU WEARING THIS? I love to be a hardcore princess today!
MY CITY IN THREE WORDS: HARAJUKU!! Can't stop loving.

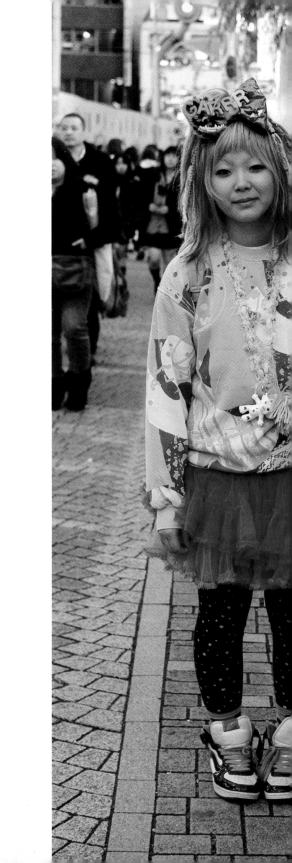

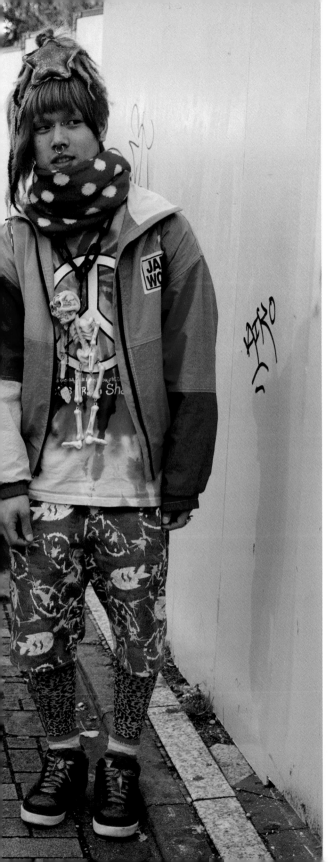

JUN

OCCUPATION
Shop staff
I'M WEARING all used.
**WHY ARE YOU
WEARING THIS?**
'Cos it's loud.
**MY CITY IN
THREE WORDS:**
Love, play, fun.

CHIKAKO

OCCUPATION
"Servicing"
I'M WEARING all
vintage.
**WHY ARE YOU
WEARING THIS?**
'Cause it's so loud.
**MY STYLE IN
FIVE WORDS
OR LESS:** Loudly
'80s, yarn,
pink, neon.

194

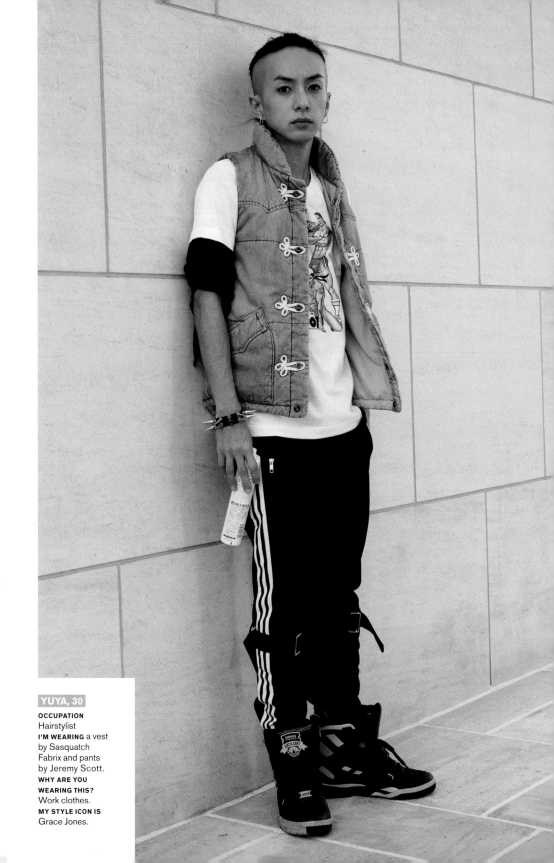

YUYA, 30

OCCUPATION
Hairstylist
I'M WEARING a vest
by Sasquatch
Fabrix and pants
by Jeremy Scott.
**WHY ARE YOU
WEARING THIS?**
Work clothes.
MY STYLE ICON IS
Grace Jones.

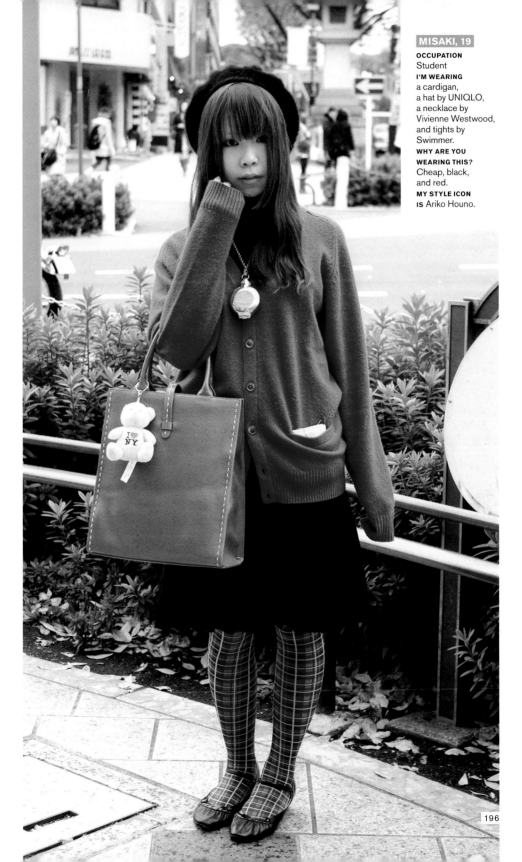

OCCUPATION
Student
I'M WEARING
a cardigan,
a hat by UNIQLO,
a necklace by
Vivienne Westwood,
and tights by
Swimmer.
**WHY ARE YOU
WEARING THIS?**
Cheap, black,
and red.
**MY STYLE ICON
IS** Ariko Houno.

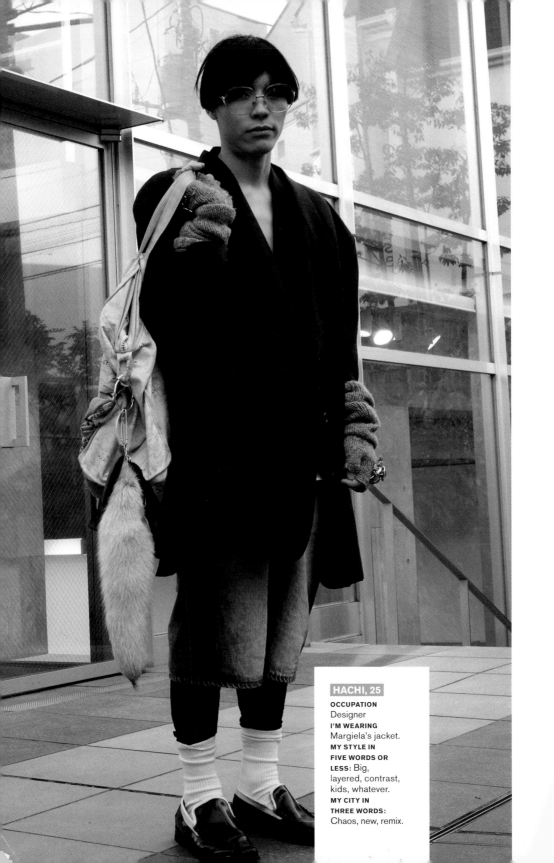

HACHI, 25
OCCUPATION
Designer
I'M WEARING
Margiela's jacket.
MY STYLE IN
FIVE WORDS OR
LESS: Big,
layered, contrast,
kids, whatever.
MY CITY IN
THREE WORDS:
Chaos, new, remix.

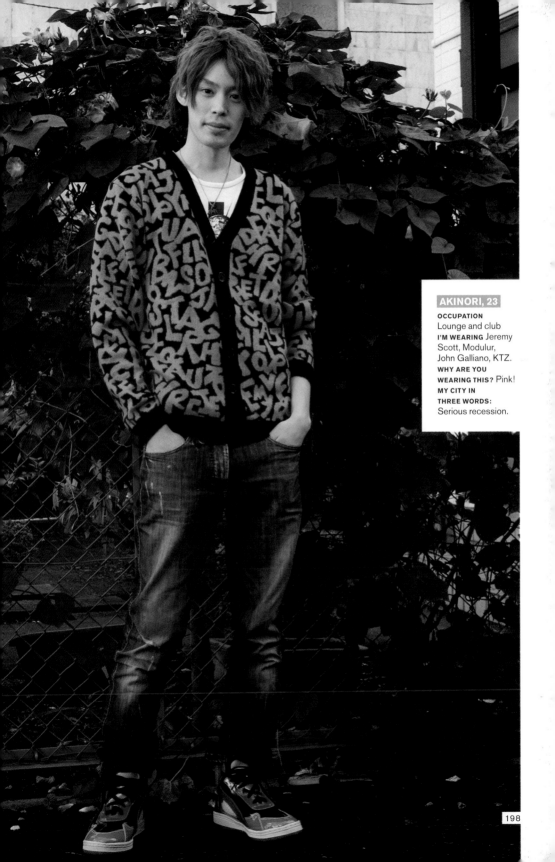

AKINORI, 23

OCCUPATION
Lounge and club
I'M WEARING Jeremy
Scott, Modulur,
John Galliano, KTZ.
WHY ARE YOU
WEARING THIS? Pink!
MY CITY IN
THREE WORDS:
Serious recession.

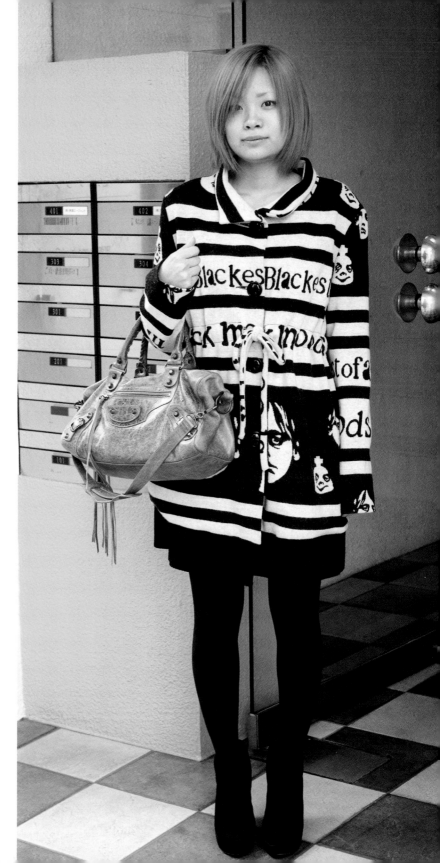

HARUKA, 23

OCCUPATION
Shop staff
I'M WEARING
a cardigan by
Devaste, boots by
Pour la Victoire,
and a bag
by Balenciaga.
WHY ARE YOU
WEARING THIS? It's
so unique.
MY STYLE IN FIVE
WORDS OR LESS:
Black, simple,
warm, relax, leather.

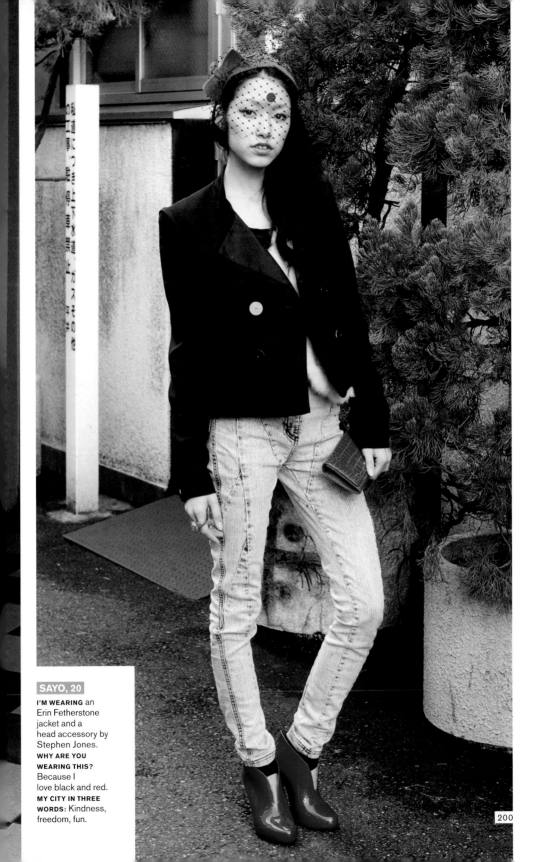

SAYO, 20
I'M WEARING an
Erin Fetherstone
jacket and a
head accessory by
Stephen Jones.
**WHY ARE YOU
WEARING THIS?**
Because I
love black and red.
**MY CITY IN THREE
WORDS:** Kindness,
freedom, fun.

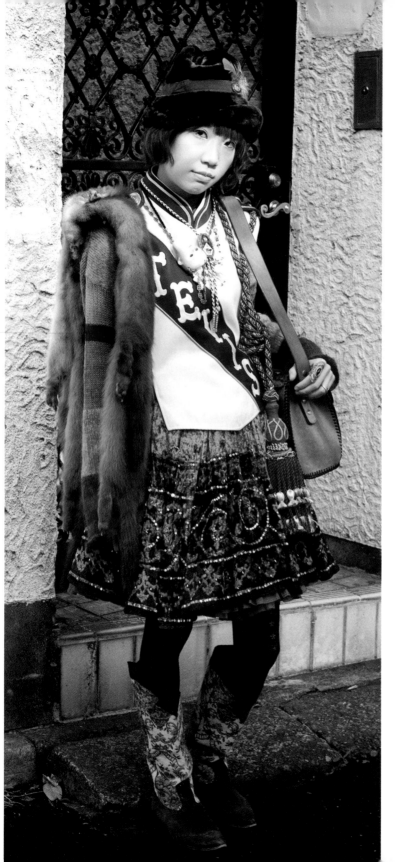

AYAKA

OCCUPATION
Student
I'M WEARING
Grinoire's vintage.
**WHY ARE YOU
WEARING THIS?**
Worthless
marching band.
**MY STYLE
ICON IS** someone
in a fairy tale.

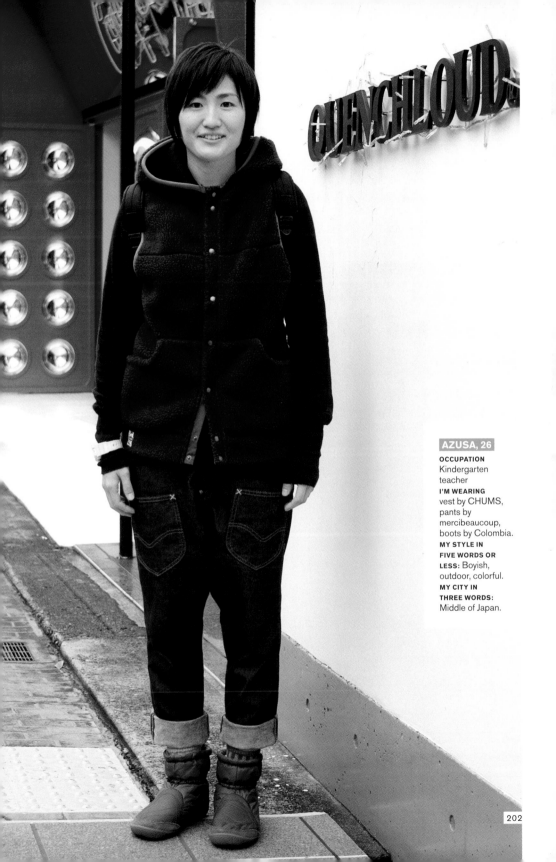

AZUSA, 26

OCCUPATION
Kindergarten
teacher
I'M WEARING
vest by CHUMS,
pants by
mercibeaucoup,
boots by Colombia.
MY STYLE IN
FIVE WORDS OR
LESS: Boyish,
outdoor, colorful.
MY CITY IN
THREE WORDS:
Middle of Japan.

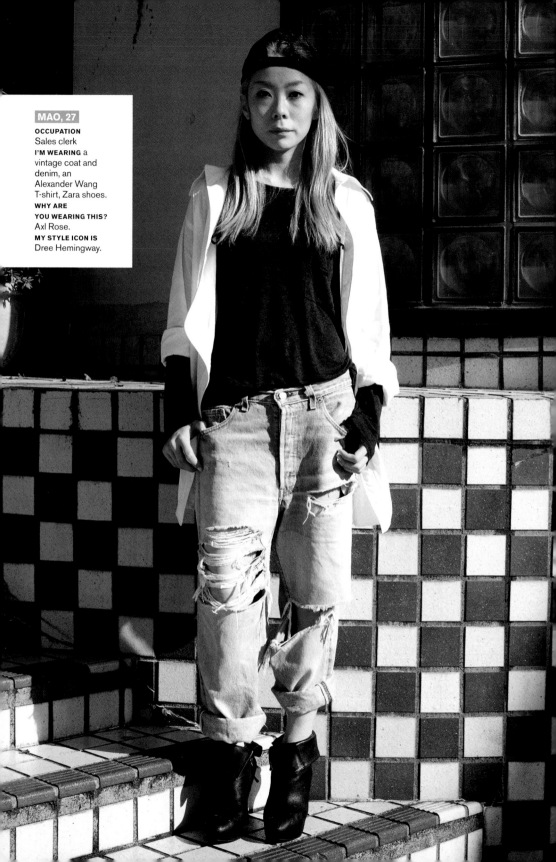

MAO, 27

OCCUPATION
Sales clerk
I'M WEARING a
vintage coat and
denim, an
Alexander Wang
T-shirt, Zara shoes.
**WHY ARE
YOU WEARING THIS?**
Axl Rose.
MY STYLE ICON IS
Dree Hemingway.

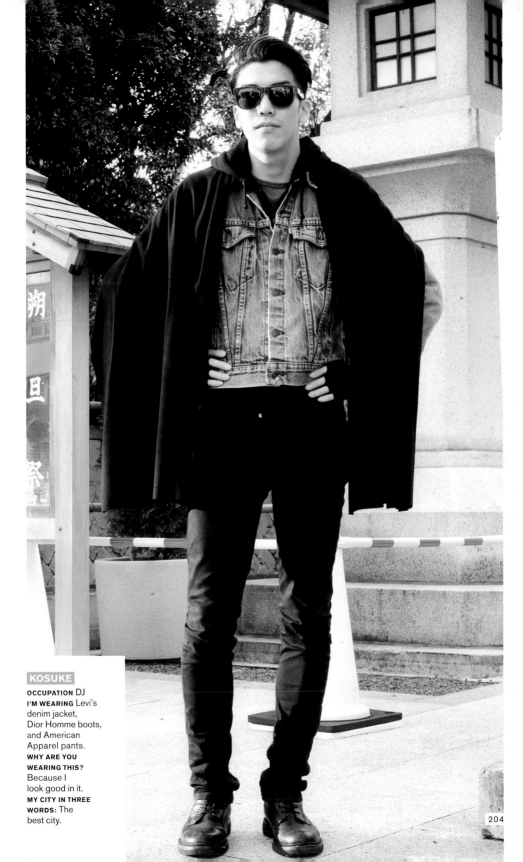

KOSUKE

OCCUPATION DJ
I'M WEARING Levi's
denim jacket,
Dior Homme boots,
and American
Apparel pants.
**WHY ARE YOU
WEARING THIS?**
Because I
look good in it.
**MY CITY IN THREE
WORDS:** The
best city.

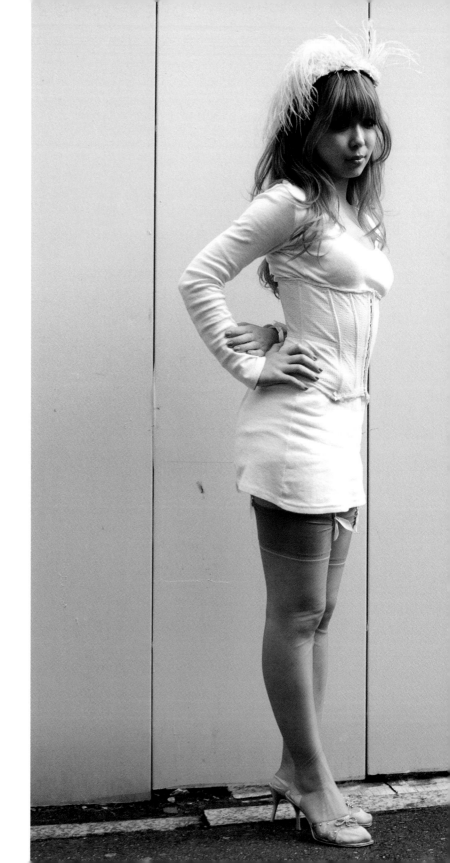

WHY ARE YOU WEARING THIS?

Simple.

SACHIKO

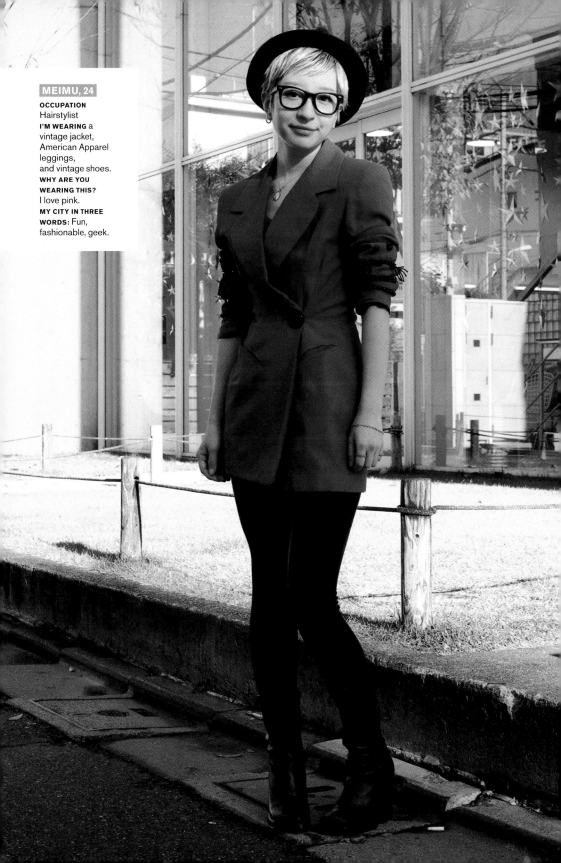

MEIMU, 24

OCCUPATION
Hairstylist
I'M WEARING a
vintage jacket,
American Apparel
leggings,
and vintage shoes.
WHY ARE YOU
WEARING THIS?
I love pink.
MY CITY IN THREE
WORDS: Fun,
fashionable, geek.

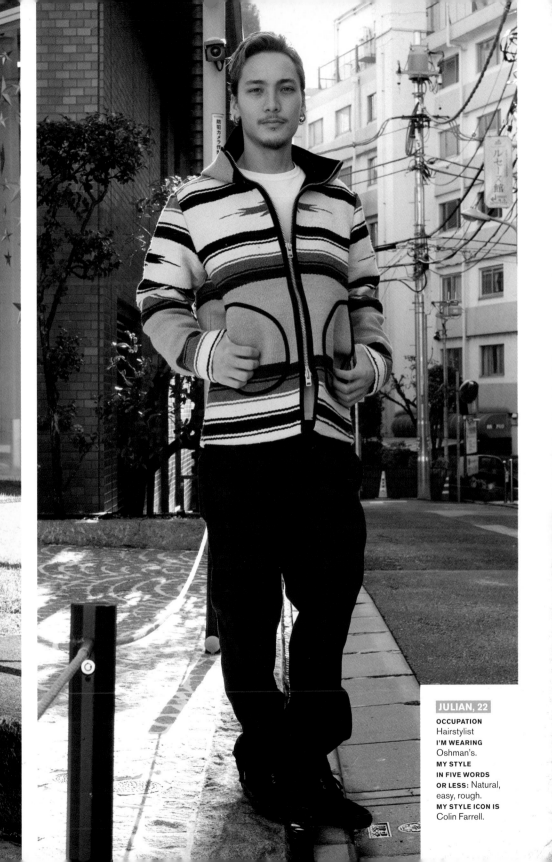

JULIAN, 22

OCCUPATION
Hairstylist
I'M WEARING
Oshman's.
**MY STYLE
IN FIVE WORDS
OR LESS:** Natural,
easy, rough.
MY STYLE ICON IS
Colin Farrell.

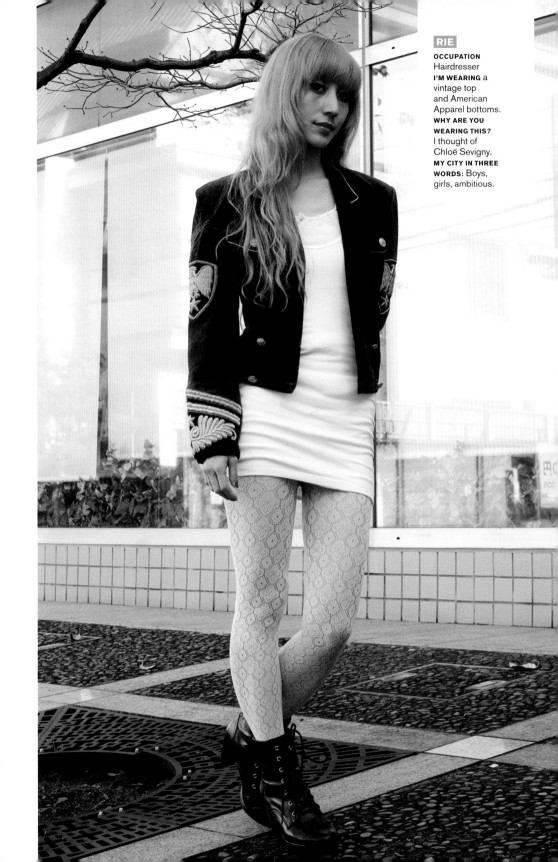

RIE

OCCUPATION
Hairdresser
I'M WEARING a
vintage top
and American
Apparel bottoms.
**WHY ARE YOU
WEARING THIS?**
I thought of
Chloë Sevigny.
**MY CITY IN THREE
WORDS:** Boys,
girls, ambitious.

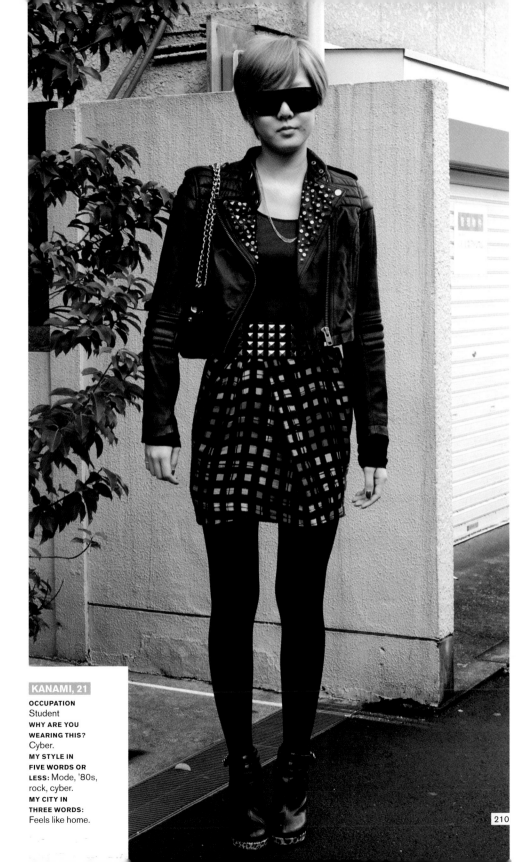

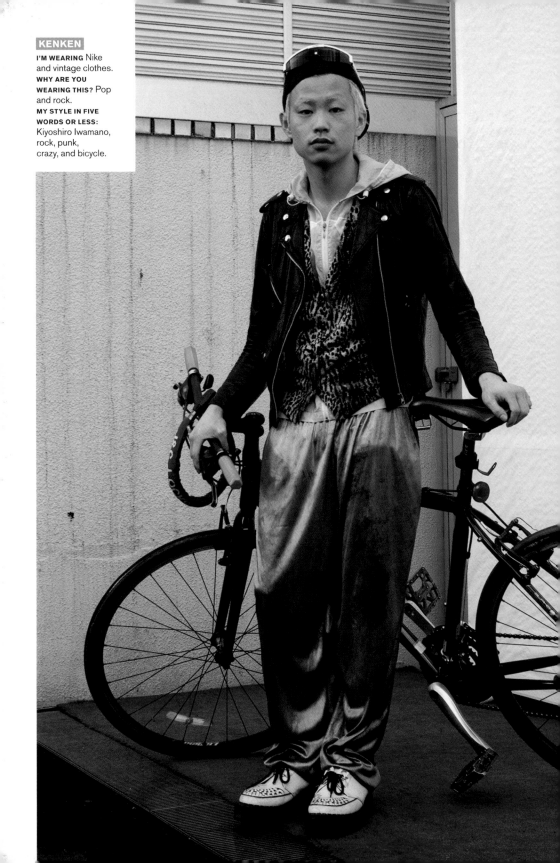

KENKEN

I'M WEARING Nike
and vintage clothes.
**WHY ARE YOU
WEARING THIS?** Pop
and rock.
**MY STYLE IN FIVE
WORDS OR LESS:**
Kiyoshiro Iwamano,
rock, punk,
crazy, and bicycle.

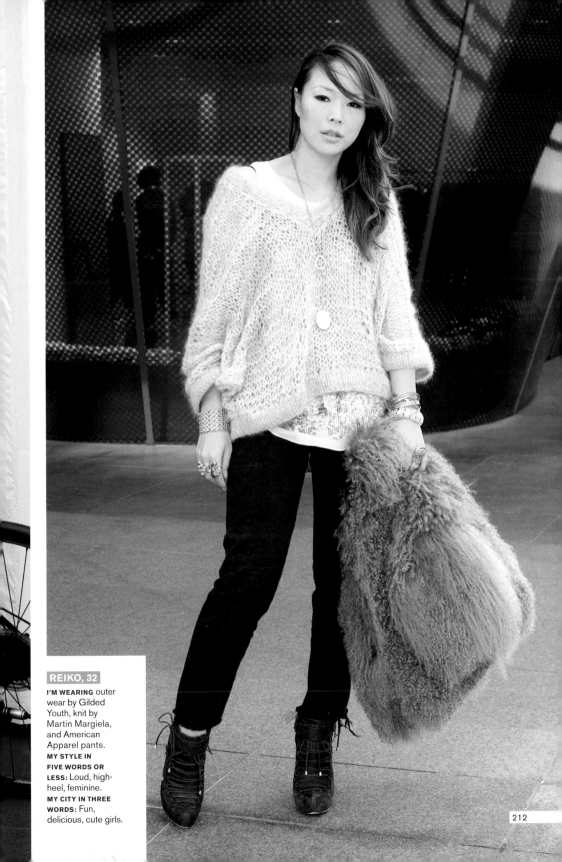

REIKO, 32

I'M WEARING outer wear by Gilded Youth, knit by Martin Margiela, and American Apparel pants.
MY STYLE IN FIVE WORDS OR LESS: Loud, high-heel, feminine.
MY CITY IN THREE WORDS: Fun, delicious, cute girls.

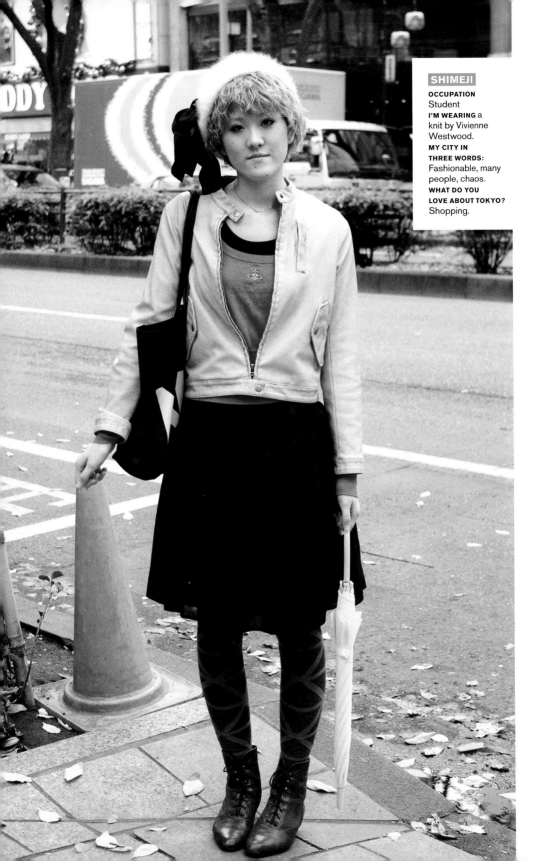

SHIMEJI

OCCUPATION
Student
I'M WEARING a
knit by Vivienne
Westwood.
**MY CITY IN
THREE WORDS:**
Fashionable, many
people, chaos.
**WHAT DO YOU
LOVE ABOUT TOKYO?**
Shopping.

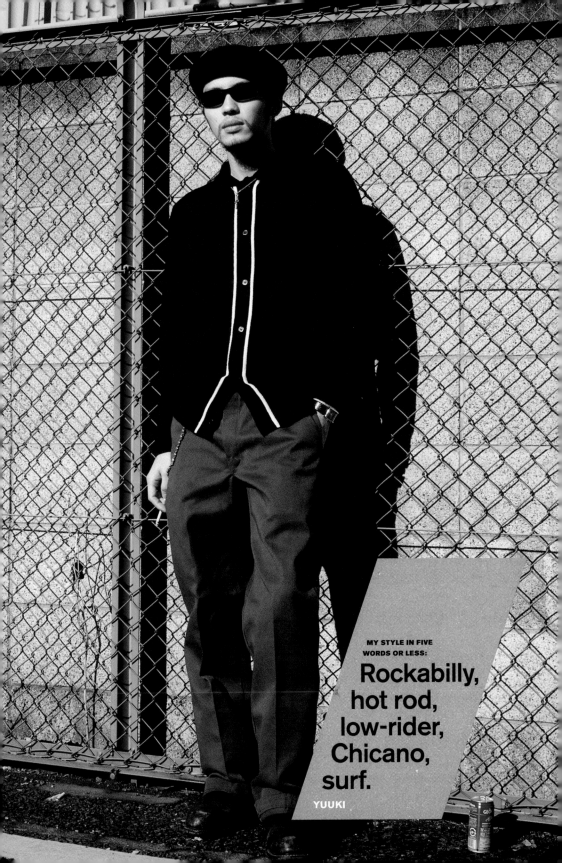

MY STYLE IN FIVE
WORDS OR LESS:
**Rockabilly,
hot rod,
low-rider,
Chicano,
surf.**
YUUKI

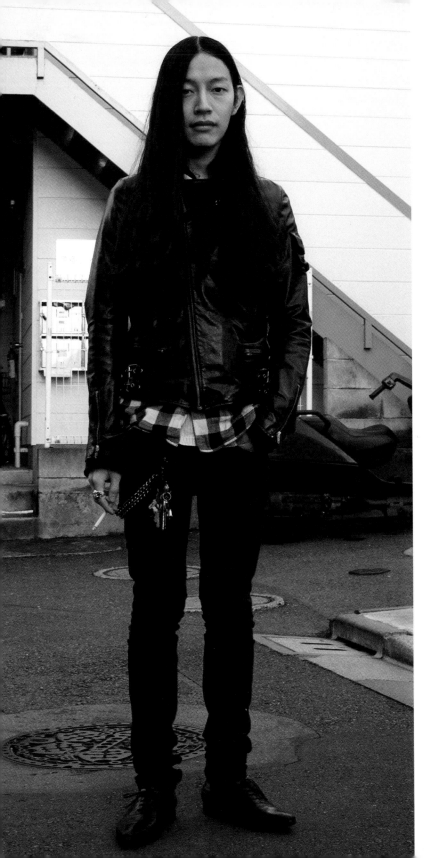

YUSUKE, 24
I'M WEARING Raf
Simons' jacket.
WHY ARE YOU
WEARING THIS?
I'm always wearing it.
WHAT DO YOU
LOVE ABOUT TOKYO?
I can do anything.

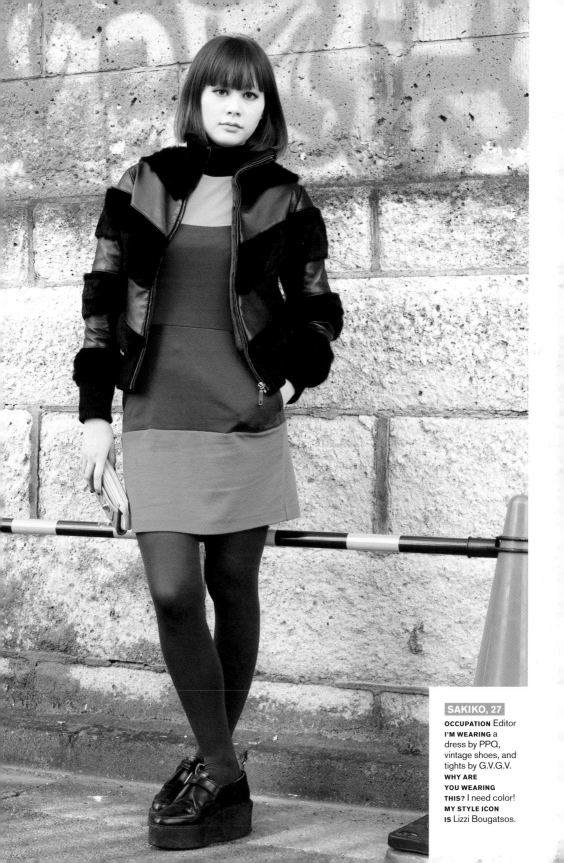

Something unexpected happened while Hollywood
trained its eye on the search for the next big blockbuster:
Los Angeles became a genuine center of emerging
art and design. As mainstream American filmmaking has
become increasingly anodyne, Los Angeles has, almost
inversely, come alive, even somehow seducing *Project
Runway* into trading Seventh Avenue for downtown L.A.,
and the Parsons workrooms for those at the Fashion
Institute of Design and Merchandising. (Santino Rice
and Nick Verreos—and will.i.am—are among the school's
alumni.) In the past, this neighborhood might easily have
been identified as the one L.A.'s residents were most
likely to avoid. It is now famous, world over, as the home
of design icons both high and low, of American Apparel's

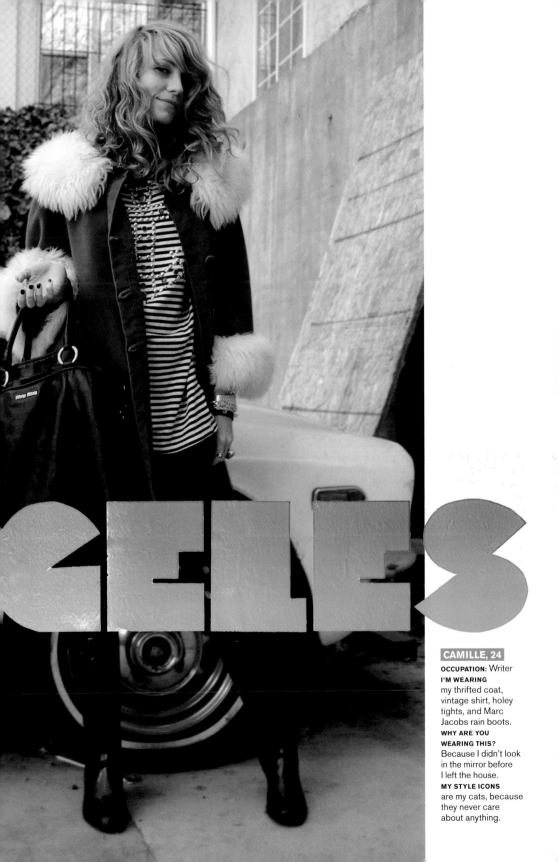

CELES

CAMILLE, 24

OCCUPATION: Writer
I'M WEARING
my thrifted coat,
vintage shirt, holey
tights, and Marc
Jacobs rain boots.
**WHY ARE YOU
WEARING THIS?**
Because I didn't look
in the mirror before
I left the house.
MY STYLE ICONS
are my cats, because
they never care
about anything.

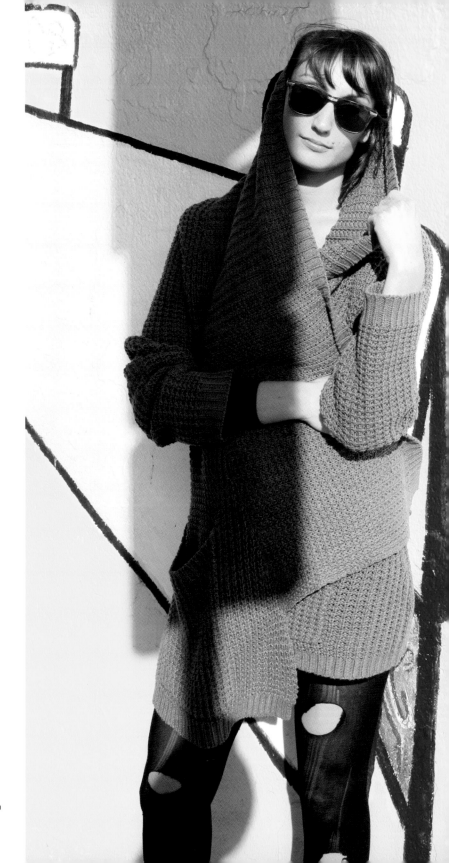

LARISSA

MY STYLE IN FIVE WORDS OR LESS: It changes with my mood.
WHAT DO YOU LOVE ABOUT L.A.? The Mexican food, the great hikes, and the weather.
WHO IS YOUR STYLE ICON AND WHY? Diane Keaton in the '70s.

sweatshop-free manufacturing plant and the Walt Disney Concert Hall, a Frank Gehry masterwork that rivals his Guggenheim in Bilbao.

In other words, L.A.'s not just about the movies anymore. Not far from downtown is the Los Angeles County Art Museum, the Museum of Contemporary Art, the Getty Center, and in Malibu, the Getty Villa, perhaps the most beautiful museum in the United States. The city has its very own outpost of Mood Designer Fabrics, on Pico Boulevard, along with a smattering of other fabric stores clustered around 9th Street and Maple. Then there are the reasons why for generations young, creative people have heeded this country's sense of Manifest Destiny and headed west: low rents, good weather, nice people, even if the transported New Yorkers grumble about how contentment makes an artist soft. As they grumble, they are quite possibly outside, perhaps at a barbecue, while it is overcast and dreary in what they might still think of as home.

Though still a car-loving culture for the foreseeable future, L.A. now boasts busier, buzzier sidewalks, especially in neighborhoods like Venice, long one of the city's most walkable districts, and Los Feliz and Eagle Rock—but they're still blessedly free of the human swarm found on the streets of more densely populated metropolises, like Tokyo or London. Here there is always space for a moment to appreciate, or to judge. There are other key distinctions: Unlike New York or Stockholm, L.A. doesn't spend four months of the year trapped inside a North Face parka. This is the land of jean skirts from hometown labels like J Brand and Current/Elliott— maybe picked up at Kitson or Fred Segal, or at one of the city's edgier boutiques: Satine in Mid-City West or the city's own version of NoLIta's Opening Ceremony.

What all of this means is that appearances count. The artists and designers have done well to bring some scruff into the city, and certainly there is a shared culture of sartorial slack, an ongoing reveling in the freedom of choice—even if that choice is for a twenty-five-year-old screenwriter guy to drive to work in his one pair of Levi's for weeks on end. This is still L.A., and the standards for women remain somewhat stricter: The right clothes matter, the right shoes, the right make-up—and perhaps most of all, the right attitude, a West Coast twist on that most Parisian of expressions, a certain *je ne sais quoi*. Here, that ineffable effect may be more offhand insouciance than that willful French chic—but with three hundred days of sunshine every year, who's going to argue over such a distinction as that?

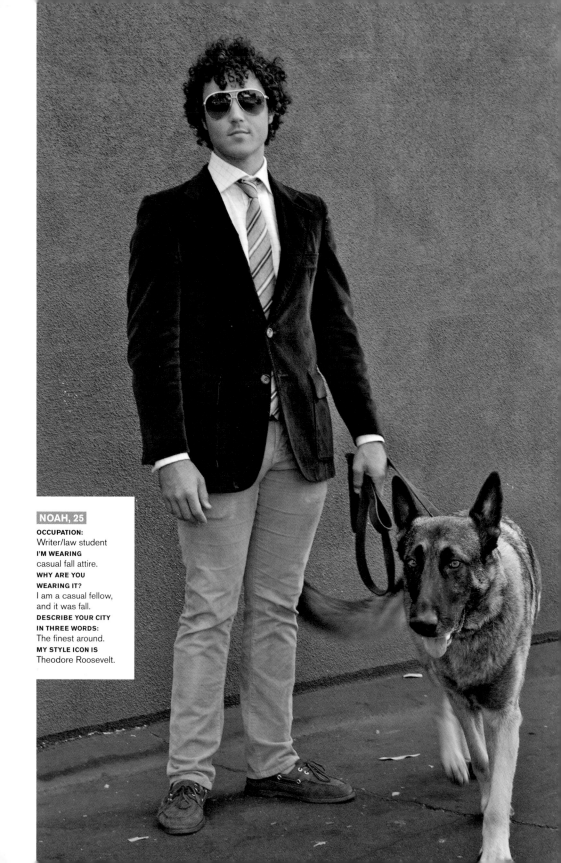

NOAH, 25

OCCUPATION:
Writer/law student
I'M WEARING
casual fall attire.
**WHY ARE YOU
WEARING IT?**
I am a casual fellow,
and it was fall.
**DESCRIBE YOUR CITY
IN THREE WORDS:**
The finest around.
MY STYLE ICON IS
Theodore Roosevelt.

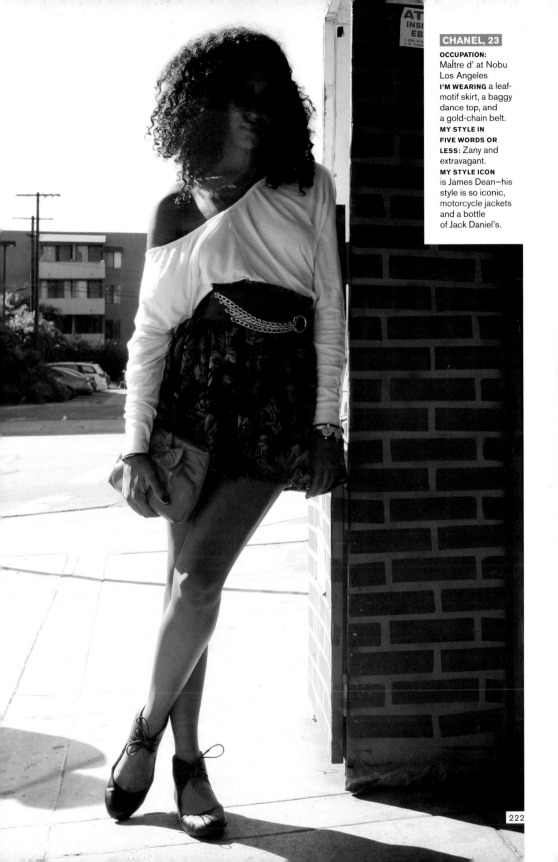

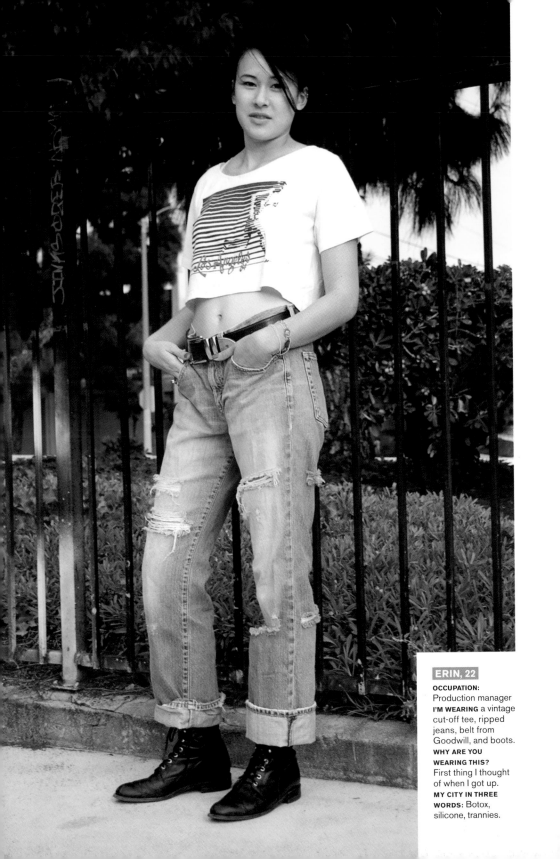

ERIN, 22

OCCUPATION: Production manager
I'M WEARING a vintage cut-off tee, ripped jeans, belt from Goodwill, and boots.
WHY ARE YOU WEARING THIS? First thing I thought of when I got up.
MY CITY IN THREE WORDS: Botox, silicone, trannies.

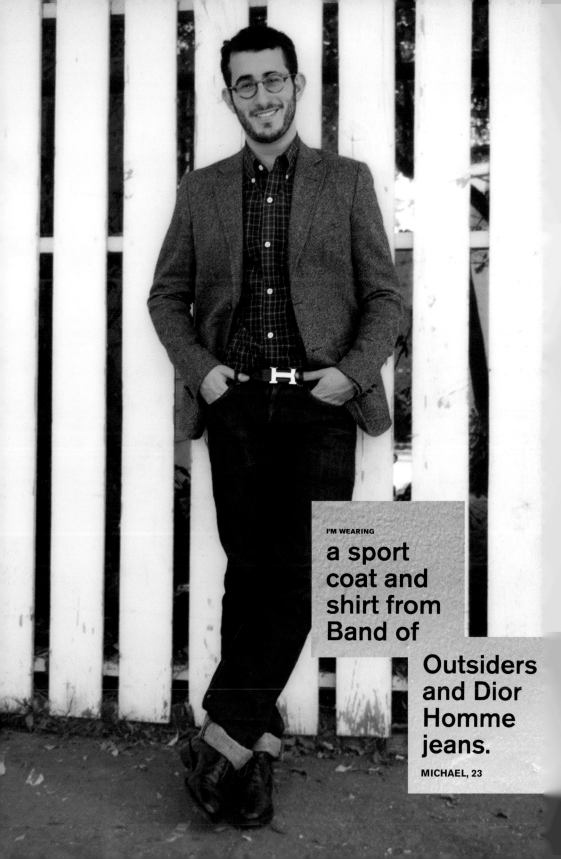

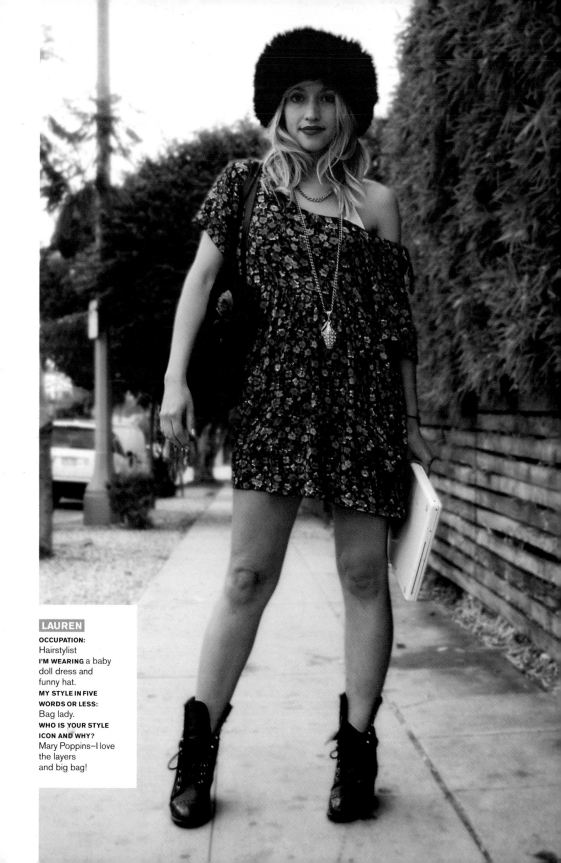

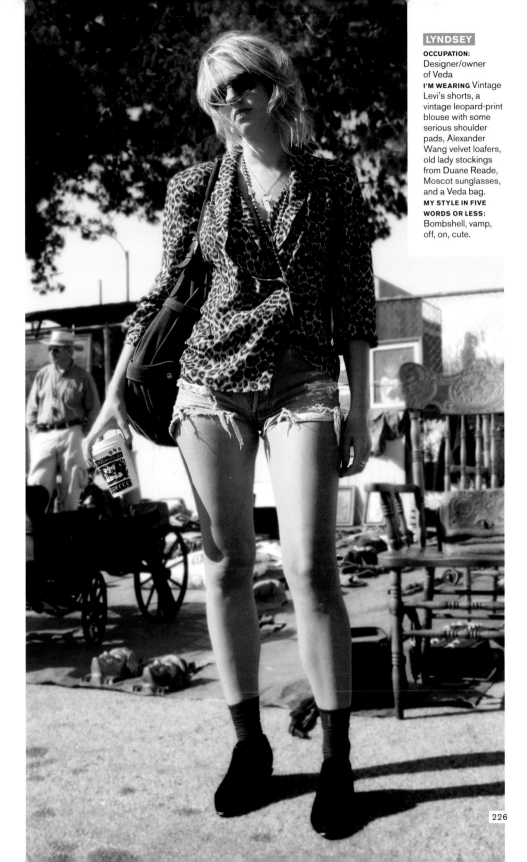

OCCUPATION:
Designer/owner
of Veda
I'M WEARING Vintage
Levi's shorts, a
vintage leopard-print
blouse with some
serious shoulder
pads, Alexander
Wang velvet loafers,
old lady stockings
from Duane Reade,
Moscot sunglasses,
and a Veda bag.
**MY STYLE IN FIVE
WORDS OR LESS:**
Bombshell, vamp,
off, on, cute.

226

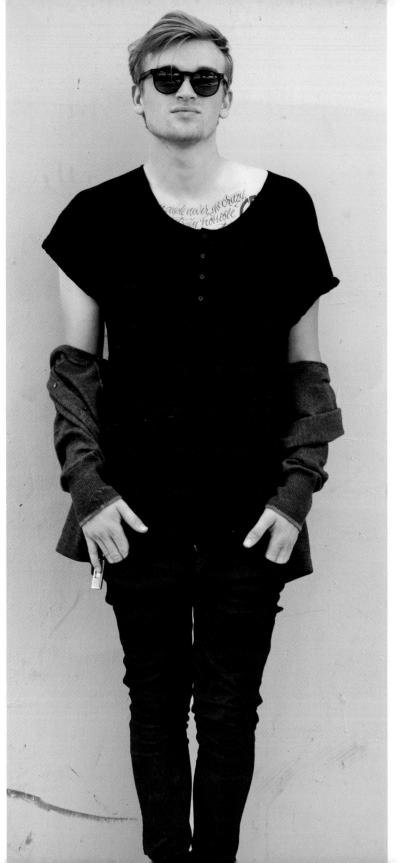

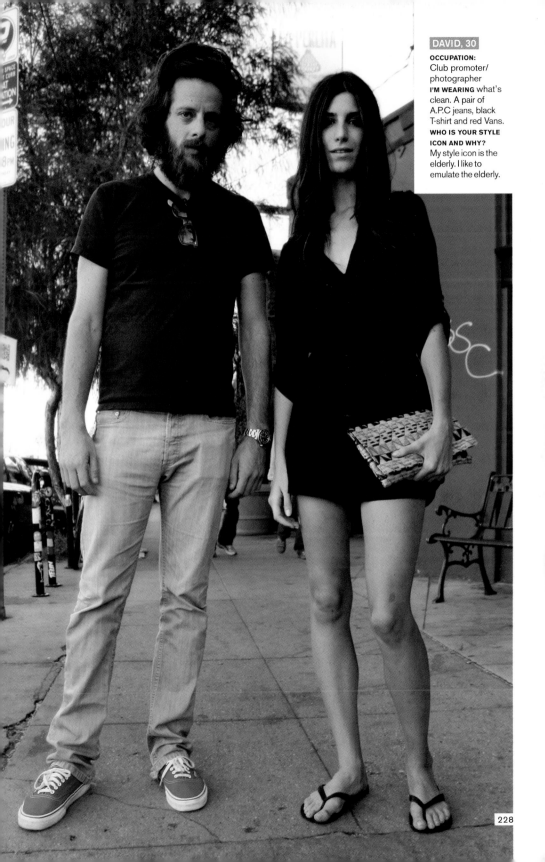

DAVID, 30

OCCUPATION:
Club promoter/
photographer
I'M WEARING what's
clean. A pair of
A.P.C jeans, black
T-shirt and red Vans.
**WHO IS YOUR STYLE
ICON AND WHY?**
My style icon is the
elderly. I like to
emulate the elderly.

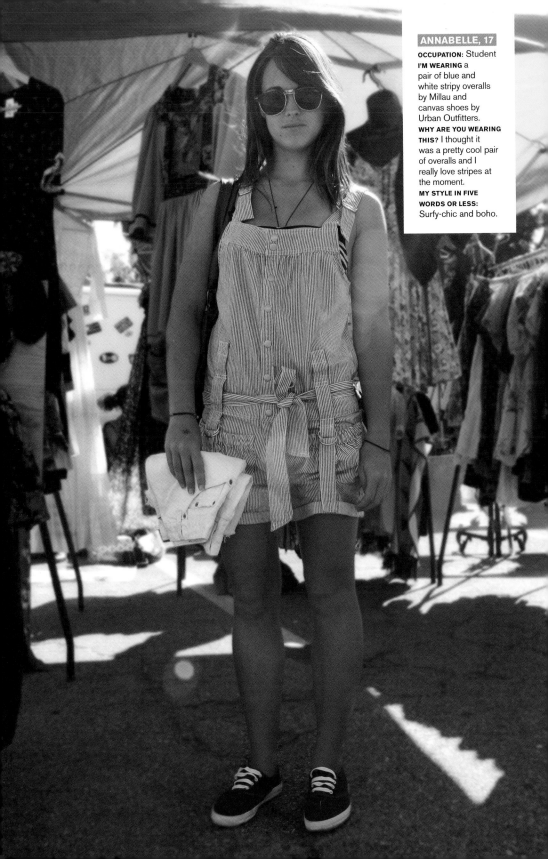

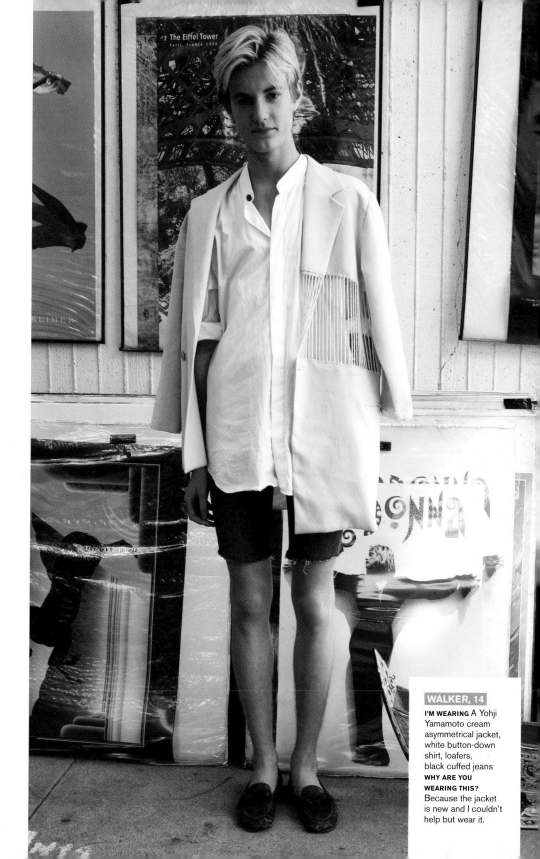

BRANDIN, 21

OCCUPATION:
Manager of tween
scene boutique/chef
**MY STYLE IN FIVE
WORDS OR LESS:**
Daring, eclectic, bold,
fun, stylish, girly.
**MY CITY IN THREE
WORDS:** Amazing,
bananas, trendy.

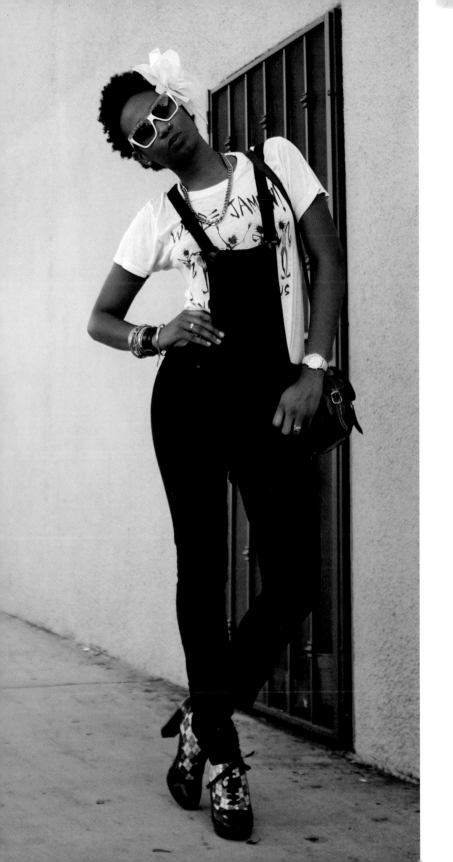

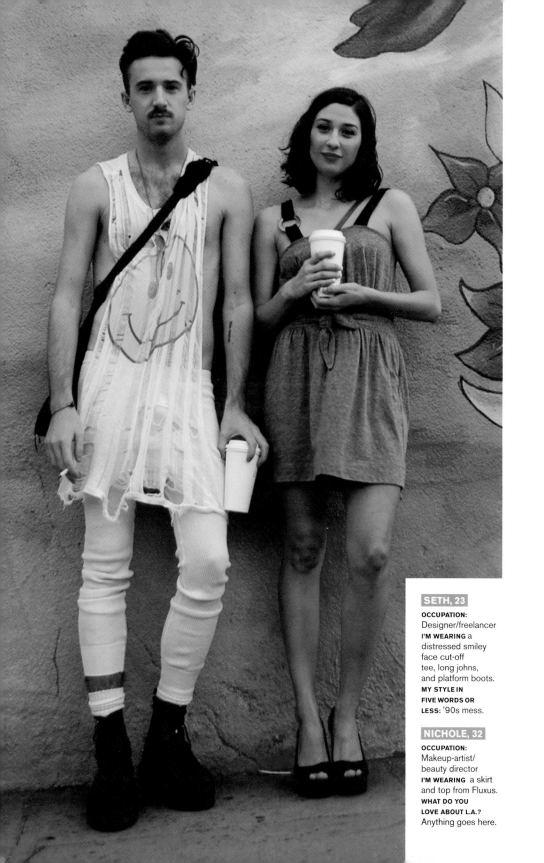

SETH, 23

OCCUPATION:
Designer/freelancer
I'M WEARING a
distressed smiley
face cut-off
tee, long johns,
and platform boots.
**MY STYLE IN
FIVE WORDS OR
LESS:** '90s mess.

NICHOLE, 32

OCCUPATION:
Makeup-artist/
beauty director
I'M WEARING a skirt
and top from Fluxus.
**WHAT DO YOU
LOVE ABOUT L.A.?**
Anything goes here.

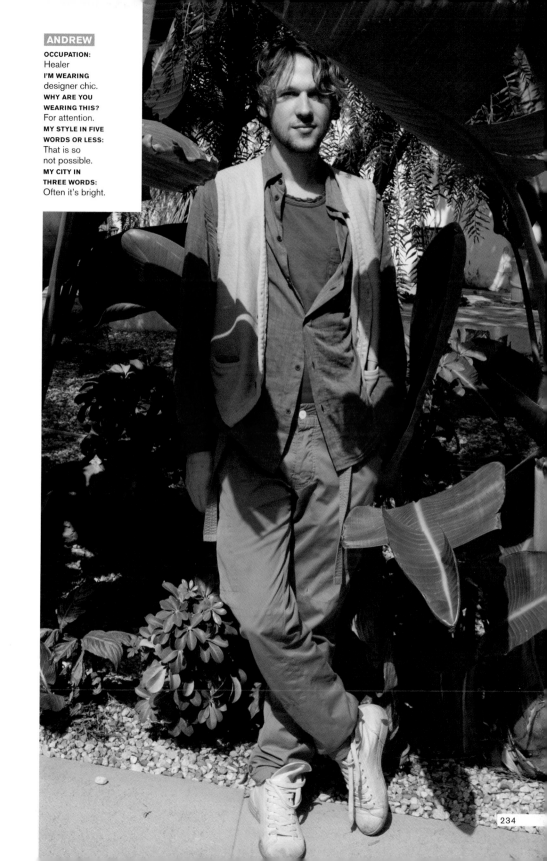

ANDREW

OCCUPATION:
Healer
I'M WEARING designer chic.
WHY ARE YOU WEARING THIS?
For attention.
MY STYLE IN FIVE WORDS OR LESS:
That is so
not possible.
MY CITY IN THREE WORDS:
Often it's bright.

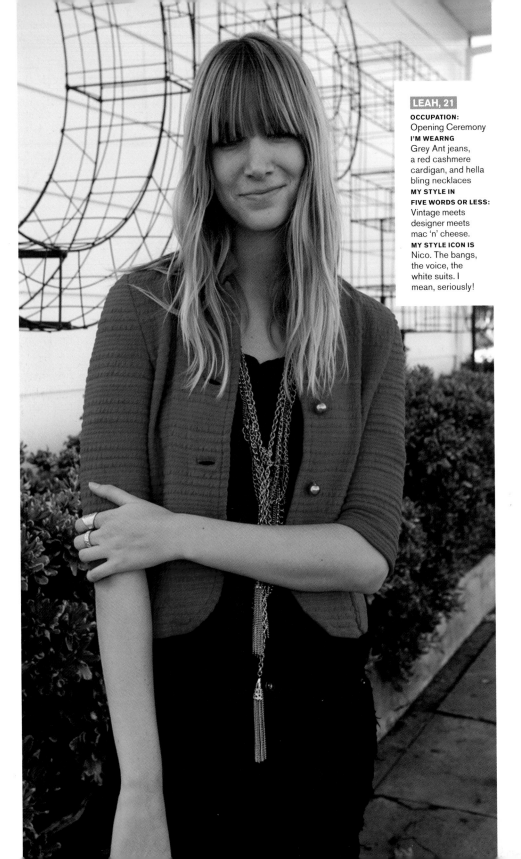

LEAH, 21
OCCUPATION:
Opening Ceremony
I'M WEARNG
Grey Ant jeans,
a red cashmere
cardigan, and hella
bling necklaces
MY STYLE IN
FIVE WORDS OR LESS:
Vintage meets
designer meets
mac 'n' cheese.
MY STYLE ICON IS
Nico. The bangs,
the voice, the
white suits. I
mean, seriously!

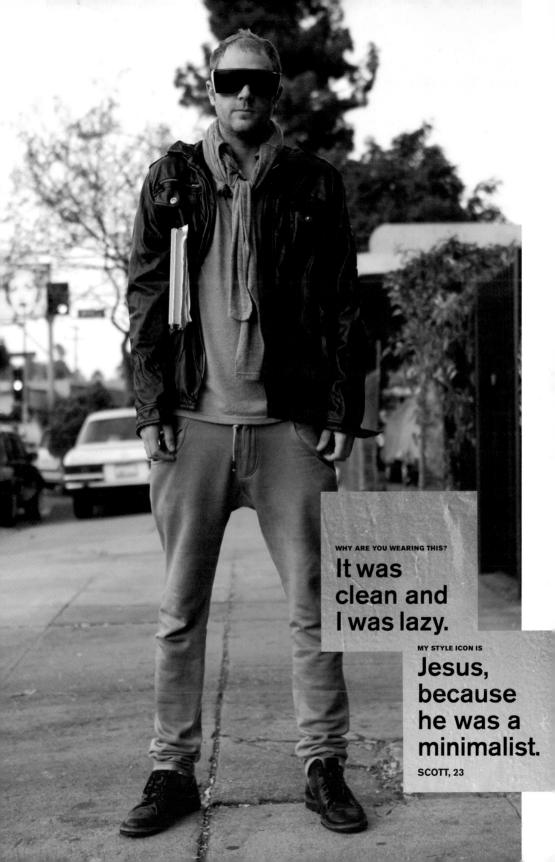

WHY ARE YOU WEARING THIS?

It was clean and I was lazy.

MY STYLE ICON IS

Jesus, because he was a minimalist.

SCOTT, 23

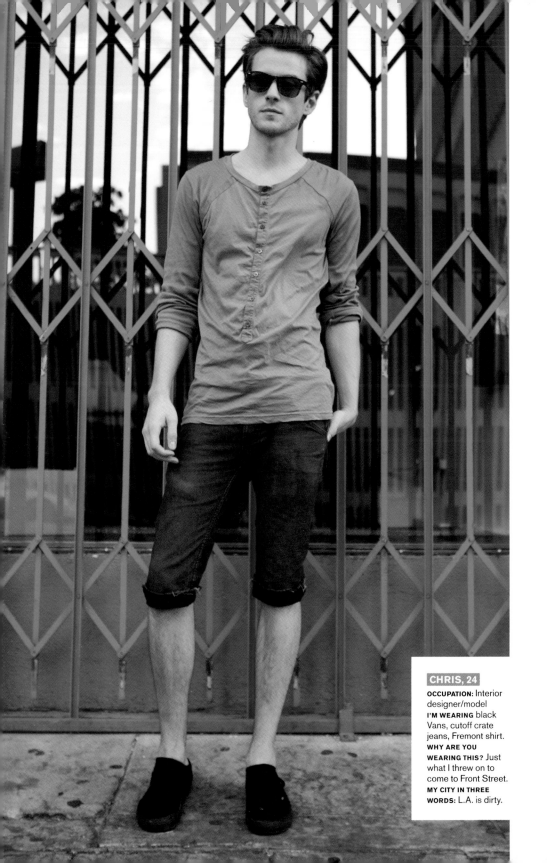

CHRIS, 24

OCCUPATION: Interior designer/model
I'M WEARING black Vans, cutoff crate jeans, Fremont shirt.
WHY ARE YOU WEARING THIS? Just what I threw on to come to Front Street.
MY CITY IN THREE WORDS: L.A. is dirty.

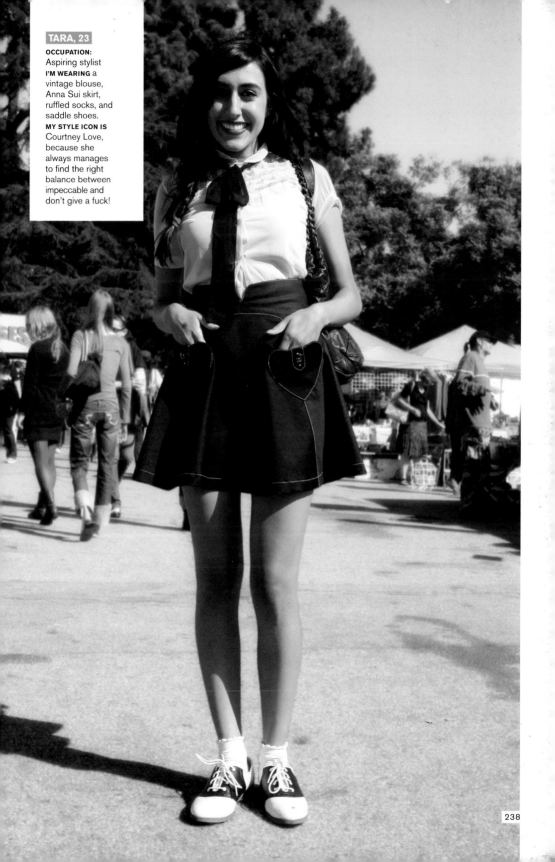

TARA, 23

OCCUPATION:
Aspiring stylist
I'M WEARING a
vintage blouse,
Anna Sui skirt,
ruffled socks, and
saddle shoes.
MY STYLE ICON IS
Courtney Love,
because she
always manages
to find the right
balance between
impeccable and
don't give a fuck!

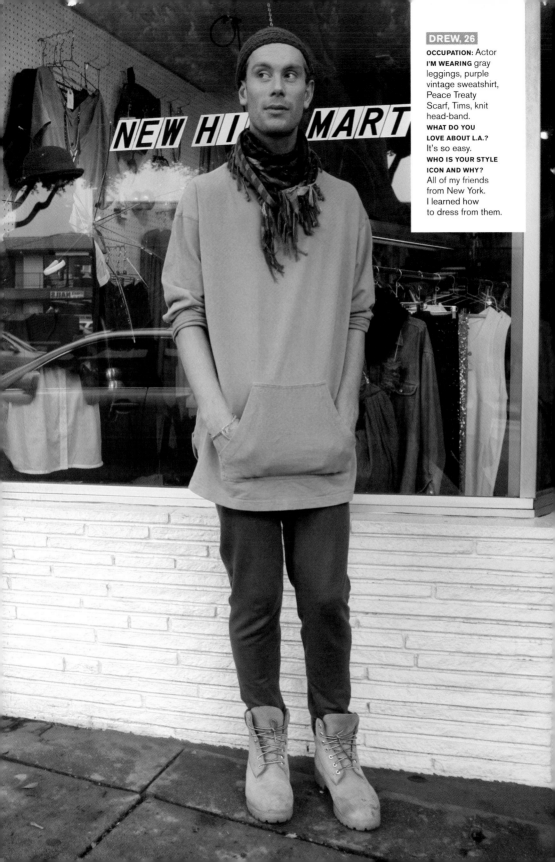

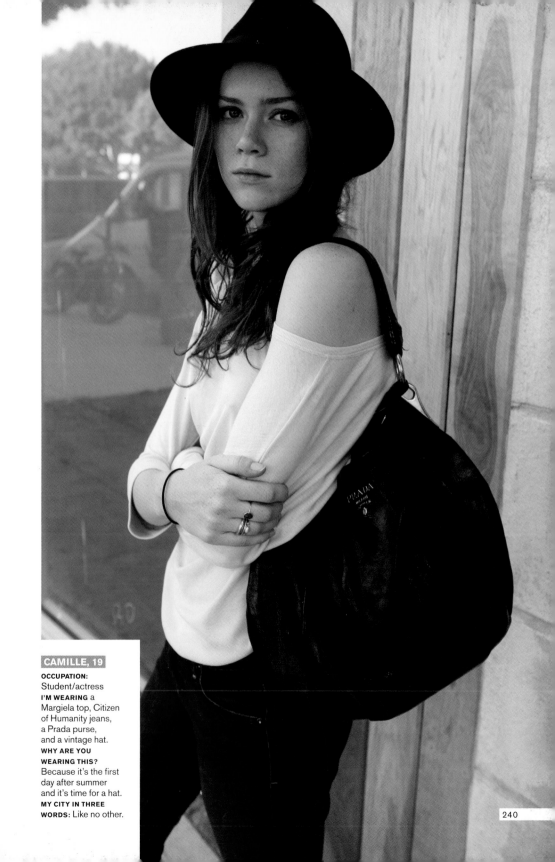

CAMILLE, 19

OCCUPATION:
Student/actress
I'M WEARING a
Margiela top, Citizen
of Humanity jeans,
a Prada purse,
and a vintage hat.
**WHY ARE YOU
WEARING THIS?**
Because it's the first
day after summer
and it's time for a hat.
**MY CITY IN THREE
WORDS:** Like no other.

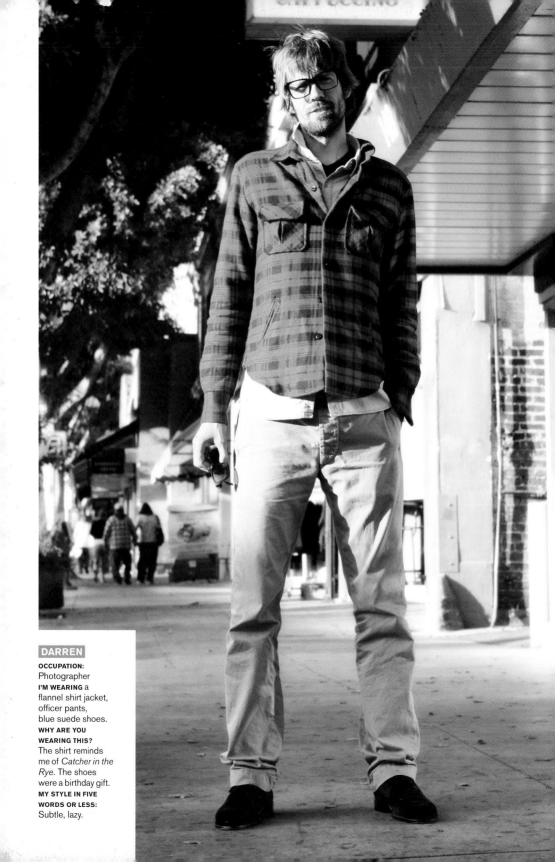

DARREN

OCCUPATION:
Photographer
I'M WEARING a
flannel shirt jacket,
officer pants,
blue suede shoes.
**WHY ARE YOU
WEARING THIS?**
The shirt reminds
me of *Catcher in the
Rye*. The shoes
were a birthday gift.
**MY STYLE IN FIVE
WORDS OR LESS:**
Subtle, lazy.

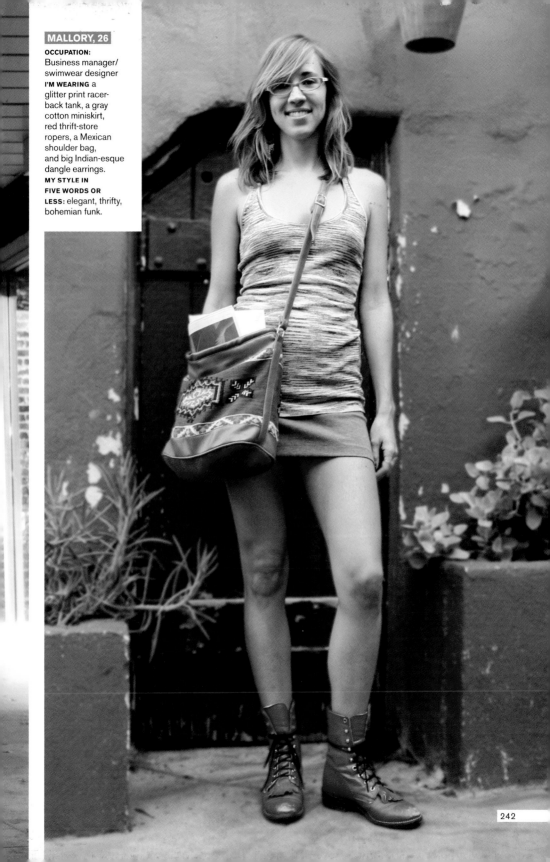

MALLORY, 26

OCCUPATION:
Business manager/
swimwear designer
I'M WEARING a
glitter print racer-
back tank, a gray
cotton miniskirt,
red thrift-store
ropers, a Mexican
shoulder bag,
and big Indian-esque
dangle earrings.
**MY STYLE IN
FIVE WORDS OR
LESS:** elegant, thrifty,
bohemian funk.

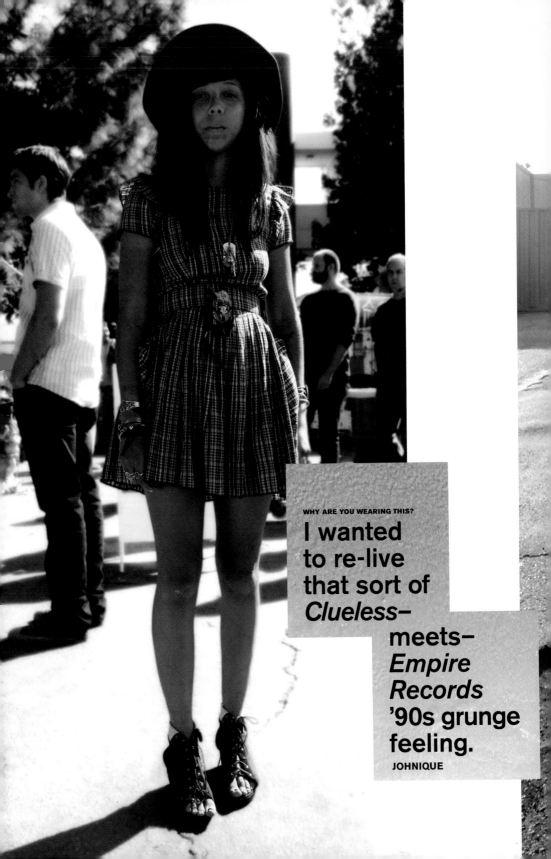

WHY ARE YOU WEARING THIS?

I wanted to re-live that sort of *Clueless*–meets–*Empire Records* '90s grunge feeling.

JOHNIQUE

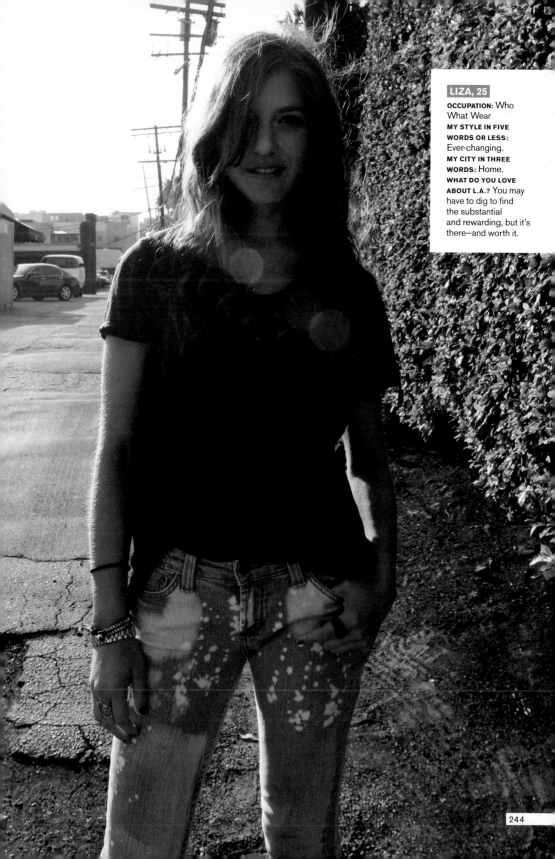

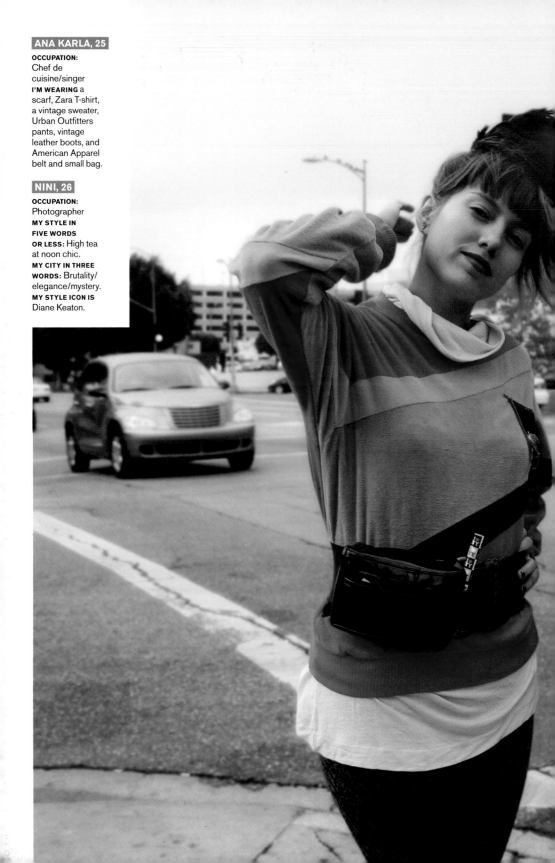

ANA KARLA, 25

OCCUPATION:
Chef de
cuisine/singer
I'M WEARING a
scarf, Zara T-shirt,
a vintage sweater,
Urban Outfitters
pants, vintage
leather boots, and
American Apparel
belt and small bag.

NINI, 26

OCCUPATION:
Photographer
**MY STYLE IN
FIVE WORDS
OR LESS:** High tea
at noon chic.
**MY CITY IN THREE
WORDS:** Brutality/
elegance/mystery.
MY STYLE ICON IS
Diane Keaton.

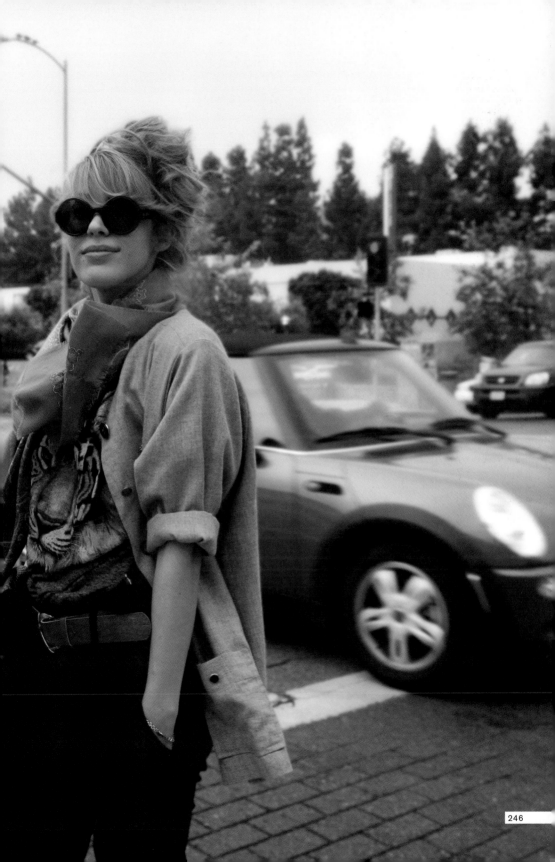

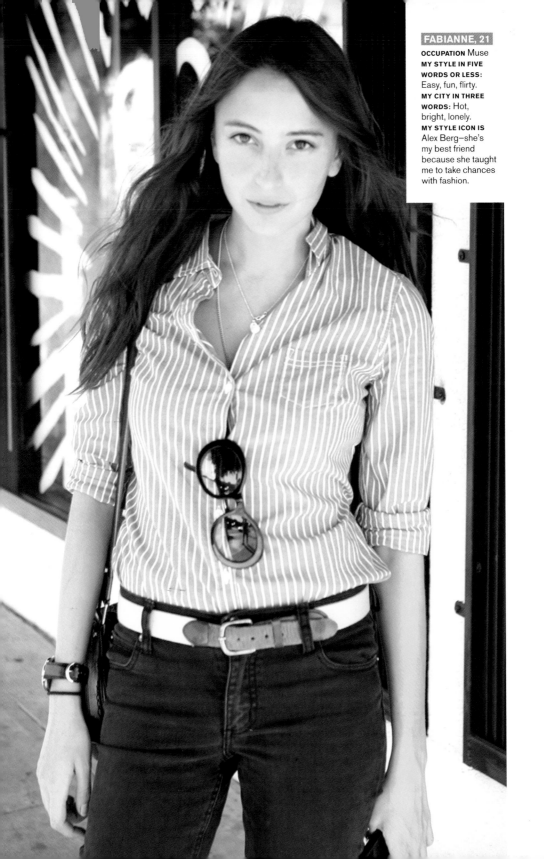

FABIANNE, 21

OCCUPATION Muse
MY STYLE IN FIVE WORDS OR LESS: Easy, fun, flirty.
MY CITY IN THREE WORDS: Hot, bright, lonely.
MY STYLE ICON IS Alex Berg—she's my best friend because she taught me to take chances with fashion.

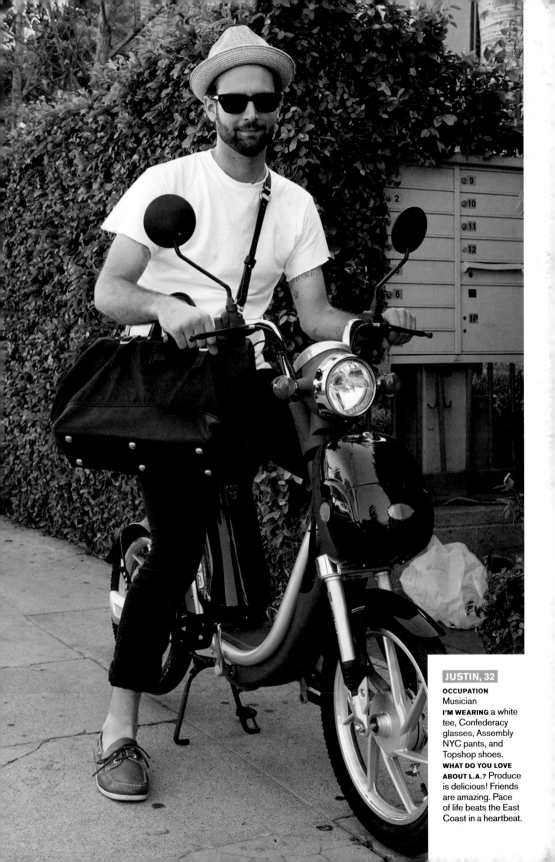

JUSTIN, 32

OCCUPATION
Musician
I'M WEARING a white
tee, Confederacy
glasses, Assembly
NYC pants, and
Topshop shoes.
**WHAT DO YOU LOVE
ABOUT L.A.?** Produce
is delicious! Friends
are amazing. Pace
of life beats the East
Coast in a heartbeat.

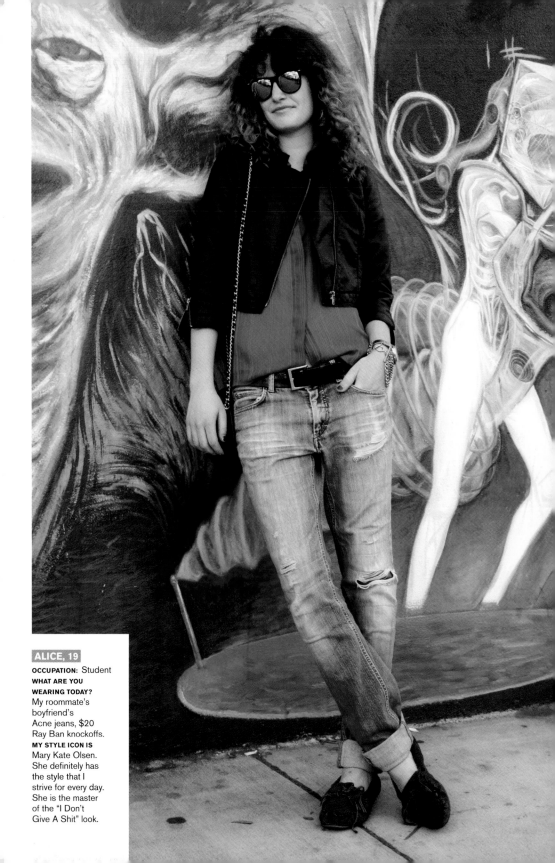

ALICE, 19

OCCUPATION: Student
WHAT ARE YOU WEARING TODAY?
My roommate's boyfriend's Acne jeans, $20 Ray Ban knockoffs.
MY STYLE ICON IS Mary Kate Olsen. She definitely has the style that I strive for every day. She is the master of the "I Don't Give A Shit" look.

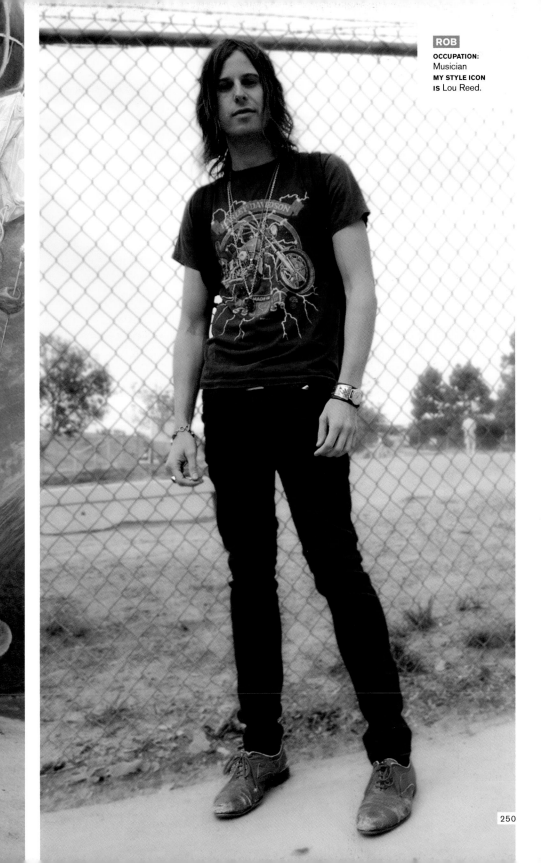

ROB

OCCUPATION:
Musician
**MY STYLE ICON
IS** Lou Reed.

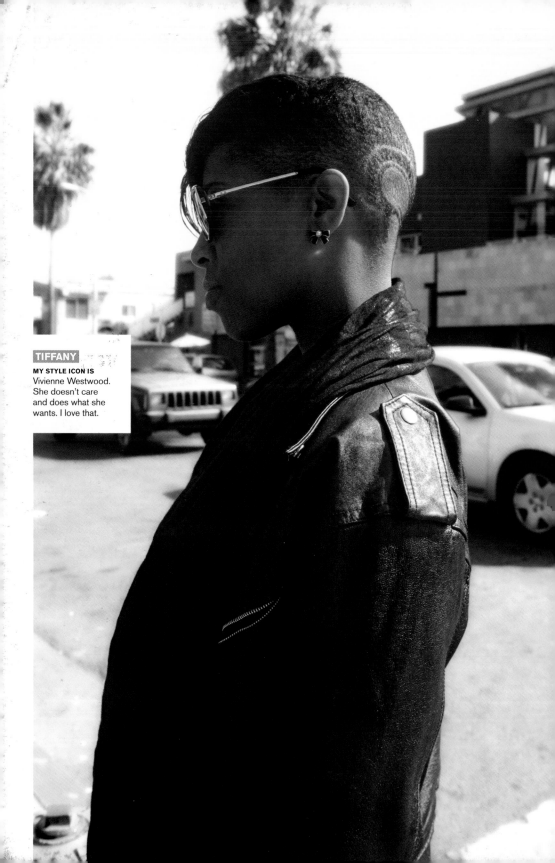

TIFFANY

MY STYLE ICON IS
Vivienne Westwood.
She doesn't care
and does what she
wants. I love that.

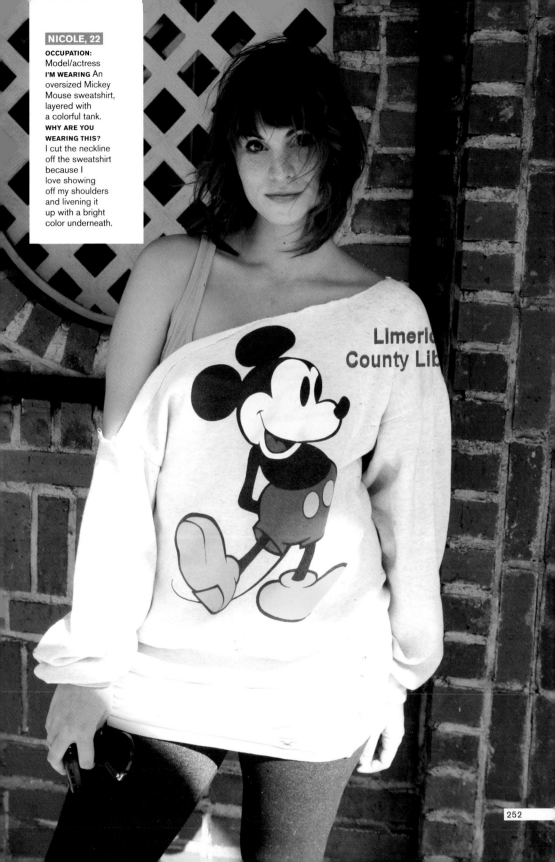

shopping list

Malin Landaeus 157 N 6th St 646 361 0261;
malinlandaeus.com
Gargyle 16A Orchard St 917 470 9367;
gargyle.com
Brooklyn Flea brooklynflea.com
Sir 360 Atlantic Ave 718 643 6877;
sirbrooklyn.com
Century 21 22 Cortlandt St 212 227 9092;
c21stores.com

Barcelona

Trust Nobody Carrer Tallers 1
+34 933 043 731; trustnobody.es
Camper Rambla Catalunya 122
+34 932 172 384; camper.com
Zara Passeig Gràcia 16 +34 933 187 675;
zara.es
Custo Barcelona Avinguda Diagonal 557
+34 933 222 662; custo-barcelona.com
Doshaburi Calle Lledó 4-6
+34 933 199 629; doshaburi.com
Blow Doctor Dou 11 +34 933 023 698;
leswingvintage.com
Exodus Carrer dels Carders 51
Heritage Carrer dels Banys Nous 14
+34 933 178 515; heritagebarcelona.com
Holala Riera Baixa 11 +34 934 419 994;
holala-ibiza.com
Santa Eulalia Passeig de Gràcia 91
+34 932 150 674; santaeulalia.com
Mango Paseo de Gracia 65
+34 932 157 530; mango.com
On Land Carrer Valencia 273
+34 932 155 625; on-land.com
Mayday Carrer Portaferrissa 7-9
+34 934 124 571; mayday.es
Jean Pierre Bua Diagonal 467-469
+34 934 444 962; jeanpierrebua.com

New York

Dear Fieldbinder 198 Smith St
718 852 3620; dearfieldbinder.com
Oak 208 N 8th St 718 782 0521; oaknyc.com
Opening Ceremony 35 Howard St
212 219 2688; openingceremony.us
Castor & Pollux 238 W 10th St 212 645
6572; castorandpolluxstore.com
Pixie Market 100 Stanton St 212 253 0953;
pixiemarket.com
Aloha Rag 505 Greenwich St 212 925 0882;
aloharag.com
Narnia 161 Rivington St 212 979 0661
Earnest Sewn 821 Washington St
212 242 3414; earnestsewn.com
Marc by Marc Jacobs 403-405 Bleecker St
212 924 0026; marcjacobs.com
Beacon's Closet 88 N 11th St 718 486 0816;
beaconscloset.com
J. Crew 99 Prince St 212 966 2739;
jcrew.com
American Apparel 429 Broadway
212 925 0560; americanapparel.net
Levi's 536 Broadway 646 613 1847; levi.com
Ina 15 Bleecker St 212 228 8511; inanyc.com
The Cast 119 Ludlow St 212 228 2020;
thecast.com
Bird 220 Smith St 718 797 3774;
shopbird.com
Buffalo Exchange 504 Driggs Ave
718 384 6901; buffaloexchange.com

London

Topshop 216 Oxford St +44 207 636 7700;
topshop.co.uk
Portobello Road Market portobelloroad.
co.uk
The Shop at Bluebird 350 Kings Rd
+44 207 351 3873; theshopatbluebird.com
Luna & Curious 198 Brick Lane
+44 207 033 4411; lunaandcurious.com
Twenty8twelve 172 Westbourne Grove
+44 207 221 9287; twenty8twelve.com
Beyond the Valley 2 Newburgh St
+44 207 437 7338; beyondthevalley.com
Hurwundeki 98 Commercial St
+44 207 392 9194; hurwundeki.com
Dover Street Market 17-18 Dover St
+44 207 518 0680; doverstreetmarket.com
Selfridges 400 Oxford St +44 800 123 400;
selfridges.com
Vivienne Westwood 44 Conduit St
+44 207 439 1109; viviennewestwood.com
No-one 1 Kingsland Rd
+44 207 613 5314; no-one.co.uk

Silas at Bond 17 Newburgh St
+44 207 437 0079; bondinternational.com
Hoxton Boutique 2 Hoxton St
+44 207 684 2083; hoxtonboutique.co.uk
Viola 25 Connaught St +44 207 262 2722
Miu Miu 123 New Bond St +44 207 409
0900; miumiu.com
Miss Sixty 39 Neal St +44 207 836 3789;
misssixty.com
Beyond Retro 110-112 Cheshire St
+44 207 613 3636; beyondretro.com
Brick Lane Market londonmarkets.co.uk
Primark 499 Oxford St +44 207 495 0420;
primark.co.uk
Rokit 101 and 107 Brick Lane
+44 207 375 3864; rokit.co.uk
Euforia 61B Lancaster Rd
+44 207 243 1808
Camden Stables Chalk Farm Rd;
camdenlock.net
Absolute Vintage 15 Hanbury St
+44 207 247 3883; absolutevintage.co.uk
Jocasi 19 Fouberts Place +44 207 734
2828; jocasi.com

Montreal

Preloved 4832 Blvd St. Laurent
514 499 9898; preloved.ca
Lustre 4068 Blvd St-Laurent 514 288 7661;
lustreboutique.blogspot.com
E.R.A. Vintage Wear 1800 Rue Notre-Dame
Ouest 514 543 8750
Memento 3678 Rue St-Denis
Revenge 3852 Rue St-Denis 514 843 4379;
boutiquerevenge.com
La Gaillarde 4019 Rue Notre-Dame Ouest
514 989 5134; lagaillarde.blogspot.com
Requin Chagrin 4430 Rue St-Denis
514 286 4321
General 54 54 St. Viateur West
514 271 2129; general54.blogspot.com
Arterie 176 Bernard West 514 273 3933;
arterieboutique.blogspot.com
Three Monkeys 1455 Peel St. Suite 207
514 284 1333; threemonkeys.ca
Holt Renfrew 1300 Sherbrooke St West
514 842 5111; holtrenfrew.com
Reborn 231 Rue St-Paul Ouest Suite 100
514 499 8549; reborn.ws
Unicorn Boutique 5135 St. Laurent
514 544 2828; boutiqueunicorn.com
Tristan 1001 Ste-Catherine Street West
514 289 9609; tristanstyle.com
Lola & Emily 3475 St-Laurent 514 288 7598;
lolaandemily.com
Dubuc 4451 Rue St-Denis 514 659 6211;
dubucstyle.com
Abe & Mary's 4175 Jean Talon West
514 448 6223; abeandmarys.com

Stockholm

Cheap Monday Olofsgatan 1 +46 8 411 5150;
cheapmonday.com; weekday.se
Gina Tricot ginatricot.com
Filippa K +46 8 615 7000; filippa-k.com
Obscur obscur.se
Paul & Friends @ NK Hamngatan 18-20
+46 8 762 8330; paul-friends.com
H&M Götgatan 36 +46 8 442 1850; hm.com
NK Hamngatan 18-20 +46 8 762 8000;
nk.se
Acne Norrmalmstorg 2 +46 8 611 6411;
acnestudios.com
Whyred Mäster Samuelsgatan 5
+46 8 660 0170; whyred.se
Weekday Götgatan 21 +46 8 642 1772;
weekday.se
Bruno Götgatsbacken Götgatan 36
+46 8 5580 5000; brunogotgatsbacken.se
Beyond Retro Åsögatan 144
+46 8 5591 3645; beyondretro.com
Chambre Separée Nybrogatan 7
+46 8 678 3535; chambreseparee.se
Emmaus Götgatan 14 +46 8 644 8586;
emmausstockholm.se
Lisa Larsson Bondegatan 48
+46 8 643 6153; lisalarssonsecondhand.com
Stockholms Stadmission Hantverkargatan
78 +46 8 652 7475; stadsmissionen.se
Tiger of Sweden Jakobsbergsgatan 8
+46 8 440 3060; tigerofsweden.se
Sneakerpimps Åsögatan 124
+46 8 743 0322; sneakersnstuff.com
Grandpa Södermannagatan 21
+46 8 643 6080; grandpa.se
Jus Brunnsgatan 7 +46 8 611 9800; jus.se

Tokyo

A Bathing Ape bape.com
Head Porter 3-21-112 Jingumae
+81 3 5771 2621; headporter.co.jp
Real Mad Hectic 4-26-21 Jingumae
+81 3 3405 6933; madhectic.com
Comme des Garçons 5-2-1 Minami-Aoyama
+81 3 3406 3951
Frapbois A Building - 19-5 Sarugakucho
+81 3 5459 2625; frapbois.jp
Uniqlo 6-10-8 Jingumae +81 3 5468 7313;
uniqlo.com
Tokyo Hipsters Club 6-16-23 Jingumae
+81 3 5778 2081; tokyohipstersclub.com
Jeanasis jeanasis.jp
E Hyphen ehyphen.jp
A Store Robot 2-31-18 Jingumae
+81 3 3478 1859; astorerobot.co.jp
Faline 1-7-5 Jingumae
+81 3 3403 8050; bambifaline.com
Isetan 3-14-1 Shinjuku +81 3 3352 1111;
isetan.co.jp
Beams 1F/2F, 3-25-14 Jingumae; beams.
co.jp
Collect Point collect-point.jp
Height 3-35-16 Jingumae +81 3 5775 0530

Los Angeles

Decades 8214 Melrose Ave 323 655 0223; decadesinc.com
Fred Segal 420 & 500 Broadway; fredsegal.com
Ron Herman 8100 Melrose Avenue 323 651 4129; ronherman.com
Satine 8134 W 3rd St 323 655 0426; satineboutique.com
Flight Club LA 503 N Fairfax Ave 323 782-8616; flightclubla.com
Slow 7474 Melrose Ave 323 655 3725; slow7474.com
South Willard 8038 W 3rd St 323 653 6153; southwillard.com
American Rag Cie 150 S La Brea Ave 323 935 3154; amrag.com
Mas 3511_ Sunset Blvd 323 663 3112; masboutique.com
Revolve Clothing 8452 Melrose Ave 3 23 944 0311; revolveclothing.com
White Trash Charms 1951 Hillhurst Ave 323 666-9585; whitetrashcharms.com
Kitson 115 S. Robertson Blvd 310 859 2652; shopkitson.com
Giant Robot 2015 Sawtelle Blvd 310 478 1819; giantrobot.com
G-Star 7966 Melrose Avenue; g-star.com
Diesel 1340 Third Street 310-899-3055; diesel.com

websites

More street style and photo websites:

nylonmag.com

stylecaster.com
refinery29.com
theselby.com
fashionista.com
coacdinc.com
urbanoutfitters.com
fashionologie.com

thesartorialist.com
fashionisspinach.com
bunnyshop.org
stylebubble.typepad.com
bryanboy.com
gofugyourself.celebuzz.com
nymag.com/daily/fashion

credits

Photographers

Stockholm: Nina Andersson
London: Bella Howard
Montreal: Marcus Troy
New York: Alexander Chow and Stephen Walker
Tokyo: Fumi Nagasaka
LA: Stella Berkofsky
Barcelona: Coke Bartrina

Front cover: Rachel Ballinger
Photograph by Marvin Scott Jarrett
Special thanks to Seiji
@ The Wall Group &
Mizu @ Susan Price Inc

Back cover photograph
by Fumi Nagasaka

Contributors

Editor-In-Chief: Marvin Scott Jarrett
Art Director: Rob Vargas
Producer: Heather Catania
Editor: Caitlin Leffel
Text: Diane Vadino
Design Coordinator: Alexander Chow
Assistant Editor: Katie McCaskie